THE ARTIST'S MENTOR

Ian Jackman
editor

RANDOM HOUSE
REFERENCE
New York

The Artist's Mentor

Please address inquiries about electronic licensing of reference products for use on a network, in software or on CD-ROM to the Subsidiary Rights Department, Random House Reference, fax 212-572-6003.

This book is available for special discounts for bulk purchases for sales promotions or premiums. Special editions, including personalized covers, excerpts of existing books, and corporate imprints, can be created in large quantities for special needs. For more information, write to Special Markets/Premium Sales, 1745 Broadway, MD 6-2, New York, NY, 10019 or e-mail specialmarkets@randomhouse.com.

Cover design by Tigist Getachew.

Text design by Tina Malaney.

Printed in the United States of America.

Visit the Random House Web site: www.randomhouse.com

Library of Congress Cataloging-in-Publication Data is available.

First Edition

0 9 8 7 6 5 4 3 2 1

ISBN: 0-375-72063-4

THE
ARTIST'S
MENTOR

CONTENTS

◎ ◎ ◎

INTRODUCTION

◎ ◎ ◎

In 1940, Pablo Picasso visited a site near the town of Montignac in the Dordogne valley in France. Picasso wanted to see the Lascaux cave complex, where, adorning the walls of underground chambers, an ancient treasury of Paleolithic paintings and engravings had just been discovered. Picasso is celebrated as one of the greatest artists who ever lived. He was instrumental in developing abstraction in modern art and revolutionizing the forms artists use to represent the world they see or experience. What modern humankind thinks of as "art" would have been a meaningless concept to the Lascaux cave painters who lived 17,000 years ago or thereabouts, yet when Picasso emerged, having looked at their renderings of horses, bison, and ibex, he said, "We have discovered nothing." In the intervening thousands of years, art may have evolved into one of the noblest human enterprises, but an artist could look back across time and recognize what he was looking at as the work of a fellow artist, and know it at once.

" 'Lascaux man' created, and created out of nothing, this world of art in which communication between individual minds begins." —George Bataille

Even older than the Lascaux paintings are artifacts whose discovery was announced in December 2003. Found in a cave in southwestern Germany were three small carvings—a bird, a horse's head, and a half-man/half-beast figure—each made from the ivory of a mammoth's tusk. The age of the pieces is reckoned to be 30,000 to 33,000 years. These figurines, together with others from three different sites in Germany, join the Chauvet cave paintings in the Dordogne in France as the very earliest examples yet found of the artistic efforts of homo sapiens. Anthony Sinclair, an archeologist at the University of Liverpool said of the newly found objects, "Without question, they are the oldest body of figurative art in the world."

The discovery of the figurines in Germany was reported by Nicholas Conard, a professor of early prehistory at Tübingen University, who said, "These kinds of finds are proof to me that starting at that time, or no later than that time, we have ways of living that are no different to our own—certainly in terms of their complexity and symbolic communication."

The notion of communication, used both in connection with ancient paintings and carvings and in modern art in all its manifestations, has been important in defining the terms of this book. *The Artist's Mentor* is the second in a series that began with *The Writer's Mentor*. It is easier to say what is a writer than it is to define an artist. (Definitions are difficult, even within the

designation of "artist." Penelope Curtis, the curator of the Henry Moore Institute in Leeds, United Kingdom, said:

> **"Can we define sculpture in any meaningful way? The easiest way is to allow sculpture to be anything that is not painting. In recent years it has become even more noticeable that artists who make all kinds of work, but who do not sculpt as such, nevertheless wish to call themselves sculptors."**

For simplicity's sake, *The Writer's Mentor* took anyone who wrote seriously whether published or not to be a writer. An artist is more broadly associated with creativity; in making something that is unique. When a chef or a designer is particularly creative or innovative, he can be described as "an artist." But before a chef is an artist, he is a cook. We need to narrow the field to artists who are artists first, and that can be those who are engaged in communication.

While writers use words on a page, artists choose from a broad range of visual languages; each language made up of signs or symbols. The signs can be painted forms, sculptural elements, musical notes, video images, photographs, pieces of a collage, drawings, and so on. Each can be effective in communicating its message. So which to include?

Almost arbitrarily, this book follows the blueprint suggested by the conventional roster of most museums of art: painting, sculpture and other installations, and photography. Architecture, to a small extent, is in; design is out. And in the same way that we set aside buildings where we listen to music that aren't museums, the artistic efforts of composers and songwriters and those who interpret music through dance or ballet belong in another book entirely. Likewise, cinema.

In the interests of full disclosure, it should be noted that this writer has never displayed any discernable artistic talent in any of the pursuits that are covered in this book. Unlike its predecessor, this volume does not offer any advice as to how to become an artist or a better artist other than that given by the artists themselves. Rather than the practical issue of how to paint, say, *The Artist's Mentor* is more concerned with investigating the sources of the artist's inspiration. Artists describe their own art and how it came to be made. When advice can be extrapolated from any precepts the artists set forward, it is presented. In this way, these artists are collectively mentoring anyone engaged in a creative endeavor. We can follow their lead and hope that some of the sources of the creative fire that urges the artist on will be revealed and shared.

It might go without saying, but it is a challenge to adequately describe any visual medium in words. This is even more the case in a book about art that doesn't have any illustrations. In *The Writer's Mentor,* the writing was about writing so there is a one-to-one correspondence between the description and what is being described. The writing here is about creating objects that are observed and experienced emotionally. A painting has an immediate effect as soon as its image is captured by the eye and processed by the brain. The artist is manipulating materials like paint, clay, or video images to elicit these sensations. The deliberate and relatively slow act of reading and taking in each word is bypassed. Art goes straight for the gut.

"If it possesses but a single moment, it concentrates the *effect* of that moment; the painter is far more the master of that which he wants to express than is the poet or musician, who is in the hands of interpreters." —Eugène Delacroix (1798–1863)

Standing in front of a work or art, then, you are in direct communication with the artist. In speaking with us, however, an abstract artist might make use of elements (words) we cannot "read" to create a work we cannot "understand" in the same way we would understand a piece of writing. Take Robert Smithson's *Spiral Jetty,* a giant curlicue of stones built on a lake bed in Utah in the 1970s. Looking at pictures of *Spiral Jetty,* both as it was originally constructed and as it has recently reemerged from the drought-depleted lake, beautifully stained by thirty years of immersion in briny water, there is an emotional reaction. This reaction would surely be magnified if you were looking at the actual *Spiral Jetty* rather than a small picture of it. Articulating and then writing about that reaction, no matter how evocative the account may be, is far removed from the experience of the feeling itself.

The same is true of writing about the creation of the art itself and this is the focus of this book. If these pages are representative, artists seem much more at ease discussing the technical aspects of what they are doing (how they are working) than the metaphysical elements (what it might "mean" to them). If you ask an artist what impelled him to create a particular work, he might reasonably reply, "It's right there—look at it. What more do you want me to say?"

A few words of caution. In discussing the work of Henri Rousseau in his book *The Great Banquet,* Roger Shattuck

introduces the idea of the intentional fallacy he borrowed from literary theory. This posits that if you're trying to discover what the artist/writer was intending, she is the last person to ask. If this is true, then this book is looking for answers in the wrong place. Also, there is clearly no one correct way to go about making art. When talking about their processes, artists contradict each other and, quite often, themselves. The temperament of an artist can be playful—not everything everyone says should be taken at face value.

It is noticeable that many artists are able to discuss weighty matters of history and theory with great felicity. Established artists are likely to be sensitive to the cultural currents around them and where their work fits in the hierarchy of the world of art. Artists are placed together in movements, sometimes by critics, sometimes by themselves, as was the case with the impressionists, for example. The work of one artist effects other artists. Many react to something they have just seen when they are working, and that is reflected here as artists describe the impact of another artist on them. More than a few times, artists describe an epiphany they have had looking at the work of another artist that has caused their own creative explosion.

All this is by way of explaining how *The Artist's Mentor,* a book about art that doesn't have any pictures, goes about its business. This book is more concerned with the process of creation than the art-historical lineage of the artists involved. Is Picasso correct to imply that there is some driving force common to the artistic temperament? Are the figurines carved from mammoth ivory over 30,000 years ago and the modern artifacts designated as "art"—paintings, a sculpture, or Andres Serrano's controversial *Piss Christ*—products of a very

similar kind of inspiration? The cultural value ascribed to the objects produced—whether totemic, spiritual, or monetary—is not really our concern. It is more the intention or desire of the artist herself that we are interested in. What was she *thinking?* How did he do it?

Any artist is, of course, a product of his precise cultural, social, and political circumstances. In the Western sense of the word, an artist only exists when there is an artistic establishment and apparatus that recognizes him as such. Furthermore, to be represented in this book, the artist has to have given voice to his views on "art" and found a place for those views to be published. There is a market in opinions on art as well as in art itself and these markets preclude the vast majority of artists within and outside the Western market who remain anonymous and voiceless.

The Western art world has clearly concentrated on a relatively small number of "great" artists, the canonical pantheon that is made up of, overwhelmingly, the stereotypical dead white males. It follows that the majority of artists represented in this book are from that group. Perhaps that canonical age has passed and perhaps the art world more resembles the society it is from today. It is certainly easier for an aspiring artist to be heard. The continuing expansion of media, especially the Internet, means there are far more places for artists, and anyone else for that matter, to find a voice. We know what Leonardo thought because he was prestigious enough in his own lifetime to have his ideas recorded, but the majority of artists of former ages left few if any traces of themselves. Now, with video recorders, Web cams, cameras in cell phones, all feeding online publishing in every form, it seems that very little is ever truly lost to posterity. Not only do these develop-

ments facilitate reproduction of art, but they also allow new technology into the making of art itself.

Across the generations and throughout the various techniques of art, artists are linked by the fact that, in as many ways as there can be, they have been *creative*. Where does this urge come from? How does an artist describe the moment when she is inspired to create something? On a more prosaic level, what is she thinking about when she is painting? Does she know where she is going before she starts? What conditions does an artist require? How much are they affected by popular taste?

Many artists give vague and imprecise answers to questions like these. Prose and poetry can embody more than a single meaning, but rarely is a work of fiction, say, as opaque and thematically malleable as a modern painting. One viewer can stand for hours in front of a painting that consists only of a few daubs of color and ask, "What is this?" and never come to any conclusion. Often, the artist won't be any help either and there is no "right" answer to any of these questions. Phalanxes of critics and art historians, together with the legitimizing power of the art market, can say, "It is good," or, "It is important," or "It is expensive," but that is not our concern here either. Whatever anyone else might say about what the artist has done, we are concerned with what he was trying to do, even if he is not quite sure himself.

After spending a little time looking at each, it is clear there are certain similarities between the worlds of the writer and of the artist. According to Stephen Spender:

"When they paint, painters are exercising some of the qualities essential to good writing. Apart from the most obvious of these—the organizing power of the visual imagination—they observe what Blake called 'minute particulars.' They create images and they store memories. For all these things writers may envy them. Painters are the enemies of generalization, journalism, cliché, and these are the pitfalls that surround every writer in our day of newspapers, television, advertising."

John Updike points out the number of writers who were also accomplished artists: William Makepeace Thackeray, Max Beerbohm, Evelyn Waugh, Edward Lear, Wyndham Lewis, Flannery O'Connor, and Edgar Allan Poe. Updike, who was a cartoonist himself, writes:

"Years before written words become plaint and expressive to their young user, creative magic can be grasped through pen and ink, brush and paint. The subtleties of form and color, the distinctions of texture, the balances of volume, the principles of perspective and composition—all these are good for a future writer to explore and will help him visualize his scenes, even to construct his personalities and to shape the invisible contentions and branchings of plot."

Art is a fine training for writing, he says. "Small wonder that writers, so many of them, have drawn and painted: the tools are allied, the impulse is one." Updike also writes about artistic creativity and what propels the artist forward, the main topics of this book. He also brings us back to the original artist. Art, Updike says, is a social activity. "Art is a transaction. It needs a market." He writes:

"The abiding mystery is not what art is for but what force it is that seizes the artist and makes him exceed the strict requirements of the market. This excess, strangely, is what we value. Call it virtuosity, inspiration, dedication, the cave artists had it."

PART 1

Learning the Art

"Many are they who have a taste and love for drawing, but no talent; and this will be discernible in boys who are not diligent and never finish their drawings with shading."

—Leonardo da Vinci

"When I was nine years old I had St. Vitus Dance. I painted a picture of Hedy Lamarr from a Maybelline ad. It was no good, and I threw it away. I realized I couldn't paint."

—Andy Warhol

Giorgio Vasari's *The Lives of the Painters, Sculptors, and Architects,* first published in 1550, remains an important source on the lives and careers of the great Italian Renaissance artists like Leonardo and Michelangelo and their contemporaries. Part of Vasari's contribution to art history has been his fund of stories that humanize masters like Titian and Raphael and other painters and sculptors. Two of Vasari's best-known tales concern Giotto. In one, the painter draws a perfect circle freehand to prove his mettle to a representative of the pope. In another, Vasari relates how the youthful Giotto was discovered by an older painter, Cimabue.

Giotto di Bondone (1267–1337) lived a full two centuries before Vasari and was among the earliest painters Vasari wrote about. Vasari described how Giotto was born near Florence to a peasant family and from the age of ten he looked after the family's sheep. Vasari writes:

> **"And he leading them for pasture, now to one spot and now to another, was constantly driven by his natural inclination to draw on the stones or the ground some object in nature, or something that came into his mind."**

Apocryphally, probably, Giotto's pastoral sketches were witnessed by the painter Cimabue (Cenni di Pepo 1240–1302?), who happened to be passing by on his way from Florence to Vespignano.

> **"[Cimabue] found Giotto, while his sheep were feeding, drawing a sheep from nature upon a smooth and solid rock with a pointed stone, having never learnt from any one but nature. Cimabue, marveling at him, stopped and asked him if he would go and be with him. And the boy answered that if his father were content he would gladly go."**

After coming across the young Giotto, Cimabue took the talented boy in and gave him an apprenticeship the likes of which is no longer feasible—Giotto would have been about twelve at the time Cimabue supposedly stumbled across him. This story most usefully serves as an ideal of the old master coming across his protégé living humbly, spontaneously exhibiting his latent greatness. But long after Giotto and Vasari, artists describe the equivalent of scratching pictures of

sheep on a rock with a stone—powerful childhood memories of the first encounters with art.

"As far back as I can remember, I was drawing. Almost as soon as my fat baby fingers could grasp a pencil, I was marking up walls, doors, and furniture. To avoid mutilation of his entire house, my father set aside a special room where I was allowed to write on anything I wished. This first 'studio' of mine had black canvas draped on all the walls and on the floor. Here I made my earliest 'murals.' " —Diego Rivera (1886–1957)

"As a child I had always been in my own world, preferring to stay at home and draw rather than play." —Bill Viola

"According to doña María, Pablito, as she usually called her son, could draw before he could speak, and the first sound he made was 'piz, piz . . .'—baby language for lapiz, i.e., pencil." —John Richardson on the infant Picasso

"First of all, I had an uncle who was a painter and who seemed to live a very exotic and colorful life. I adored him. And then I had a Romanian governess who taught me to draw very nicely when I was about three or four. On my first day of school, I found I was the only kid who could make drawings." —Rebecca Horn

Architect Frank Gehry recalls childhood memories of playing with his grandmother, building houses and cities out of wood scraps from his father's hardware store:

"That's what I remembered, years later, when I was struggling to find out what I wanted to do in life. It made me think about architecture. It also gave me the idea that an adult could play."

Other artists describe how early experiences shaped their creative careers. Robert Smithson, in an interview from 1972, talked about a long and memorable road trip he took as a boy:

"Well, my first major trip was when I was eight years old and my father and mother took me around the entire United States. Right after World War II we traveled across the Pennsylvania Turnpike out through the Black Hills and the Badlands, through Yellowstone, up into the Redwood forests, then down the Coast, and then over to the Grand Canyon. I was eight years old and it made a big impression on me. I used to give little post card shows. I remember I'd set up a little booth and cut a hole in it and put post cards up into the slot and show all the kids these post cards."

In turn, Jeff Koons mentions Robert Smithson in connection with his own childhood influences; in his case relating to his father:

"My father was an interior decorator and had a showroom where things were on display, so I was brought up around objects. When I ultimately lost interest in painting, I enjoyed seeing art that used display, like Robert Smithson's. My own earliest works present themselves as Smithson-type displays."

"My dad made cartoon characters for me, and they were very similar to the way I started to draw—with one line and a cartoon outline. They were simple line drawings. . . .

"I was never into comics like Dick Tracy or Batman. However, I was really obsessed by Walt Disney. And I was really into Dr. Seuss. And I liked the early Charles Schultz. . . . Then, of course, there were the television cartoons. I was constantly watching them." —Keith Haring.

"The great majority of advice I have received comes from my father. You see, I practically grew up under his drafting table and then when I was old enough to get on top, I was drawing on the other end of it." —Eero Saarinen

The great sculptor and architect Gian Lorenzo Bernini (1598–1680) had as his mentor his father Pietro, himself a sculptor. By the age of eight, young Bernini was reputedly already making his own pieces under his father's guidance. "Watch out," said Cardinal Barberini to Pietro in a story Bernini told of himself, "he will surpass his master." "It doesn't bother me," said the father, "for in that case the loser wins." The father encouraged and pushed his son. Bernini was said to have spent every day for three years in the Vatican, making sketches of marbles and paintings.

◎ ◎ ◎

James Rosenquist often paints on a huge scale, a preference prefigured by summer work he did as a young man painting billboards with advertisements for companies like Phillips 66 and Coca-Cola. Rosenquist describes how he learned techni-

cal necessities like mixing colors and how to paint figures right in front of his face that would be recognizable from a hundred yards away. Rosenquist's midwestern upbringing also afforded the experiences he believes were essential in developing his particular artistic sensibilities:

"Living in the Plains, you'd see surreal things; you'd see mirages. I'm sitting on the front porch, as a little kid at sunset and the sun is in back of me, and walking across the horizon is a Trojan horse four stories tall. I go, 'Uh-oh—what's that?' So I run in the house and say, 'Look! Look at the big horse!' It was the neighbor's white stallion, which had got loose, caught the light in the heat, and it looked four stories tall. These kinds of little things make, I think, the curiosity, or the inquisitiveness, that make an artist."

Today, there is no set study program required for any artistic endeavor. Also, art school is expensive and doesn't guarantee any kind of art career afterward. What's more, it's possible to argue that art cannot be taught at all.

"There have long been doubts whether art can be taught. They go back at least to Plato's concept of inspiration, *mania,* and Aristotle's concepts of genius and poetic rapture (the *ecstaticos*). If art is made with the help of *mania,* then ordinary teaching can have little effect—and if it is inspired teaching, then it isn't teaching in the sense that I mean it here, but something more like infection. I may give someone the flu, but I am hardly ever sure how or when I did it. Teaching *mania* by being ecstatic and inspirational is like being infected and spreading disease: you can't really control it." —James Elkins

It is by no means necessary to be an artistic prodigy. It really is never too late to start, or almost never. The critic David Sylvester talked about the case of Barnett Newman, who was born in 1905 but whose earliest recorded drawing dates from 1944 and his earliest painting from 1945. Sylvester says Newman, "by his own reckoning he found himself" with the painting *Onement I,* which was painted in 1948. Newman's art reached full maturity with *The Voice, Vir Heroicus Sublimis,* and *Cathedra,* which were made between 1950 and 1951.

"That is to say, he was forty when he produced his first known painting, around forty-five when he produced what seem the most indispensable paintings of this half of the twentieth century. Newman, then—given the resemblance of artists, not to mountaineers, with their finite ambition to scale particular peaks, but to jumpers and vaulters with their infinite ambition to reach as far as they can (and their recognition that, whatever their success by comparison with others, they are bound to fall short in the end)—Newman was like those champion high jumpers who delay coming into competition till the bar is nearing its ultimate level."

"Men who are born painters know by instinct how to find means of expressing their ideas; they bring their ideas to light through a mingling of sudden impulses and tentative gropings, and perhaps with a more special charm than that offered by the production of a consummate master." —Eugène Delacroix

To harness inquisitiveness and talent, young men and women still go to school to learn technique and discipline in pursuit of an artistic career. It can be argued they need to study in order to throw off the spontaneity of childhood.

"The primitive childish stage is when children are geniuses. Before fact bothers them. But one fact bothers them, then I think you have to learn to draw and all that. If you want to."
—Alice Neel

Architect Alvar Aalto (1898–1976) talks about his time as a teacher in the United States. Students would ask him questions:

"One of the questions they asked me was how to make good art. I said: 'I don't know.' The consequences were appalling. One day the parents of one of my students turned up at the professor's office. . . . Their first words were: 'We are paying seven hundred dollars a term for our son's studies and all the professor says is "I don't know."' I think that must have been the end of my brief teaching career."

As we'll see in the chapter on technique, artists have been complaining about declining technical standards for centuries. If artists can't learn inspiration, they can surely learn some fundamentals of technique. From Leonardo da Vinci to Salvador Dalí, artists prescribe what young people should learn if they are to acquire any proficiency:

"The first endeavours of a young Painter . . . must be employed in the attainment of mechanical dexterity, and confined to the mere imitation of the object before him." —Sir Joshua Reynolds (1723–1792)

"The youth ought first to learn perspective, then the proportions of everything, then he should learn from the hands of a good master in order to accustom himself to good limbs; then from nature in order to confirm for himself the reasons for what he has learned; then for a time he should study the works of different masters; then make it a habit to practice and work at his art." —Leonardo da Vinci (1452–1519)

"Begin to paint by learning to draw and paint like the old masters. After that, you can do as you like; everyone will respect you." —Salvador Dalí (1904–1989)

Many artists point to a key moment in their development that came in a moment of inspiration standing in front of the work of an established painter or sculptor. (See the chapter on influences.) In the first part of the twentieth century, if you wanted to have a creative epiphany, you went to Paris. The photographer Walker Evans went to France at the age of twenty-two in 1926, a time when it was much cheaper to live in Europe than it was in the United States. Forty-five years later, Evans says that "[a]ny man of my age who was sensitive to the arts was drawn as by a magnet to Paris because that was the incandescent center, the place to be." As Evans points out, Proust was just dead, Gide was alive, and Picasso was in midcareer. Around the same time, Francis Bacon was visiting exhibitions by Soutine, Chirico, Arp, Picabia, Juan Gris, and

I s art school necessary?

Is it possible to learn how to be an artist in school? Robert Rauschenberg thinks it's better to be in school than struggling to pay the rent (assuming you can find the fees for school, of course). Picasso complains that, at the Beaux-Arts school, "They try to teach us everything. They wind up teaching us nothing."

> "I still think that going to a school is a much better way to start out as a young artist than doing the battle of the landlords." —Robert Rauschenberg

> "It is often the case that the value of an education is derived from other students. I certainly learned less from 'teachers' than from my fellows." —Richard Hamilton

> "They have us make copies of everybody, trying to turn us into another Velásquez or another Goya or maybe Poussin, and we remain nobody. Art begins with the individual. When the individuality appears, that's the beginning of art." —Pablo Picasso (1881–1973)

> "Some students possess the school they work in. Others are possessed by the school." —Robert Henri (1865–1929)

Mondrian, each of whom might have provided invaluable inspiration.

American artists flooded to Paris from the time of the Civil War through the era of Gertrude Stein and Ernest Hemingway. Fledgling artists wrote home excitedly:

> " 'Paris is the best school in the world,' exulted one. 'The best in modern art,' proclaimed another. Paris has 'the greatest museums,' rejoiced a third. 'I am falling head-over-heels in love with Paris,' a fourth chimed in. American painters freshly arrived in the French capital bubbled over with excitement and enthusiasm. Among Europe's institutions, the museums, schools, and studios of Paris enjoyed the greatest prestige, led of course by the Louvre and the École des Beaux-Arts. 'I just finished my first day. It is marvelous! I feel that I am really becoming an artist.' " —Annie Cohen-Solal

Edward Hopper demurred. "Whom did I meet?" He was asked of Paris, where he went in 1906. Not quite truthfully he replied, "Nobody."

◎ ◎ ◎

Parents are often disappointed with their children's choice of career. Not every parent expresses his or her displeasure as forcefully as Joan Miró's father, as recalled by the painter's daughter, Dolorès:

> "When [Miró] was a teenager, my grandfather made him work as a bookkeeper in a hardware store in Barcelona. He had a nervous breakdown while working here, followed by

typhoid fever. His father objected to his vocation; he didn't like the idea of having a son who was a painter. In the family, the life of an artist was considered immoral."

"My father didn't think being an artist was a respectable or worthy goal for a man." —Richard Diebenkorn

If he can find his way through the childhood maze, avoiding being side-tracked into a more conventional career, and if he can actually start creating, then the artist's great reward comes with the first art he makes on his own.

"Sundays my camera and I would take long car-rides into the country around Chicago—always alone—and nights we spent feverishly developing my plates in some makeshift dark-room, and then the first print I made from my first 5 x 7 negative—a snow-scene—the tightening—choking sensation in my throat—the blinding tears in my eyes when I realized that a 'picture' had really been conceived—and how I danced for joy into my father's office with this initial effort: I can see every line of the composition yet—and it was not half-bad." —Edward Weston (1886–1958)

At the end of the day, after training and the first art of adulthood, perhaps you'll yearn for what you remember as simple times, if you remember them properly at all. Artists frequently speak of a desire to unlearn what they have accumulated:

"I pray every day that God make me a child, that is to say that he will let me see nature in the unprejudiced way that a child sees it." —Jean-Baptiste-Camille Corot (1796–1875)

"In one of his letters from Tahiti, Gaugin had written that he felt he had to go back beyond the horses of the Parthenon, back to the rocking-horse of his childhood. It is easy to smile at this preoccupation of modern artists with the simple and childlike, and yet it should not be hard to understand it. For artists feel that this directness and simplicity is the one thing that cannot be learnt. Every other trick of the trade can be acquired. Every effect becomes easy to imitate after it has been shown that it can be done. Many artists feel that the museums and exhibitions are full of works of such amazing facility and skill that nothing is gained by continuing along these lines; that they are in danger of losing their souls and becoming slick manufacturers of paintings or sculptures unless they become as little children." —E.H. Gombrich

It is, of course, impossible to consciously eradicate experience. Perhaps the earliest memories are the most vivid, or the most durable. What we learn first, we have, by definition, remembered longest. And the successful artist will continue to grow. Long deaf, and old and infirm, Goya (1746–1828) wrote on one of his last drawings, "I keep learning." In *The Creative Act*, André Malraux writes about the triumphs of age; informed by youth but accomplished by experience:

"The artist has 'an eye,' but not when he is fifteen; and what length of days does a writer need before writing with the sound of his own voice! The greatest painters' supreme vision is that of the last Renoirs, the last Titians, Hals' last works—recalling the inner voice heard by deaf Beethoven—that vision of the mind's eye, whose light endures when the body's eyes are failing."

THE WORLD
OF INFLUENCES

"Artists are influenced primarily by other artists, which means
that standard art history can sound like a baseball broadcast
of an infield play: Velázquez to Goya to Picasso."
—Arthur Lubow

"It is in the museum that one learns to paint."
—Pierre-Auguste Renoir (1841–1919)

In *The Writer's Mentor,* the writers list their influences—
that is, the writers they have read who made them want to
write or, later, have caused them to pause and reconsider their
own work. Because the acquisition of influence and inspira-
tion are necessary for development, writers advise aspiring
writers to read, to read widely and deeply. In the same way,
looking at other people's art is an essential part of the artist's
life at all its stages.

Artists speak of the impact that a particular work of art has
had on them. The universality of this event is described by
André Malraux, who writes that an artist has to have been

inspired by another artist. In a vacuum, he is saying, there is no art.

> **"It is a revealing fact that every artist, when asked how his vocation came to him, invariably traces it back to the emotion experienced at his contact with some specific work of art. A writer traces his vocation back to the reading of a certain poem or a novel (or, perhaps, a visit to the theatre); a musician, to a concert he attended; a painter, to a painting he once saw. Never do we hear of the case of a man who, out of the blue so to speak, feels a compulsion to 'express' some scene of startling incident. 'I *too* will be a painter!' "**

A writer doesn't need to read Dickens's original manuscript of *Our Mutual Friend* to absorb the full benefit of the power of the work. Any copy will do. Paintings can be reproduced on paper but have little of the immediate impact of the original. It is even more the case, of course, with sculpture, where a three-dimensional form is reduced to a flat image. Installations by definition can only be experienced in situ. The viewer might not even know as basic a fact as a painting's size before seeing it in the flesh. Visitors to the Louvre often comment that they expected the *Mona Lisa* to be larger. The Art Institute of Chicago houses three of the most recognizable paintings of the twentieth century: Georges Seurat's *Sunday on the Grand Jatte*; Edward Hopper's *Nighthawks*; and Grant Wood's *American Gothic*. One visitor was surprised at the size of each: how large the first two are (ten feet by seven feet and two-and three-quarters by five) and how small *American Gothic* (at two-and-a-half by two feet) seems, although the expectations were built on little of substance.

The fact that art needs to be witnessed helps explain why aspiring artists have always flocked to major metropolitan centers—Rome, Florence, Paris, and New York—cities where art is not only bought and sold but displayed. When Diego Rivera visited the Prado in Madrid, he said that Velázquez left him indifferent. But when he found himself in a room full of the works of El Greco, he sensed what he described as the "fire of a great beauty":

> **"The feeling produced on me by El Greco was so strong that it even showed itself physically and a friend came up and asked me if I was ill."**

Francis Bacon points to an exhibition of drawings by Picasso he saw in Paris in a gallery on the rue La Boëtie in the summer of 1927 as the defining moment in his development as an artist. They were classical works—106 drawings, many in ink. "They made a great impression on me," he said, "I thought afterwards, well, perhaps I could draw as well." Without any formal training, Bacon started drawing and making watercolors himself. What Picasso meant to Bacon was that Picasso came closest to "[t]he core of what feeling is about."

> **"Only the great distance that separates Paris from my native town prevented me from returning to it immediately or at least after a week, or a month.**
>
> **"I even wanted to invent some sort of holiday as an excuse to go home.**
>
> **"The Louvre put an end to all these hesitations.**
>
> **"When I made the tour of the Veronese room and the**

rooms in which Manet, Delacroix, Courbet are hung, I wanted nothing more." —Marc Chagall (1887–1985)

Wassily Kandinsky saw one of Monet's *Haystacks* in Moscow in 1895. "Previously I knew only realistic art," he said. "Suddenly for the first time, I saw a 'picture.' "

"It was one morning at the Villa Borghese, in front of a painting by Titian, that I had a revelation of what great painting was: I saw tongues of fire appear in the gallery, while outside beneath the clear sky over the city, rang out a solemn clangor as of weapons beaten in salute, and together with a great cry of righteous spirits there echoed the sound of a trumpet heralding a resurrection." —Giorgio De Chirico (1888–1978)

"I liked the painter Pieter Brueghel so much when I was in art school that the fellows used to call me Pete for a nickname." —Romare Bearden (1914–1988)

Sometimes, the influence can be isolated to a particular benefit the younger artist felt, such as in Alexander Calder and Monet's cases, as a result of meeting an artist. In the late 1920s, Calder was in Paris, making small figures in wire that he used to perform a miniature circus. A number of famous artists saw the show, including, in 1930, Piet Mondrian. Mondrian took Calder to his studio, an event that Calder marks as the start of his serious art career. Any young artist can dream of such good fortune.

"Though I had heard the work 'modern' before, I did not consciously know or feel the term 'abstract.' So, now at thirty-two, I wanted to work in the abstract."

"While still young I was fortunate enough to meet the painter Eugène Boudin who opened my eyes and taught me a love of nature." —Claude Monet (1840–1926)

"Manet drew inspiration from everywhere, from Monet, Pissarro, even from me. But with what marvelous handling of the brush did he not make something new of it!" —Edgar Degas (1834–1917)

"Paul Klee was of seminal importance to me because he showed me what abstraction meant." —Bridget Riley

"The thing that really overwhelmed me was a show at the Met called '1940–1970.' It was the New York School. I was knocked out, and went through a lot of different attitudes in my own work. I still used the same materials. But I went from making cage-like structures with human forms—almost Bosch-like—to abstract biomorphic shapes mixed with geometric shapes. Pretty soon it was all geometric." —Gary Hill

The sculptor Constantin Brancusi (1876–1957) moved to Paris in 1904. When the already towering Rodin asked the younger man to come to his studio, Brancusi refused, saying, "One cannot grow in the shadow of great trees." Brancusi followed a different technical path from Rodin, preferring to carve the stone himself rather than use models like the French master. (Rodin's pupils did much or most of the stonework. Cheekily, Brancusi carved a version of Rodin's *The Kiss*.)

Brancusi was himself generous with a younger artist. In 1927, Isamu Noguchi came to Paris and met Brancusi, whom he greatly admired.

Sometimes influence could take the form of an aversion. Frank Stella recalls stopping in the middle of his Black paintings:

"It was literally staring me in the face. . . . [I began] to see the importance of Pollock . . . I tried for something which, if not like Pollock, is a kind of negative Pollockism. I tried for an evenness, a kind of alloverness, where the intensity, saturation, and density remained regular over the entire surface."

"Renoir is an artist I can't stand, but he was of great use to both Magritte and de Chirico, two artists I love. It's interesting how a bad artist can influence a good one." —David Salle

Brancusi took the younger artist under his wing:

"He spoke no English, and I no French. Communication was through the eyes, through gesture and through the materials and tools to be used. Brancusi would show me for instance precisely how a chisel should be held and how to true a plane of limestone. He would show me by doing it himself, indicating that I should do the same." —Isamu Noguchi (1904–1988)

A painter might feel the influence of the whole corps of his fellow artists rather than that of any one particular practitioner,

benefiting from what Pissarro describes as the tradition of modern art that has often corralled artists into readily identifiable movements:

"We have today a general concept inherited from our great modern painters, hence we have a tradition of modern art, and I am for following this tradition while we inflect it in terms of our individual points of view. Look at Degas, Manet, Monet, who are close to us, and at our elders, David, Ingres, Delacroix, Courbet, Corot, the great Corot, did they leave us nothing?"

"Every day I realize more and more how difficult art is . . . but also every day I rejoice and like it. I keep on admiring the great French impressionists, Manet, Degas, Renoir. I wish they would become the most strong guiding forces in my life." —Salvador Dalí

The influence of Japanese painting was significant in the nineteenth century, demonstrating how entire bodies of art can become essential to that of another culture. Of the impact of Japanese art, Robert Hughes says:

"Very few major artists of the later nineteenth century were immune to it. Through its influence on Monet, Degas, Lautrec, van Gogh, Gaugin, Bonnard, and Vuillard. It utterly transformed painting and decorative arts in the West."

"One likes Japanese painting. One has felt its influence—all the impressionists have that in common." —Vincent van Gogh (1853–1890)

The role of one artist in the work of another does not just happen when an artist is starting out. Established artists look at other established artists and their mutual forebears and the chain of inspiration runs through all artistic endeavor. Mark Rothko describes working on his Seagram murals over 1958 and 1959:

> "After I had been at work for some time, I realized that I was much influenced subconsciously by Michelangelo's walls in the staircase room of the Medicean Library in Florence. He achieved just the kind of feeling I'm after—he makes the viewers feel that they are trapped in a room where all the doors and windows are bricked up, so that all they can do is butt their heads forever against the wall."

The painter Stuart Davis (1894–1964) was accomplished enough to have five watercolors hung in the famous New York Armory Show of 1913. What he saw from the European artists who were his fellow exhibitors changed the way Davis wanted to paint.

> "I was enormously excited by the show, and responded particularly to Gaugin, van Gogh, and Matisse. . . . I resolved that I would quite deliberately have to become a 'modern' artist."

An architect can just as easily pore over the plan of another person's building, or look at a model. Ludwig Mies van der Rohe (1886–1969) describes seeing the work of Frank Lloyd Wright in 1911 in Germany:

T he acquisition of influence is not a formulaic process. A pinch of this old master and a teaspoon of that one won't be enough to make you an old master yourself.

"Let us force ourselves to understand the masters—let us love them—let us go to them for inspiration; but let us refrain from labeling them like drugs in a chemist's shop." —Auguste Rodin (1840–1917)

"It is just as well not to have too great an admiration for your master's work. You will be in less danger of imitating him." —Mary Cassatt (1845–1927)

"At this moment, so critical for us, the exhibition of the work of Frank Lloyd Wright came to Berlin. . . . The encounter was destined to prove of great significance to the European development. . . . The dynamic impulse from his work invigorated a whole generation. His influence was strongly felt even when it was not actually visible."

In the same way that a painting or a sculpture must be seen to be properly appreciated, a building has to be visited. The British architect Norman Foster met his countryman Richard Rogers at the Yale School of Architecture in the early 1960s. The two traveled the United States, driving, hitchhiking, and riding on Greyhound buses to see as many of Frank Lloyd Wright's buildings as they could. Returning to the United Kingdom, Foster and Rogers formed Team 4, which put what they'd learned in the United States into practice, beginning

with the Reliance Controls electronics factory in Swindon, a building Foster described as "[a] 32,000 square foot box, with large moveable panels acting as walls and with only the kitchens, toilets and plant room as permanent structures."

> "Some painters are more architectonic. The two great ones in recent history are Malevich and Mondrian. If you don't know those people and appreciate them, I don't know how you could be an architect. . . . Why Mondrian? Because he used a straight shape that influenced Corbusier and all the modern art shapes of our time. And Malevich." —Philip Johnson

Early in an artist's development, before she has established her own style, the influence of a more mature presence can be almost overwhelming. In the course of absorbing and assimilating the work of the other, an artist is imitative to the point of slavishness, as in the case of Rembrandt and Rubens:

> "Rembrandt ended up being the kind of painter Rubens could not possibly have imagined, much less anticipated. But for the crucial decade of his formation, the years which saw him change from being a merely good to an indisputably great painter, Rembrandt was utterly in thrall of Rubens. He pored over engravings of Rubens's great religious paintings and struggled to make his own versions, at once obvious emulations and equally obvious variants. He borrowed poses and compositional schemes wholesale from Rubens's histories and transferred them to his own choice of subjects." —Simon Schama

Over time, as Bridget Riley describes, the artist might become more discerning and begin to make his own way:

> "An artist's early work is inevitably made up of a mixture of tendencies and interests, some of which are compatible and some of which are in conflict. As the artist picks his way, rejecting and accepting as he goes, certain patterns of enquiry emerge. His failures are as valuable as his successes: by misjudging one thing he conforms something else, even if at the time he does not know what that something else is."

> "He is a poor disciple who does not excel his master."
> —Leonardo da Vinci

Eventually, the influences are subsumed within the whole, as Franklin Toker describes in his story of Frank Lloyd Wright surprised by the opinion of a visitor to his house in Scottsdale. More than this, part of the process of creative maturity is, as Elaine de Kooning puts it so well, to transcend the influences that got the artist excited about art in the first place.

> "The following story has been told in so many variations that at least some part of it must be true: a scholar visiting Taliesin West spots a book of Mayan architecture and says, 'Why, Mr. Wright, this temple looks just like your Barnsdall house,' whereupon Wright darts over, slams the book shut, and declares: 'Never saw that book in my life!' Artists are notorious for never revealing the sources of their inspiration. . . . We can see that Wright got design ideas from old books and old buildings a hundred times. He transposed the ninth-century pagoda at Horiu-ji into his 'tree' system for his 1929

St. Mark's-in the Boweries towers, for example, and the Guggenheim echoes both baroque churches and Mesopotamian ziggurats. Does that make Wright derivative? No: when the furnace of artistic energy burns as fiercely as it did for an artificer like Wright, the original contributions burn off, and only the new work is left." —Franklin Toker

"The desire of all artists for independence, for newness, for originality is really the desire for revolution—for its own sake. If he did not desire to change all art, he would never get past his love for the artists who first inspired him and be able to paint his own pictures. Revolution means existence, not progress, for an artist." —Elaine de Kooning (1920–1989)

"I am an eclectic painter by chance; I can open almost any book of reproductions and find a painting I could be influenced by." —Willem de Kooning (1904–1997)

"Don't worry about your originality. You could not get rid of it even if you wanted to." —Robert Henri

IN AND OUT OF THE STUDIO

⊚ ⊚ ⊚

"You can learn more in painting one street scene than in six months' work in an atelier."

—George Bellows (1882–1925)

Like any creative endeavor, art is most effectively pursued in a quiet space dedicated to that activity. Finding studio space is a rite of passage; an indication that the artist is serious about what she is doing. For the aspiring artist, a studio brings freedom, both physical and mental; but it can also mean a set of new responsibilities—another rent to pay, more pictures to paint, more time to find to do it all in. It might well be that shortly, the artist spends more time in the studio than at home.

Over time, the artist's studio takes on elements of the tenant's personality and it retains physical traces of the art made

there. To the observer, the creation of art is a mysterious and magical process. The studio is where unknowable forces come together, and in the case of great artists, their place of work is like a shrine, imbued with a spiritual power.

More prosaically, a studio might also serve as the artist's place of business, where he shows dealers and clients his work. It is also a meeting place—somewhere to hang out with other artists perhaps. In this way, a studio can be both a private office and a living room. In rare cases, like Jackson Pollock's barn, the site of the art-making becomes famous in its own right and inextricably associated with the art and the artist and emblematic of each.

Claude Monet's garden at Giverny inspired some of the painter's most enduring work. Monet worked at home, as it were. Some artists have a strong opinion as to whether it is better to go out and work directly from nature than it is to stay in the studio. In the studio, unless using a model, the artist relies on memory and whatever sketches or studies he has made. Outside, he is free to roam and work straight from nature.

"After my outings I invite Nature to come spend several days with me; that is when my madness begins. Brush in hand, I look for hazelnuts among the trees in my studio; I hear birds singing there, trees trembling in the wind; I see rushing streams and rivers laden with a thousand reflections of sky and earth; the sun sets and rises in my studio."
—Jean-Baptiste-Camille Corot

Édouard Manet's "A Bar at the Folies-Bergère" might look like it would have been made on site but in fact Manet painted it in his studio where he recreated the bar scene. Rather than

a model, Manet used a young woman named Suzon who worked at the famous music hall. The picture was painted in 1881 and 1882 and Manet (1832–1883) died the following year. He painted slowly and would rest on a couch and look at what he had just done. The painter Georges Jeanniot saw Manet at work in his studio in January 1882.

"He was then painting 'A Bar at the Folies-Bergère' and the model, a pretty girl, was posing behind a table laden with bottles and comestibles. He recognized me at once, offered me his hand and said, 'It's a nuisance, excuse me, I have to remain seated, I have a bad foot.' "

The decision where and how to work has a profound impact on what that artist is going to make.

"Photographs of artists at work in their New York lofts, surrounded by big, painterly abstract pictures suggest lives in which self-reference has become burdensome. As time passed both [Philip] Guston and [Mark] Rothko started to paint darker pictures. In photographs of Monet at work on the *Nymphéas* is his vast studio at Giverny the nearby reality which is the source of what he is painting is implied. The artist is mastering the look of the world. In similarly large spaces in New York the landscape being mastered is in the artist's head, something which must grown from feelings about colours and mark which leaves big questions—is this happy? is it sad? is it clever?—for the viewer." —Peter Campbell

Discussing Monet, and, first, Jackson Pollock's studio, Kirk Varnedoe makes the point about the apparent incongruity between some art and whence it came:

"The structure, often called a barn, is in fact more like a glorified tool shed; and the working space . . . feels implausibly closeted when one finally steps up into it. It is roughly a twenty-one foot square. Physically, Pollock's big canvases just fit; experientially they don't even come close. The surprise is like that of Monet's garden at Giverny, where the real lily-pond turns out to be bafflingly tiny in relation to the oceanic art it inspired. Even more in Pollock's studio, one simply cannot get the mind to reconcile the meager room with the transporting expansiveness of the paintings that were made there."

During a visit to Paris, writer Edmond de Goncourt visited Rodin at one of his studios:

"We found him in his studio on the Boulevard Vaugirard, an ordinary sculptor's studio with its walls splashed with plaster. Its wretched little cast-iron stove, the damp chill emanating from all the big compositions in wet clay wrapped in rags, and a litter of heads, arms, legs in the midst of which two emaciated cats were posing like fantastic griffins."

In the late nineteenth century, Carolus-Duran (Charles Auguste Émile Durand, 1837–1917) was one of the most prosperous painters in Paris. For Carolus-Duran, the studio was a place of art and commerce. He held open days in his studio on Thursdays (nine to eleven A.M.) for prospective clients.

"His studio in Montparnasse was crammed with paintings from floor to ceiling, the majority standing ready in heavy and elaborately molded frames for quick dispatch to patrons, collectors and museums. Amongst copies after Rubens and

paintings inspired by Velázquez hung the portraits which made him both famous and wealthy." —John Milner

◎ ◎ ◎

Emil Pirchan was a painter and architect who was a friend of the Austrian painter Gustav Klimt (1862–1918). Pirchan described Klimt's working arrangements:

"The studio was very simple, its only decoration being pictures resting on their easels. But in front of this simple house giving on to a courtyard there was a little garden in which Klimt planted his favorite flowers for use as models. Six, eight and more cats lived there and he could not bear to part with any of his animals, from time to time they had to be disposed of discreetly, because the pack increased at such an alarming rate and had damaged more than one picture. Klimt worked all day until dark; he spent most of his evenings in the company of friends."

Picasso worked in a number of studios and left enough pictures featuring artists at work that an exhibition specifically dedicated to the subject has been mounted. Fernande Olivier described Picasso's Paris studio in 1905. At this early stage in his career, Picasso's working arrangements were down-market substantially from the likes of Carolus-Duran. Young artists would find cheap accommodations that included a small studio, which might be a distinctly humble room:

"It is full of the strangest assortment of utensils and household objects, including a rusty old frying pan grandly called 'receptacle serving the function of chamber pot' and a large tin bucket for washing, which is always full to overflowing with dirty water."

It has long been a rite of passage for an artist in New York to set up shop in a loft downtown, such as that mentioned earlier, often in the Soho neighborhood. Now, these spaces are much sought-after and usually extremely expensive. After the second world war, when the area was not zoned for dwellings, there were bargains to be had and artists were among the first to live in Soho. Jasper Johns found a loft for himself in the mid-1950s. Robert Rauschenberg encouraged him—it was what artists did. Johns found a building on Pearl Street in downtown Manhattan.

> "Around the corner on Fulton Street was Rauschenberg's fifteen-dollar-a-month walk-up loft, which had no running water. Johns's Pearl Street loft had pressed tin ceilings so low they could be touched, old floorboards with gaping half-inch spaces between them through which the floor below was visible, a bed on a platform, a refrigerator, hot plate, shower, and toilet." —Jill Johnson

> "Cindy Sherman's studio is just off the living room. Her SoHo loft is traditionally furnished and could be a home anywhere, but the studio is another story. At the time I was there, it was littered with body parts, eyeballs, fake accident victims, magic-store props, and all sorts of gruesome paraphernalia. She was in the midst of directing a horror film." —David Seidner

Donald Judd bought a building on Spring Street in Soho in 1968. Ten years later, in search of more space, he moved to an abandoned army base in Marfa, Texas.

In 1909, Picasso moved to a new place on the Boulevard de Clichy. Olivier said that Picasso wouldn't allow the studio to be dusted because the dust would fly up and get stuck on the canvases. Every couple of months, the paintings would be moved so the studio could be cleaned.

Much later, Picasso had a studio in Vallauris on the French Riviera. The photographer and art director Alexander Liberman visited Vallauris and noticed what seemed to be a flaw:

> "Picasso works with very little of the painter's essential—light. The little light there is comes through the window nearest his easel in a single, intense shaft of sunlight, its blinding brightness making everything around it darker. Sabartés, Picasso's lifelong friend and secretary, once said to me, 'He does not need light . . . he has his own light from within.' "

Italian futurist painter Gino Severini (1883–1966) worked in Paris at the same time as Picasso, moving there in 1906. A few years later, Severini moved his studio, and regretted it at once:

> "Upon entering my new studio, I immediately felt it had been a mistake for me to relocate. I found the new walls, freshly painted gray, disorienting, while the gray in the old studio had already mellowed, was rarified, thanks to years of life and light, and therefore was familiar to me. Even the light was different, all things that matter to painters."

Severini decided that artists should stay put, and not just in the same studio:

> "Artists in my opinion, should never change studios and should also travel as little as possible. I really believe that creative intelligence needs a certain amount of calm and external continuity, which in no way limits the variety and movement in the works produced."

Severini's notion that artists should lock themselves away is a little-held opinion. Many artists extol the virtues of the outdoors over the confines of the studio—the closer they can get to nature the better. In a letter to Emile Zola in 1866, Paul Cézanne made the case for working in the field:

> "But you know all pictures painted inside, in the studio, will never be as good as the things done outside. When out-of-door scenes are represented, the contrasts between the figures and the ground are astounding and the landscape is magnificent. I see some superb things and I shall have to make up my mind only to do things out-of-doors."

In his book *The Studios of Paris,* John Milner describes how the impressionists moved away from the methodical and studio-bound Beaux-Arts methods of composition. The impressionists worked in and with daylight and they didn't need all the traditional trappings and encumbrances of the studio. "By taking up a light-weight easel with paints lying casually on the garden grass," Milner writes, "a consider-

able revolution in painting technique has been achieved, and the studio and its seclusion has been largely abandoned."

Working outdoors can bring its own perils. Berthe Morisot describes trying to paint in the English countryside:

> "I made an attempt in a field, but the moment I had set up my easel more than fifty boys and girls were swarming about me, shouting and gesticulating. All this ended in a pitched battle, and the owner of the field came to tell me rudely that I should have asked for his permission to work there, and that my presence attracted the village children who caused a great deal of damage."

Robert Smithson offers another reason for the interest in the outdoors:

> "Cézanne and his contemporaries were forced out of their studio by the photograph. They were in actual competition with photography, so they went to sites; because photography does make Nature an impossible concept. It somehow mitigates the whole concept of Nature in that the earth after photography becomes more of a museum."

In an 1868 letter, Claude Monet wondered of his fellow painter Frédéric Bazille (1841–1870) how he could work in the metropolis, "I assure you that I don't envy your being in Paris. Frankly, I believe that one can't do anything in such surroundings. Don't you think that directly in nature and alone one does better?"

"Everything that is painted directly on the spot has always a strength, a power, a vividness of touch that one doesn't find again in the studio." —Eugene Boudin (1824–1898)

"You know, any picture done indoors, in the studio, never equals things done outdoors. In pictures of outdoor scenes, the contrast of figures to scenery is astonishing, and the landscape is magnificent. I see superb things and I must resolve to paint only out of doors." —Paul Cézanne

THE ARTIST AT WORK

> "I am working away in my room without
> interruption which does me good and chases away
> what I imagine are abnormal ideas."
>
> —Vincent van Gogh

> "I worked in between carpools and buying food
> and cooking and whatever else I had to do. I lived an
> outside life, but really I was living an inside life."
>
> —Anne Truitt

The habits and rituals of an artist at work might be expected to be more eccentric than those of others in the working population. An artist is unlikely to be able to switch it on for a nine-to-five shift. You have to work when the inspiration takes you. And while we all have something we need to get us going in the morning and through the day, the artist, working alone, awaiting an idea, perhaps, might be able to indulge himself. Artists operate beyond the restrictions of an ordinary workplace.

Matthew Spender, in a biography of Arshile Gorky, describes how Agnes Magruder, who was to become Gorky's

second wife, became acquainted with the painter's studio mannerisms and peculiarities:

> "She learned about his ritual for preparing to work in the morning: the canvas selected and brought out to the easel, the cigarette lit before starting. Never before had she come across baking bowls filled with tube after tube of finest artist's paint. Which Gorky left until they formed a fine skin to be worked into the surface of the painting, smelling 'like melons,' as he put it. The sounds of the working day: steps on the floorboards of the hall outside, the traffic in the streets, the radio turned on, transmitting intimate talks about baking cakes, followed by soap operas, to which he sometimes added his own comments out loud, such as 'Poor little lady,' or, 'Silly cow.' "

> "M. Rey says that instead of eating enough and at regular times, I kept myself going on coffee and alcohol. I admit all that, but at the same time it is true that to attain the high yellow note that I attained last summer, I really had to be pretty keyed up." —Vincent van Gogh

> "I must live soberly as Plato did." —Eugène Delacroix

Gorky listened to soap operas on the radio. Some contemporaries of his liked to listen to jazz, perhaps because of a perceived similarity in their pursuits:

> "The analogous improvisatory methods of the jazz musicians of the day and the Abstract Expressionist artists are enlightening: the way jazz musicians enter the material, develop it,

and then exit without finishing off its possibilities is very much the way these painters functioned." —April Kingsley

"Jackson [Pollock] told me he couldn't do this weird poured work unless he had been drinking and listening to jazz—perhaps not his exact words. He was very lucid as to why he had to drink. It was to overcome the blockage or whatever it was." —Isamu Noguchi

Mark Rothko listened to music with intensity.

"Not only was it always a presence in his life, but even when he visited others, he spent hours listening rapt, not even turning the leaves of a book. Herbert Ferber describes him lying on the grass in Vermont listening with total attention to the whole of *Don Giovanni*, while Carlo Battaglia remembers Rothko stretched out on a leather couch in Rome, windows open above the Renaissance plaza, wakefully attending the same Mozart opera." —Dore Ashton

Robert Gwathmey says he likes to be read to while he works—the classics like William Shakespeare, Leo Tolstoy, Thomas Mann, and Herman Melville. Specifically, when Gwathmey was working on *Children Dancing,* Gwathmey's wife, Rosalie, read *Moby Dick* to him.

Joan Mitchell would also listen to jazz while she painted, but also to Mozart, Bach, or Stravinsky. Mitchell was one of the painters who often worked at night, although she preferred daylight.

"Certain colors change enormously with electric light. Blue is one of them. Yellow is another. They all change, but some really change. I do a bit of guessing. The next day, I walk up to the studio at noon and I am excited but also afraid: is it what I thought in terms of color? A painting that works in electric light does not necessarily work in daylight."

However satisfying the creative process might be, however liberating the freedom to create, and however sublime the art might turn out to be, artists can be frustrated and unhappy in their work. They might be uninspired or blocked or painted out. Money might be tight, a show might not be coming together, or any one of a hundred petty problems that impede the work. In other words, art can be like any other job.

"I wish I could paint more. I get sick of reading and going to the movies. I'd much rather be painting all the time, but I don't have the impulse. Of course I do dozens of sketches for oils—just a few lines on yellow typewriter paper—and then I almost always burn them. If I do one that interests me, I go on and make a painting, but that happens only two or three times a year." —Edward Hopper (1882–1967)

"I have a professional commitment to painting and I do what's necessary to make art. There are times when I am bored doing my work, but it's not boredom in the normal sense: to sustain the same attitude long enough to pull off a piece that takes months and months to do gets tiresome, which means that I can't worry about how I feel when I paint.

I have to go into the studio and paint whether I feel like it or not." —Chuck Close

"I certainly have times where I walk around in my studio thinking: 'I can't paint, I'm not as good as I think I am, I'm certainly not as good as everyone else thinks I am.' And I'm freaked. The other side is when you've opened a door and you feel the weight of the responsibility. There's something sacred about paint. You make a pact with the painting, you will be responsible for whatever you're putting on it, what you find out." —Eric Fischl

"I have been drawing from sunrise till night: six mathematical faces of angels, of such great and explosive beauty that it has left me exhausted and stiff. When I went to bed I was reminded of Leonardo comparing death after a full life to the coming of sleep after a long day's work." —Salvador Dalí

Art is also primarily executed alone. With the long hours of studious contemplation, not to mention the time spent executing the work, it can be a lonely profession:

"Painting is the loneliest thing you can do." —Damien Hirst

"Painting is a very lonesome business whereas photography is a more friendly affair. What's more, you have something in hand when you've finished—every 15 seconds you've made something." —Lee Miller (1907–1976)

"An artist is always lonely. An artist is a man who functions beyond or ahead of his society. In any case seldom within it." —David Hare

There are few occupational hazards associated with being an artist. The painter's use of white lead as a staple pigment for centuries would count as one of those. Lead is extremely toxic and has been replaced in paint by zinc oxide in the nineteenth century and by titanium dioxide in the twentieth century. When Winslow Homer gave up painting, he wrote a friend, "No painters colic for me," meaning he was saying good-bye to the gastrointestinal distress he associated with continually wetting his brush in his mouth.

"In order that the well-being of the body may not sap that of the mind the painter or draftsman ought to remain solitary, and especially when intent on those studies and reflections of things which constantly appear before his eyes and furnish material to be well kept in the memory. While you are alone you are entirely your own; and if you have but one companion you are but half your own, or even less in proportion to the indiscretion of his conduct." —Leonardo da Vinci

"Let no one marvel that Michelangelo loved solitude, for he was devoted to art, which claims man for itself alone; and because those who study must avoid society, the minds of those who study art are constantly preoccupied, and those who consider this to be eccentricity are wrong, for he who would do well must avoid cares and vexations, since genius

demands thought, solitude and comfort, and a steadfast mind." —Giorgio Vasari (1511–1574)

"There were times when I was younger I would get up in the middle of the night and go to the bathroom, turn on the light and scribble a few ideas, and test it out and see if it works. If it doesn't work I go back to bed and think again. No, I'm gradually . . . I'm doing that a lot less—fortunately for my wife." —I.M. Pei

MAKING A LIVING

"Either a comfortable life and lousy work
or a lousy life and beautiful work."
—Fernand Léger (1881–1955)

"I discovered early in life that a certain amount of money
is indispensable to a man in my position."
—Eugène Delacroix

Many great painters, van Gogh most famously, have been unable to reap the rewards of their craft in their lifetime. They labor in obscurity, struggle to sell anything, and rely on the generosity of others to survive. Critics and the public are notoriously fickle and inconstant. When they confer fame on an artist like van Gogh only after his death, the work of a man who was unable to even make a living from painting fetches huge prices much too late for him to benefit.

The number of artists able to work solely for themselves, going where their creative whims may take them, is surely very small. For the majority of artists (if they aren't lucky enough

to have a private income), their art must remain a hobby, no matter how intensely it is pursued. Even when an artist is able to pursue her art like a job, she'll have to supplement whatever money she can make with a more regular source of income. To begin with, at least, there'll be financial sacrifices.

> **"The only sensible way to regard the art life is that it is a privilege you are willing to pay for."** —Robert Henri

For the photographer Alfred Eisenstadt (1898–1955), the moment came to take the plunge. He was working in Berlin in the wholesale belt and button trade and he was selling some of his photographs to the Associated Press on a freelance basis:

> **"One day my boss said to me, 'Look, you're such a bad salesman.' 'I know I am bad, because I am not really interested in selling buttons. I have other interests. I want to do photography.' 'What do you call it? Photography?' He looked at me as if I was going to cut my own throat. The idea of photography was as new as flying."**

> **"Architecture is a terribly foolish profession to go into. I think most students know that. At least I always tell them."** —Philip Johnson

The example of Vincent van Gogh might not be encouraging for someone looking to make a career as an artist. Vincent was subsidized by his brother, Theo, who paid Vincent 220 francs a month for and received paintings in exchange. In this way, van Gogh could earn 2,660 francs a year, which was a

quarter as much as a doctor or lawyer, for example, might make in France at the time, according to Cynthia Saltzman, who wrote a book about van Gogh's painting *Portrait of Dr. Gachet*. Dr. Paul Gachet treated van Gogh shortly before the artist committed suicide. Van Gogh's picture of the doctor had the distinction of being the most expensive painting ever sold, fetching $82.5 million in 1990. The first time *Portrait of Dr. Gachet* sold was in 1897, seven years after the artist's suicide, it went for 300 francs, the equivalent in 2004 of about $1,300. (In May, 2004 Picasso's *Boy With a Pipe* was sold for $104.2 million at auction in New York.)

The manner of van Gogh's death and the asceticism of his life might lend integrity to him as an artist. The image of the poor artist is persistent. If he is pure, he is apparently unsullied by commerce as he pursues his art. Van Gogh's letters show a steadfast commitment to art and a constant concern about money. Somewhere between Theo's help and *Dr. Gachet* there must be a level of comfort for an artist to make the art he wants. But unless he lives in a country like the Netherlands, where individual artists have been state subsidized,[1] he is going to have to throw himself on the vagaries of the art market in the effort to find it.

Works of art, especially paintings, are desirable objects that confer status on their owners. Buying a painting, it can be argued, is a more passionate act than buying a car or a house perhaps because you're buying a part of the artist. In his book *Ways of Seeing*, John Berger identifies the period of

[1]Among the state schemes in the Netherlands was the Visual Artists Financial Assistance Scheme. According to Dutch government figures, in 1983, 3,800 artists were getting money from the government. The scheme was discontinued in 1987.

oil painting as 1500 to 1900, which was when photographs became the main source of images. To Berger, the oil painting is primarily an object to be owned, usually depicting material possessions of the owner of the painting, although Berger identifies artists who were exceptions to the commercial rule, such as Rembrandt, El Greco, Giorgione, Vermeer, and Turner.

Mark Rothko kept a record of how many paintings he sold each year and for how much:

1957: 17 paintings; average price $1,700
1958: 13 paintings; average price $2,400
1959: 17 paintings; average price $5,400
1960: 11 paintings; average price $7,500
1961: 8 paintings; average price $12,000
1962: 7 paintings; average price $18,000

This shows a steady progression in the price each painting fetched, but even allowing for inflation, the entire proceeds from these six years is dwarfed by the $16,359,500 paid in May 2003 for *No. 9 (White and Black on Wine)*. (The record for the work of an American-born painter is $27,502,400 for George Bellows's *Polo Crowd* in 1999.)

◉ ◉ ◉

In previous eras, artists could often rely on institutional patrons for commissioned work:

"In the twentieth century direct commissions, so influential on the painters' profession for over six hundred years,

have gone into definite decline; after 1950 even the brief revival of interest in commissioning war monuments died out. The old patrons of art such as friars, city-republics and courts have vanished from the social scene. The new powers in society—modern states and wealthy entrepreneurs and companies—express little or no interest in commissioning works from artists, and the tradition of patronage established in the Renaissance has come to an end." —Bram Kempers

Van Gogh was, of course, not alone in his penury. Dutch masters Hals and Rembrandt both declared bankruptcy, as did James McNeill Whistler. When Théodore Géricault (1791–1824) died, appraisers of his estate put a higher value on the blank canvases he left than the painted ones.

"How right Delacroix was, who lived on bread and wine alone, and who succeeded in finding a way of life in keeping with his vocation. But the inevitable question of money is ever-present—Delacroix had private means. Corot too."
—Vincent van Gogh

"We painters, who are condemned to penury, accept the material difficulties of life without complaining, but we suffer from them insofar as they constitute a hindrance to work. How much time we lose in seeking our daily bread! The most menial tasks, dilapidated studios, and a thousand other

Architects still rely on patrons to realize their designs. The patrons are usually in the form of companies or governments. I.M. Pei is generous when it comes to sharing credit with the client:

> "I've been in practice now for half a century or more, and the most important ingredient for an architect to do a good building is to have a good client. I think a client counts for as much as fifty per cent. I would give that much credit to my client."

> "Architecture can be likened to the cinema. The architect is like the director, absolutely dependent on everybody who contributes. He tries to instill a direction in them, the vitality all coming together to produce a result which he then edits." —Charles Warren Callister

obstacles. All these create despondency, followed by impotence, rage, violence." —Paul Gauguin

In this company, Rodin's commercial success was unusual:

"Of the artists of the second half or the nineteenth century who are today treated as masters, Rodin is the only one who was internationally honored and officially considered illustrious during his working life. . . .

"At the height of his career he employed ten other sculptors to carve the marbles for which he was famous. From 1900 onwards his declared annual income was in the region of 200,000 francs: in fact it was probably higher." —John Berger

Although it was exceptional, it was possible to make your fortune from art even 300 years ago. When Bernini died in 1680 at the end of a long life, he left 400,000 scudi, which was a lot of money.

In New York in the 1980s, there was an explosion in art prices fueled by a buoyant Wall Street. Auction records were set, including that for van Gogh's *Irises* (at $53.9 million in 1987 a relative bargain compared to *Dr. Gachet*). Among the new generation of artists, there were a few who became hot, popular, and enormously success-ful.

"In the eighties, the bifurcated role of art as a vehicle for stardom and art as raw commodity reached its zenith. For the contemporary artist success meant instant recognition; magazine covers and Gap ads, not just museum shows. And the new art collectors, unlike those who invested in junk bonds, could at least pretend they had put their money into something of value." —Phoebe Hoban

The burgeoning market created a group of what Hoban calls "suddenly famous young 'careerist-artists': Julian Schnabel, David Salle, Francesco Clemente, Eric Fischl, Keith Haring,

Robert Longo, Mark Kostabi, Kenny Scharf." There are few artists who would reject this mantle, especially given the enormous competition. Consider these two statements by Robert Hughes:

> "Every year in the 1980s, about 35,000 graduate painters, sculptors, potters, and other 'art-related professionals' issued from the art schools of America, each clutching a degree. This meant that every two years the American educational system produced as many aspirant creators as there had been *people* in Florence in the last quarter of the fifteenth century."

> "There are about 200,000 artists in the United States, each making (at a conservative guess) fifty or so objects a year. From the homeless proletariat of these ten million works almost anything may be designated as 'happening,' but it is not likely to have any more significance in the long historical run than, say, [architecture critic] Charles Jencks's classification of a previously uncatalogued subgroup of Japanese neo-Palladians does in architecture history."

That is, not much.

There is a popular image, or cliché, of an artist in a garret room; poor, misunderstood, under-appreciated. It's a view in which the artist does not compromise her art. She certainly doesn't pursue fame; she just wants to create. Following are six statements and it would be interesting to see

how many of them practicing artists agree with or admit to:

"Have you ever met an artist who didn't want to be famous? Artists are the greatest delayed-gratification people in the world." —Mary Beth Edelson

"Business art is the step that comes after Art. I started as a commercial artist, and I want to finish as a commercial artist. After I did the thing called 'art' or whatever it's called, I went into business art. I wanted to be an Art Businessman or a Business Artist. Being good in business is the most fascinating kind of art. During the hippie era, people put down the idea of business—they'd say, 'Money is bad,' and 'Working is bad,' but making money is art and working is art and good business is the best art." —Andy Warhol (1928–1987)

"Painters are people, before and after they are painters. They are as dismayed as the rest of us by what is being done to other people, and to the world, in our name. Painting is an edgy, lonely, uncertain business, and it is very disagreeable to feel that the end product of it is being used to make money fast for a pack of speculators." —John Russell

"The modern artist's social history is that of a spiritual being in a property-loving world." —Marc Shell

"The more I live among artists, the more I am convinced that they are fakes from the minute they get to be successful in the smallest way." —Marcel Duchamp (1887–1968)

"It is frequently remarked that all the 'successful artists look like businessmen.' The fact is, they are shrewd, politically sensitive, and tough businessmen who dabble in painting. Of good intelligence and fair insight, a spark of creative revolt can scarcely be found in the entire lot." —Clyfford Still

TECHNIQUE

"Real painters understand with a brush in their hand. . . .
What does anyone do with rules? Nothing worthwhile."
—Berthe Morisot (1841–1895)

"I think best in wire."
—Alexander Calder (1898–1976)

An artist's technique begins with the first efforts of youthful play. It might be developed and honed in class in art school. Whether the artist has been subjected to the discipline of the classroom or not, technique will mature over time through experiment and a great deal of hard work. What an artist seeks to establish is mastery over the materials of the craft. He wants to reach a state where he can transfer his intentions directly onto the canvas or into the raw material of his art. The aim is to achieve the freedom that Matisse describes:

"When I am doing the cut-outs you cannot imagine to what degree the sensation of flight which comes to me helps me better to adjust my hand as it guides the path of my scissors."

"A great free joy surges through me when I work." —Clyfford Still (1904–1980)

This chapter will investigate the artist's progress toward this technical adeptness. The concern is not so much with particular types of brushwork or balance of colors, a sculptor's tools, or a photographer's equipment, rather, it is with the place of technique in an artist's work. For the purposes of this book, the key question is: How does technique affect creativity?

"During the seventeenth century, all painters used the same materials, materials which tended to be rather simple, if not at times crude. Cloth serves as the support, and the pigments and binding materials were made by combining a range of organic and inorganic substances. Yet the results obtained vary considerably from painter to painter. These differences surely result from a given painter's vision of the possibilities of his art; in other words, his pictorial intelligence. The more daring, ambitious, or unconventional that vision, the more a painter had to experiment with the basic materials and techniques of execution—thus the unfailing coincidence between technical mastery and great art." —Carmen Garrido

"I always tell students that it's no coincidence that the two greatest, most inventive modernists happened also to be the two greatest draughtsmen of the human figure in our time,

as well and you can add to that, greatest sculptors, collagists, protégés of Cézanne, and much else." —R.B. Kitaj

"Technique must be solid, positive, but elastic, must fall not into formula, must adapt itself to the idea. And for each new idea there must be new invention special to the expression of that idea and no other. And the idea must be valuable, worth the effort of expression, must come to the artist's understanding of life and be a thing he greatly desires to say." —Robert Henri

Even the great artists, those who have apparently reached a high level of technical expertise, can have a crisis of faith in their own ability:

"Around 1883 a sort of break occurred in my work. I had gone to the end of impressionism and I was reaching the conclusion that I didn't know how either to paint or draw. In a word, I was at a dead end." —Pierre-Auguste Renoir

Renoir's loss of confidence lead him to destroy some of his own canvases. Because he felt he lacked technical skill as a draftsman, he started to learn draftsmanship. Damien Hirst makes a point about what he perceives as a technical deficit in Francis Bacon. But it is something that isn't, in Hirst's view, an impediment to Bacon's ability to create art.

"There's a painting he's done of a guy cross-legged, and he can't paint baseball boots. But he doesn't pretend he can. That's why he's brilliant. He paints a baseball boot to the best of his ability, and it's totally naked and clean, and it's right there in your face, and you go, 'This is a painting by a

geezer who totally believes, and it's everything he says it is, and whatever his aim is, he's achieving much more than that.' It's totally laid out in front of you: no lies, no doubt, nothing. And he's a different kind of painter, and he came from nowhere."

Whether you've lost it or never had it, good technique alone does not make an accomplished artist:

"In saying that an artist 'really can draw' (or paint or write), one may be referring entirely to his technical facility. Technique in itself can be exciting, and therefore it can be an important element in art. But the skill of the juggler to entertain should not be confused with the power of the creative artist to move. And technical skill in itself does not necessarily identify the artist. Picasso is more skilled at drawing—in the sense of dexterity, facility, manual articulation—than either Raphael or Cézanne, but he is not a greater maker of drawings. [Algernon] Swinburne was more felicitous with words than many a great writer. But as Hemingway observed, 'Few great authors have a brilliant command of language.' " —John P. Sedgwick

"I detest writing or talking about *technique* in general. . . .

"That thought, I can't find the right word, is based not on something negative but on something positive. On the positive awareness that art is something greater and higher than our own skill or knowledge or learning. That art is something which, though produced by human hands, is not wrought by hands alone, but wells up from a deeper source, from man's soul, while much of the proficiency and technical expertise

associated with art reminds me of what would be called self-righteousness in religion." —Vincent van Gogh

"As far as execution is concerned, we regard it as of little importance; art, as we see it, does not reside in the execution: originality depends only on the character of the drawing and the vision peculiar to each artist." —Camille Pissarro (1830–1903)

"Basquiat's work, like that of most of his peers, was based on appropriation rather than draftsmanship. In contrast to most of his peers, the images he appropriated—whether they were from the Bible or a chemistry textbook—became part of his original vocabulary, alphabet letters in an invented language, like notes in a jazz riff, or phonemes in a scat song. Basquiat combined and recombined these idiosyncratic symbols throughout his career: the reclusive references to anatomy, black culture, television, and history are his personal hieroglyphics." —Phoebe Hoban

In all walks of life, values are in decline and standards have fallen. Or so you'd believe, as promoters of various good old days wistfully recall simpler, safer, cleaner, happier, *better* times. Artists have been complaining for centuries about how much better technique, execution, and general artistic liveliness used to be:

"The one cause of the decadence in painting today is the total loss of skill, *technique.* Today, the words skill and technique,

through the activities of the modernists, have come to stand for very little, something which is definitely not fit to mention." —Giorgio De Chirico (1888–1978)

"We are none of so good architects as to be able to work habitually beneath our strength; and yet there is not a building that I know of, lately raised, wherein it is not sufficiently evident than neither architect nor builder has done his best. It is the especial characteristic of modern work. All old work nearly has been hard work. It may be the hard work of children, of barbarians, of rustics; but it is always their utmost. Ours has as constantly the look of money's worth, of a stopping short wherever and whenever we can, of a lazy compliance with low conditions; never of a fair putting forth of our strength." —John Ruskin (1819–1900)

"The chief cause of the difference between the ancients and men of our age is our laziness and life without exercise: always eating, drinking, and no care to exercise our bodies. Therefore, our lower bellies, ever filled by a ceaseless voracity, bulge out overloaded, our legs are nerveless, and our arms show the signs of idleness." —Peter Paul Rubens (1577-1640)

Almost anything can be used to make art. Facility with tools goes far beyond handling a paintbrush, although this is, of course, the most traditional implement. But it is surprising how often it turns out that paint has been applied not with a brush but with the palette knife or the fingers, or something else.

"When I asked Cy [Twombly] about the near absence of brushes, he said, 'Oh, I never use brushes.' 'What do you use?' I asked. And he answered, 'Oh, rags, sticks . . . whatever I can get my hands on.' " —David Seidner

"Nothing is more revealing of the confidence and even the audacity with which Degas approached technical problems in his maturity than the delight he took in triumphing over them under particularly difficult conditions. He seems in fact to have gone out of his way to practice his art during vacations in his friends' country homes and at other times when he was deprived of the materials normally available to him. Thus, when the civil war in Paris forced him to remain at the Valpinçon's estate in Normandy in 1871, without his usual canvas and stretchers, he contrived to paint a most engaging portrait of their daughter Hortense anyway, using a piece of cotton ticking taken from the lining of a cupboard and fastened to an improvised frame. And when a heavy sleet storm prevented him from leaving the house of Alexis Rouart one day in 1882, he succeeded nevertheless in making an etching, the *Woman Leaving Her Bath,* by using a *Crayon électrique,* an instrument made of the carbon filament from an electric light bulb, which Rouart had found in his factory next door; and typically, this then became one of Degas's favorite means of etching." —Theodore Reff

" 'Take an object. Do something to it. Do something else to it. Ditto.' The recipe is from an early notebook of (Jasper) Johns, and it is the best explanation of his procedure. It is why a list of the materials Johns has used over the 40 years of his career

includes beeswax, lighter fluid, oil stain, plaster casts, crayon, charcoal, chalk, cardboard, ink on plastic, and the impress of his own body. One painting features his teeth marks. He doesn't want to represent or to deconstruct. He wants to transform." —Louis Menand

One of the most technically innovative artists of the twentieth century was Jackson Pollock (1912–1956). In a well-known passage, he describes his dynamic interaction with his canvas:

"My painting does not come from the easel. I hardly ever stretch my canvas before painting. I prefer to tack the unstretched canvas to the hard wall or the floor. I need the resistance of a hard surface. On the floor I am more at ease. I feel nearer, more a part of the painting, since this way I can walk around it, work from the four sides and literally be *in* the painting. This is akin to the method of the Indian Sand painters of the West.

"I continue to get further away from the usual painter's tools such as easel, palette, brushes, etc. I prefer sticks, trowels, knives and dripping fluid paint or a heavy impasto with sand, broken glass and other foreign matter added.

"When I am in my paintings, I am not aware of what I'm doing. It is only after a sort of 'get acquainted' period that I see what I have been about. I have no fears about making changes, destroying the image, etc., because the painting has a life of its own. I try to let it come through. It is only when I lose contact with the painting that the result is a mess. Otherwise there is pure harmony, an easy give and take, and the painting comes out well."

In 1950, Hans Namuth photographed Pollock in his studio, which was housed in a barn in Springs, New York. As Namuth describes it, a wet canvas covered the floor of the barn:

> "Pollock looked at the painting. Then, unexpectedly, he picked up can and paintbrush and started to move around the canvas. It was as if he suddenly realized the painting was not finished. His movements, slow at first, gradually became faster and more dance-like as he flung black, white, and rust-colored paint onto the canvas. . . . My photography session lasted as long as he kept painting, perhaps half an hour. In all that time Pollock did not stop. How long could one keep up that level of physical activity? Finally, he said, 'This is it.' "

As the drip method was to Pollock, dots were to Seurat:

> "Admirers of Seurat often regret his method, the little dots. Imagine, Renoir said, Veronese's *Marriage at Cana* done in *petit point*. I cannot imagine it, neither can I imagine Seurat's pictures painted in broad or blended strokes. Like his choice of tones, Seurat's technique is intensely personal. But the dots are not simply a technique; they are a tangible surface and the ground of important qualities, including his finesse." —Meyer Schapiro

There are enough instruction manuals and treatises on perspective to indicate that art can be approached mechanically. The following statements underscore the point about great art not being solely made up of technical expertise. How far beyond the determinism and simplicity of their ideas is the art of Cézanne and Leonardo?

"Painting is concerned with all ten attributes of sight: darkness and light, solidity and color, form and position, distance and nearness, motion and rest." —Leonardo da Vinci

"Cézanne said that the five simple solids are all there is to nature. It is the ability to feel this when painting a human face, for instance, that makes for artistic understanding. To bring this about, the students should learn to imagine a cylinder which has a hemispherical stop for the head; put a half cone before it for a nose, then take two reversed hollow spheres for the eyes with sold spheres set in then for eyeballs. The mouth is a truncated cone which does not begin directly underneath the nose but extends all the way back to the ears following the line of the jaws. In this way he will learn to constantly analyze apparently complicate structures into the simple basic forms. How clearly some modernist experiments have shown this." —John Sloan

"What else is there in architecture when you talk about form and space. It is the play between the solids and the voids. Therefore, the effects of light on these solids and voids is so important. And there you cannot separate architecture from painting or sculpture. It was never more graphically evident than in Picasso's work." —I.M. Pei

"The painter must know all about the movements of the body, which I believe he must take from Nature with great skill. It is extremely difficult to vary the movements of the body in accordance with the almost infinite movements of the heart. Who, unless he has tried, would believe it was such a difficult thing, when you want to represent laughing faces,

In choosing which colors to work with, task and technique collide. "[Robert] Motherwell liked to speculate that, generically speaking, there were six basic types or 'families' of painting-minds. Different families rise to prominence at different historical moments. He suggested that, as far as he could tell, he belonged 'to a family of 'black' painters and earth-color painters in masses,' a group that included Manet, Goya, Matisse ('don't forget that his greatest color is black'), Miró, and sometimes Picasso. There is no question that he aspired to join this company of painters who used black as a color rather than a tone, who amassed it as a primary territory to explore." —Edward Hirsch

"Generally speaking, color directly influences the soul. Color is the keyboard, the eyes are the hammers, the soul is the piano with many strings. The artist is the hand that plays, touching one or another purposively, to cause vibrations in the soul." —Wassily Kandinsky (1866–1944)

to avoid their appearing tearful rather than happy?" —Leon Battista Alberti (1404–1472)

Color is as susceptible to academic discourse as line or form. Seurat attempted to apply the rigors of the laws of physics to the color he used in his paintings. He located colors on a disc, arranging them according to their "complementaries." (The law of contrast states that a color achieves

its maximum intensity when it is brought close to its complementary.) Color is another element in an artist's signature. Claude Monet and John Singer Sergeant painted together once out of doors. Sergeant asked Monet for some black pigment but Monet didn't have any—he never used it.

> "Perhaps Velázquez's most distinctive quality is his profound knowledge of each and every material and technical resource. He paints with supreme confidence, finding not just the right solutions to the problem at hand. His technique, which becomes increasingly schematic without sacrificing realistic effects is the result of a long process of intellectual maturation. As time went on, he was able to do more with less. Velázquez saw the world with fresh eyes, something few artists have been able to do. The original vision would only be expressed with an original technique, and thus he became an innovative practitioner of the art of painting."
> —Carmen Garrido

ALL TOGETHER NOW

"What's in a name? Not much, the historian of art
is bound to answer. Cubism was not about cubes,
nor was Fauvism about wild beasts."

—Robert Hughes

"If you're going to have any success, you will be
categorized somehow, good or bad."

—Richard Estes

Making art can be a lonely business. But no one works
entirely alone. The Western art world includes com-
munities and movements—that is, groupings of artists and
their followers creating art to show and to sell. Attending
them is the business and service superstructure made up of
dealers, buyers, publishers, and exhibitors. There is also the
smaller band of critics that helps shape the currents and trends
that flow through this complex system.

Artists are in an anomalous position. Their creative work
is part of an intensely personal process that is usually under-
taken alone. But artists are subject to substantial pressures:

critical, financial, historical, political, social, and more. The challenge an artist faces is to make a mark with art that is relevant, that is, interesting to the contemporary art world while being innovative at the same time by showing the art world something it hasn't seen before. It is the rare artist who can be a real pioneer. When Picasso and Georges Braque (1887–1963) made the works that became described as cubist, they were commenting on the contemporary state of art.

> "For Picasso cubism constituted, among other things, a reaction against impressionism, whose two great luminaries, Renoir and Monet, were still hard at work and by now venerated by the public which had once ridiculed them. Picasso's attitude to impressionism was irreverent and ironical, not to say iconoclastic. . . .
>
> "It was not so much against these elderly impressionists that Picasso and Braque were in revolt against as the whole outmoded concept of impressionism; the lack of substance inherent in the very term; the flimsy art-for-art's sake shimmer of impressionist light effects. Cubism was also a reaction against the followers of the impressionists: against the methodology of the divisionists, the garishness of fauvism, and, in Picasso's case, against his pet aversion, Bonnard. 'A potpourri of indecision' is how he described this artist's work. He had caught his fear of melting in the bath like a piece of soap from Bonnard, he said." —John Richardson

Established artists know where they fit in the art world. Their stock might rise and fall, but, if established, they will have a reputation, something that is hard to gain and quite difficult to lose entirely. Aspiring artists, meanwhile, seek a niche,

a place where they fit in the order of things. Some would say this is an essential part of the artist's development.

> **"Art exists today because artists continue to create it, and artists exist because art makes creation possible for them (the reason why individuals who call themselves artists but keep aloof from any particular art are trapped in absurdity)."**
> —Harold Rosenberg

Perhaps, artists find their feet working alongside other artists with a similar sensibility. The impressionists were painters, among them Monet, Renoir, Pissarro, Sisley, Degas, Cézanne, and Berthe Morisot, who exhibited together in Paris in 1874. The group adopted the name that was coined by a journalist, who certainly didn't intend it as a compliment. After the original scorn and dismay that greets most revolutionary leaps of creativity, impressionism became the new paradigm. Edgar Degas was an enormous source of inspiration to Mary Cassatt. Cassatt shows how working as part of an artistic movement increased her creative self-esteem, "Degas persuaded me to show with my friends in the group of Impressionists. I accepted with joy. I could work with absolute independence."

The American abstract expressionists were a club with an unofficial HQ: the Cedar Tavern in Manhattan:

> **"Carl Andre said one time that [the Cedar Tavern] was where he got his education. In a way I kind of agree with him."**
> —Robert Smithson (1938–1973)

> **"A young, ambitious artist new to the New York art world, [Robert] Rauschenberg gravitated naturally to the Cedar, a**

dirty neighborhood bar that had been adopted by the painters and their hangers-on in part because of its seediness. Definitionally bohemian, it was so bad it was good. When fame finally arrived and the owners responded to the new influx of artists' cash by promising new interior décor, the artists threatened a boycott. They wanted to avoid at all costs the impression of an artists' bar, with its connotations of an effete elite preoccupied with questions of beauty. Unwilling to countenance that, the Abstract Expressionists created a facsimile of the Wild West that never was within the confines of the Cedar, a macho art world complete with drunken brawls, fights over women, vain boasting, and, of course, artist talk. It was a heady mix." —Jonathan Katz

"As soon as Rosenquist arrived in New York in 1955 from Minnesota he got a room at the YMCA and headed straight for the Cedar Tavern to, 'See the old guys.' " —Walter Hopps and Sarah Bancroft

Some artists viewed themselves as agents of political and social change or even revolution, although it can be difficult to differentiate between adept publicity seeking and genuine conviction. The Italian futurists of the early years of the twentieth century were notably ambitious, desiring nothing less than the destruction of the past. Futurists idolized speed and modernity and the cleansing properties of warfare. Their creed was the futurist manifesto written by Filippo Marinetti and published in Milan in 1909 in a book of poetry. When it was reprinted in the French daily *Le Figaro*, the manifesto reached a European-wide audience.

"We launch from Italy into the world this our manifesto of overwhelming and incendiary violence, with which today we found *Futurism,* because we want to liberate this land from the fetid cancer of professors, archeologists, guides and antiquarians." —Filippo Marinetti (1876–1944)

"Could the world be made new in this way? Of course not: art is invention, but it is also remembering. It is never in a real artist's interest to 'abolish' the past, which is impossible anyway." —Robert Hughes

When the first world war began ravaging Europe in 1914, the fatuousness of artistic enthusiasm for warfare was exposed. A large number of German artists saw frontline action in the conflict. Among them were George Grosz, Egon Schiele, Max Beckmann, Oskar Kokoschka, and Otto Dix. A number of artists collected in Switzerland, where Dada started up as a reaction to the lunacy of the war and the apparent certainties implied by ways of thinking like futurism.

"In Zurich in 1915, losing interest in the slaughterhouses of the world war, we turned to the Fine Arts. While the thunder of the batteries rumbled in the distance, we pasted, we recited, we versified, we sang with all our soul. We searched for an elementary art that would, we thought, save mankind from the madness of these times." —Hans Arp (1886–1966)

Writing in 1944, Robert Motherwell describes art as a retreat from the world surrounding the artist who might not be able to escape it any other way:

"Painting is a medium in which the mind can actualize itself; it is a medium of thought. Thus painting, like music, tends to become its own content.

"The medium of painting is color and space: drawing is essentially a decision of space. Painting is therefore the mind realizing itself in color and space. The greatest adventures, especially in a brutal and *policed* period, take place in the mind."

In 1945, the year that marked the end of World War II, Barnett Newman said:

"In times of violence, personal predilections for niceties of color and form seem irrelevant."

But on another occasion, he said:

"Harold Rosenberg challenged me to explain what one of my paintings could possibly mean to the world. My answer was that if he and others could read it properly it would mean the end of all state capitalism and totalitarianism."

"No, painting is not made to decorate apartments. It is an instrument of war, for attack and defense against the enemy." —Pablo Picasso

In 1949, Ben Shahn asserted:

"I believe that there is, at this point in history, a desperate need for a resurgence of humanism, a reawakening of values. I believe that art—art of any kind—can play a significant part in the reaffirming of man."

Can the artist play such a lofty role? Through history artists have found creative energy in times of social and political upheaval, like Weimar Germany in the years before Hitler came to power. But artists can be vitalized in any conditions and circumstances. But the artists must still find their own particular inspiration whether they are working alone or in a group; whether they are working to save the world or just to paint something to sell to make next week's rent.

Not everyone, of course, will find solace in the warmth of another's creative embrace. The architect Maya Lin rejects the idea of working in a large group. In her case, that would be a big architectural firm, an entity that would re-create the elements of the art world in miniature.

"And even though I build buildings and I pursue my architecture, I pursue it as an artist. I deliberately keep a tiny studio. I will hire firms or cause firms to be hired to work with me. I don't want to be an architectural firm ever. I want to remain as an artist building either sculptures or architectural works. And in a way what I disliked about architecture was probably the profession. I still am an artist. And basically what does that mean? It's much more individual. It's much more about who you are and what you need to make, what you need to say for you. Whether someone's going to look at it or not, you're still going to do it."

Frank Stella wanted to turn away from one particular group, the abstract expressionists. In the chapter on influ-

ences, Stella talked about his search for "Negative Pollock-ism." He also said he was:

> "Badly affected by what could be called the romance of Abstract Expressionism, . . . the idea of the artist as a terrifically sensitive, ever-changing, ever-ambitious person—particularly in magazines like *Art News* and *Arts,* which I read religiously. . . . I began to feel very strongly about finding a way that wasn't so wrapped up in the hullabaloo, or a way of working that you couldn't write about. . . . Something that wasn't constantly a record of your sensitivity, a record of flux."

> Q: "Can you define abstract expressionism?"
> A: "I never read a definition and to this day I don't know what it means. In a recent article I was called an action painter. I don't get it and I don't think my work has anything to do with Expressionism, abstract or any other. I am an anti-expressionist." —Mark Rothko (1903–1970)

> "How much the work of an artist owes to an art movement to which he belongs can never be determined exactly, if only because the movement derives its character from the individual creations of its members." —Harold Rosenberg

Painted in 1911, Piet Mondrian's three-part painting *Evolution* was informed by the painter's interest in the mystical theosophical ideas of Rudolf Steiner. Commenting on *Evolution,* the painter Bridget Riley denies that art can have ambitions to universality:

For many individuals, "art-for-art's-sake" is a perfectly good reason to make art. There does not have to be a great social or political message, although there often is; artists do not have to be in a movement or in the vanguard of a new movement in art, although they might be, or want to be. It is enough to be free to create and to leave the art world to its own devices.

> "Me, I would like to found a 'paternal' school to discourage people from that which our good snobs call Art with a capital. Art is everywhere, except with the dealers of Art, in the temples of Art, like God is everywhere, except in the Churches." —Francis Picabia (1879–1953)

"The creation of a common social language does not lie within the scope of an individual and the lack of such a basis has to be accepted by Modern Painting."

"The most precious factor in the creative life of an artist in any medium is freedom. Totalitarian, political, or national ideologues that seek to direct or channel the arts are pernicious; they can strangle the work of individual artists and cripple their own culture. They are not, however, the only things that hamper an artist's freedom. It can also be curtailed by commercial conditions of the theatres of aesthetics ordained by various groups, cults, cliques, or 'isms.' It seems to me that the most damaging restrictions on an artist's liberty are self-

imposed. So often, what may have begun as fresh thinking and discovery is turned into a routine and reduced to mere habit. Habits in thinking or technique are always stultifying in the long run. They are also contagious, and when a certain set of habits becomes general, a whole art period can condemn itself to the loss of freedom. It is probably this stultifying process, more often than anything else, that transforms the avant-garde of one generation into academicians in the eyes of the next." —Edward Steichen (1879–1973)

After discussing artists from futurists and dadaists to modern abstract artists saying theirs is the one true and righteous way, Arthur C. Danto mentions something Andy Warhol said in an interview in 1963:

"How can you say any style is better than another? You ought to be able to be an Abstract Expressionist next week, or a Pop artist, or a realist, without feeling you have given up something."

"This is very beautifully put. It is a response to manifesto-driven art, whose practitioners' essential criticism of other art was that it was not the right 'style.' Warhol is saying that this no longer makes sense: all styles are of equal merit, none 'better' than another. Needless to say, this leaves the options of criticism open. It does not entail that all art is equal and indifferently good. It just means that goodness and badness are not matters of belonging to the right style, or falling under the right manifesto." —Arthur C. Danto

TASTE

> "Five or six lunatics, of whom one is a woman, a group
> of unfortunates, afflicted with the madness of ambition,
> have got together . . . to exhibit their works."
> —Albert Wolff, *Le Figaro*, 3 April, 1876,
> on the second impressionist exhibition

The results of an artist's creativity can be profoundly disturbing to other people. It is as if an artist is inspired to make something only to find that the world isn't ready for him or her yet. Critics can be indifferent, politicians outraged, and the press up in arms. Questions of taste have dogged artists for centuries. Michelangelo scandalized his contemporaries because his Christ had no beard, his saints wore no clothes, and his angels had no wings. The first impressionist exhibition in 1874 was met with critical derision. The Armory Show in New York in 1913, where modernism came to the United States in the formidable forms of Matisse, Picasso, and

Duchamp, was attacked for undermining the centuries-long traditions of art. The arguments used against the 1999 "Sensation" show in Brooklyn or against the exhibitions of Robert Mapplethorpe's photographs were worded differently, but they amount to the same concern: taste. "I don't like it," someone is saying, "So take it away."

In order to have an informed opinion about a piece of art, it is surely important to try to find out what the artist is trying to do. In a performance piece where an artist cuts himself or uses a lot of animal gore, the artist is trying to shock and push boundaries of acceptable taste. The artist wants the art to be difficult to endure. In other cases, an individual might be offended by something that is simply unfamiliar, something she doesn't understand.

The artist may be put in a defensive stance, having to chose whether to justify what he has done or to let the art speak for itself. But many of the people passing judgment are not artists themselves. An artist cannot engage with a nonartist on the same terms, this argument runs. They might as well be speaking different languages.

> **"The process of creating any work of art—whether superrealistic, totally abstract, or somewhere in between—involves making an enormous number of aesthetic decisions about even the most minute details. Professional artists are trained to deal with these subtle visual distinctions. However, even viewers with no formal background in art or design have immediate, strong, and highly personal responses to the same types of details—whether looking at a painting or deciding what clothes to put on in the morning."** —Nancy G. Heller

"Many books on art are written by people who are not prac-
ticing artists, hence so many wrong ideas and judgments
arrived at capriciously or through prejudice. I firmly believe
that any man who has received a liberal education is qualified
to speak seriously of a book, but by no means of a painting or
a piece of sculpture." —Eugène Delacroix

"Most historians don't know how to create the things that
they are writing about. At any rate it is much more common
in Literature departments to find people who at least know
how they think a poem might be constructed. But the major-
ity of art historians in major universities were not trained as
artists." —James Elkins

Historians agree that Picasso revolutionized art with his
painting *Les Demoiselles d'Avignon* of 1907, which prefig-
ured what came to be known as cubism:

"No twentieth-century painting has attracted more atten-
tion than Picasso's great brothel composition of 1907, *Les
Demoiselles D'Avignon:* five confrontational whores posed
theatrically on a little stage, framed by draperies, dark red on
the left, blue on the right." —John Richardson

The women were prostitutes—Picasso wanted to call the pic-
ture *Le Bordel d'Avignon,* but this was not the issue. The
reaction of dealers and collectors centered on the abstract
form of the figures and it was almost universally negative.
These were by no means individuals with no training in art,
people whose only choices about color came with choosing
socks. But the reaction was strong: What is he doing?

Picasso's work had sold well up to that point. Now, the Russian collector Sergei Schukine said when he saw the painting, "What a loss for French art." Gertrude Stein's brother, Leo, was an important patron for Picasso and Matisse. Stein was also distinctly unimpressed:

> "[Picasso] painted a composition of nudes of the pink period, and then he repainted it again and again and finally left it as the horrible mess which was called for reasons I never heard, *Les Demoiselles d'Avignon*."

Leo Stein was completely turned off to modern painting by the new direction that *Les Demoiselles d'Avignon* implied. Gertrude Stein was much more tolerant of Picasso. She believed the painter to be a genius and, furthermore, that she was to writing what the Spaniard was to painting:

> "In the effort to create the intensity and the struggle to create this intensity, the result always produces a certain ugliness, those who follow can make of this thing a beautiful thing because they know what they are doing, the thing having already been invented, but the inventor because he does not know what he is going to invent inevitably the thing he makes must have its ugliness."

In 1902, Edward Steichen was in Paris where he was learning how to be a painter. Steichen visited a gallery that was full of unframed paintings. The pictures were dramatic and shocking to the young American and were quite unlike anything he had ever seen:

"If this was great painting, then everything I had conceived and learned was wrong. At the same time, I felt conscious of a curious force and power in these pictures. The contradictory experience was too much for me, and I was actually nauseated."

Steichen was so stricken that he went out onto the street and threw up. The next day, Steichen went back to the gallery and found that the paintings were by van Gogh. They were on sale for 1,000 francs ($200 at the time) and there were no buyers. As the section on money demonstrates, van Gogh is perhaps the best example of an artist venerated not at all in his own lifetime. Taste has caught up with van Gogh and he has been triumphantly vindicated in the century and more since his death. It is hard to see how van Gogh could have acted differently in his short life to gain acceptance for his difficult art. Most often, the creative urge is so strong that the approval of other people isn't essential. And for a living artist to attempt to cater precisely to the market, this can only be done when the market has announced its approval, that is, when an artist is somewhat established.

In 1999, a skirmish over taste took place in Brooklyn, New York, when Mayor Rudolph Giuliani said he would cut city subsidies to the Brooklyn Museum of Art if it went ahead with its "Sensation" exhibition of British artists. "Sensation" included Damien Hirst's preserved shark and maggot-and-flies piece *A Thousand Years* and also a self-portrait by Marc Quinn of his head sculpted from his own frozen blood. The

mayor concentrated on Chris Ofili's picture of the Virgin Mary, *The Holy Virgin Mary,* that included pieces of dried elephant dung as detail. Mayor Giuliani, who had only seen the show's catalog and not the show itself, denounced the art in "Sensation." Giuliani said that anything Ofili could do, like throw dung at a picture, could not be art. What's more:

> "You don't have a right to government subsidy for desecrating somebody else's religion. And therefore we will do everything that we can to remove funding for the Brooklyn Museum until the director comes to his senses and realizes that if you are a government-subsidized enterprise, then you can't do things that desecrate the most personal and deeply held views of people in society. I mean, this is an outrageous thing to do."

Ofili, it turns out, is a practicing Catholic and in the Nigerian tradition that he is from, elephant dung is a means of honoring something, not denigrating it. From London, Ofili said of his painting:

> "I don't feel as though I have to defend it. The people who are attacking this painting are attacking their own interpretation, not mine. You never know what's going to offend people, and I don't feel it's my place to say any more."

The courts decided that the mayor could not unilaterally cut off funding and the show went ahead. Ofili's reputation has only grown. Some of his works have sold for more than $200,000 and he is entering the mainstream, helping to prove the point about shifting tastes. Artists cannot control public

perception. What is today's avant-garde is tomorrow's ortho-
doxy. In 2003, a British critic wrote:

> "The next generation will be unable to comprehend that
> Chris Ofili's work was once regarded as blasphemous, just
> as it's impossible now to believe that the paintings of Gustav
> Klimt once had to be shown behind screens to stop them cor-
> rupting the young. Ofili's work is already being rapidly assim-
> ilated into the establishment. This year he was chosen to
> represent Britain at the Venice Biennale. He's almost square."
> —Bibi van der Zee

(When "Sensation" was staged at the Royal Academy in Lon-
don before it moved to New York, it aroused public ire as
well. But the focus was different, centering on a picture called
Myra by Marcus Harvey. The picture was of Myra Hindley,
a notorious British child murderer, and it was made up of the
handprints of children. The painting was attacked with ink
and eggs and had to be cleaned off before being exhibited.
"Sensation" attracted record crowds to the Royal Academy.)

There are frequent attempts by politicians to attack fund-
ing for the arts. In the mid-1990s, museums and performance
spaces came under great pressure for controversial art, includ-
ing Robert Mapplethorpe's photographs, the work of Andres
Serrano, and, most notably, a performance by Ron Athey, in
which the HIV-positive artist cut himself on stage. The budget
of the National Endowment for the Arts was reduced.

Arguments about taste have also reached the courts. In
1990, the Cincinnati Contemporary Arts Center and curator
Dennis Barrie were charged with obscenity because of an
exhibit of photographs by Robert Mapplethorpe, some of

which were graphically sexual in nature. The center was acquitted after a ten-day trial.

◎ ◎ ◎

Arguments about taste always involve a discussion of "What is art?" This is tangential to the stated aims of this book, although a narrow definition, restricting "art" to fine art, would disenfranchise most practicing and aspiring artists. So who decides what is art?

In *But Is It Art?*, Cynthia Freeland, who is a professor of philosophy at the University of Houston, brings up the case of Andy Warhol's *Brillo Boxes,* which is actually made out of plain old boxes of Brillo. It was argued that such an item could be a work of art if an institution like a museum or a gallery treated it as such. But, as Arthur C. Danto points out, *Brillo Boxes* was not accepted as art by the director of the National Gallery of Canada. Danto says that the piece had to be "interpreted" and have a theory attached to it.

> "In our time, at least since some of Duchamp's work and Andy Warhol's *Brillo Boxes,* almost anything goes. This makes the narrow and restricted views of earlier philosophers, who defined art in terms of Beauty, Form, etc. seem too rigid. Even shocking art like Serrano's *Piss Christ* can now count as art: an object with the right sort of idea or interpretation behind it. Serrano and his audience share some background theory or context within which the photo may be viewed as art: it communicates thoughts or feelings through a physical medium.
>
> "Danto argues that in each time and context, the artist creates something as art by relying on a shared theory of art

that the audience can grasp, given its historical and institutional context. Art doesn't have to be a play, a painting, garden, temple, cathedral, or opera. Art doesn't have to be beautiful or moral. It doesn't have to manifest personal genius or devotion to god through luminosity, geometry, and allegory." —Cynthia Freeland

So it *is* art. In this case, the argument is about taste, not whether something is art or not. The fact that the question is being raised at all would seem, under the broad terms defined earlier, to qualify whatever that something might be. Debates about taste are almost impossible to settle. Andres Serrano's *Piss Christ* is a photograph of a crucifix suspended in the artist's urine. Serrano does not think that what he's done is blasphemous at all, "I am not a heretic. I like to believe that rather than destroy icons, I make new ones."

Mauricio Cattelan's *La Nona Ora (The Ninth Hour)* is, unmistakably, a lifelike model of Pope John Paul II just after he has been struck and knocked down by a meteorite. When the piece was on display in the pope's native Poland in 2000, two members of Parliament tried to assist the fallen pope by removing the rock and standing him up. "I'd rather be attacked than ignored," said Cattelan afterward. He also said he wanted the piece to remain as it was after the Polish MPs worked on it. "It would have been a new work, the image of a confrontation. Instead, with the excuse of restoration, the room was closed, and now we are party to censorship."

In 2001, *La Nona Ora* sold at Christie's in New York for $886,000. There is some shock value attached to a work of art depicting the pope felled by a meteorite. Certainly, attacks on

the piece gained it a reputation and notoriety, which are valuable commodities. In *Salon.com,* commenting on the "Sensation" show, Daniel Kunitz says this kind of thing has a long and glorious tradition:

> "For 500 years artists have been courting hype; it was virtually a Renaissance ideal. Michelangelo, Cellini, Vasari and Caravaggio were some of the greatest self-promoters of all time. To them you can add David, Delacroix, Courbet, Rodin and Picasso."

If there is no "background theory or context," in Cynthia Freeland's words, then "art"—as defined by the art world— it is probably not. This is only important to the aspiring artist if you want to engage with that world.

In Britain, there is the curious case of Jack Vettriano, a former miner and self-taught painter whose work, reproduced on mugs and posters, sells more in the United Kingdom than any other artist, meaning that he is extremely successful by commercial standards. Vettriano, whose work isn't shown in public galleries, feels he isn't respected by the artistic elite in Britain. "There is room for everybody," says Vettriano. Tom Hewlett, the owner of the gallery that does show Vettriano's paintings, says:

> "Art which is accessible to the masses is often regarded as not worthy of inclusion when the people choosing for galleries prefer old masters or cutting-edge contemporary. Should a public gallery give the public what they want or what the directors want to give them?

Beneath the self-promotion and hype, it just might be that some of the art is, in fact, bad. Critics help decide what is good and what is bad by perfecting their own taste over years of immersion in art. Whether you agree with a critic or not is, of course, a matter of taste.

> "Mention video to some people and watch their faces fall. If the cliché of 'modern sculpture' used to be a piece of stone chewing-gum with a hole in it, and that of 'modern painting' was a canvasful of drips, then the cliché of 'video art' is a grainy close-up of some UCLA graduate rubbing a cockroach to pulp on his left nipple for sixteen minutes while the sound track plays amplified tape-hiss, backward. Video art has not yet shaken off its reputation as clumsy, narcissistic and obscure.
>
> Of course, video has no monopoly on that; most art of any kind, in this overloaded art world, is clumsy, narcissistic and obscure." —Robert Hughes

> "There are two art worlds: the popular one which anyone can understand, and the academic one controlled by relatively few people. The latter has a very different approach and tries to be sensational for the sake of it."

Professor Duncan Macmillan of Edinburgh University gave Vettriano one paragraph in a book about Scottish painting. In *The Observer*, the professor made an analogy using Britain's

most popular writer and its most prestigious literary award, the Booker Prize:

> "Should J.K. Rowling win the Booker Prize because she's read by a lot of people? It's interesting as a phenomenon: he's obviously struck a popular note, but it cannot be translated directly into enduring quality."

And the eternal debate about taste continues. Artists toiling away on their strange and beautiful life's work should be aware that they need to be able to answer for it cogently. They should also know that popularity does not come with critical acceptance attached (more likely the reverse) and that obscurity does not imply quality. The number of people who try their hand at serious amateur art are probably smaller than those who try to write. In each field, there are educated enthusiasts who can offer an opinion on your work, but there are very few tastemakers—buyers, publishers, critics, and curators—and no path to "discovery" by them that is trod by any other than a very lucky few. As with any creative endeavor, the first and most important person to please is yourself. If anyone else comes along for the ride, it's a bonus.

Central to any argument about taste is the art critic. Art critics help parcel artists into types and groups and formulate a climate of opinion about an artist. An artist, whether alive or dead, can find herself raised up or cast down as the tectonic plates of the critical world move about. The art historian

James Elkins doesn't think theorists have done a particularly good job with the recent past:

> "It's baffled me, how hard it is to round up a number of importantly different, cogent, historically responsible theories of the shape of twentieth-century painting. It was our century, but we still don't own it."

In a famous polemic published in 1975, Tom Wolfe writes that he noted the precise day when the theorists took over art: Sunday, April 28, 1974. In a piece in the *New York Times Arts and Leisure* section, Hilton Kramer wrote of an exhibition at Yale University that realism lacks a persuasive theory and "to lack a persuasive theory is to lack something crucial." "Crucial" is the crucial word. Now, Wolfe says, we need help to see a painting properly. "Modern Art has become completely literary: the paintings and other works exist only to illustrate the text." (Is this the same as the help we need to tell what is art?) Theory, Wolfe says, has become essential to taste:

> "Each new movement, each new *ism* in Modern Art was a declaration by the artists that they had a new way of seeing which the rest of the world (read: the bourgeoisie) couldn't comprehend. 'We understand!' said the culturati, thereby separating themselves also from the herd. But what inna namea Christ *were* the artists seeing? This was where theory came in. A hundred years before, Art Theory had merely been something that enriched one's conversation in matters of Culture. Now it was an absolute necessity. It was no longer background music. It was an essential hormone in the mating ritual. *All we ask for is a few lines of explanation!* You say

Meret Oppenheim's *Fur-Covered Cup, Saucer and Spoon* (the *pièce de résistance* of the Museum of Modern Art's Surrealism Show in December 1936) is an example of the Surrealist principle of displacement? You say the texture of one material—fur—has been imposed upon the form of another—china and tableware—in order to split the oral, the tactile, and the visual into three critically injured but for the first time fiercely independent parties in the subconscious? Fine. To get to the word was to understand."

PART 2

The World
of Inspiration

◎ ◎ ◎

"One can find beauty in everything."
—Pierre Bonnard (1867–1947)

**"My palette, newly set and brilliant with the contrasts of the
colors, suffices to inflame my enthusiasm."**
—Eugène Delacroix

I n the chapter on influences, artists mentioned other artists
who had inspired them, either in person or through the
power of their work. The influence that artists exert on each
other is like a physical force—the pull of gravity or magnetic
attraction (or repulsion). The influence operates to different
degrees. As part of a school, artists can define themselves in
relation to the work of others. They might be influenced by
another artist's technique, choice of materials, or subject mat-
ter. But when it comes to day-to-day inspiration, all artists,
however, are drawing from the same limitless catalog. Artists
live in the same world as the rest of us. If you create art,

though, an image you see is no longer just something nice to look at, or arresting, or disturbing. The image might be one you can make art out of.

In terms of inspiration, the most important part of the universe has long been the natural world (as distinct from its man-made counterpart). Vincent van Gogh was careful to make the distinction between nature and the products of humankind in the form of other people's paintings. Too much time spent looking at the work of others takes the artist away from nature. It means influence (or, its negative connotation, imitation) rather than inspiration:

> "And every day I am more convinced that people who do not first wrestle with nature never succeed.
>
> "I think that if one has tried to follow the great masters attentively, one finds them all back at certain moments, deep in reality. I mean one will see their so-called *creations* in reality if one has similar eyes, a similar sentiment, as they had. And I do believe that if the critics and connoisseurs were better acquainted with nature, their judgment would be more correct than it is now, when the routine is to live only among pictures, and to compare them mutually. . . . The most touching things the great masters have painted still originate in life and reality itself."

In the sixteenth century, when Francisco de Hollanda (1517–1584) was alive, the artist's job was primarily to go about the world and faithfully reproduce God's creation:

> "Painting is merely to copy with great care and skill one single thing of those made by immortal God, invented and

painted by Him, in His own image and the lower creation, animals and birds, perfect each according to its kind. And in my opinion that painting is excellent and divine which most resembles and best copies any work of immortal God, whether it be a human figure or a wild and strange beast or a simple straightforward fish or bird of the sky or any other creature; and that not in gold or silver or delicate tints but simply drawn with a brush or with chalk or with a pencil in black and white."

Nineteenth-century artists also describe how they perceive their mandate to be the copying of what they see in nature. Van Gogh, for one, allows himself more leeway for creative expression:

"I study nature so as not to do foolish things—however I don't mind so much whether my color corresponds exactly, as long as it looks straightforward on the canvas."

"An artist, under pain of oblivion, must have confidence in himself, and listen only to his real master: Nature." —Pierre-August Renoir

"I think a painter is happy because he is in harmony with nature as soon as he can express what he sees." —Vincent van Gogh

Some artists show a reverential attitude to the natural world. Nature is something to learn from and, at best, to emulate, with no thought of manipulating, much less commanding it. The best you can hope for, perhaps, is to, in Thomas Eakins's phrase, "sail parallel."

"I do not have the magnificent richness of coloring that animates Nature." —Paul Cézanne (1839–1906)

"The big artist keeps a sharp eye on Nature and steals her tools. . . . Then he's got a canoe of his own, smaller than Nature's but big enough for every purpose. . . . With this canoe he can sail parallel to Nature's sailing." —Thomas Eakins (1844–1916)

"How could a painter want for a subject when awakened to nature through what we see in ourselves, in our love, and in the heavens." —Philipp Otto Runge (1777–1810)

"Nature contains the elements, in color and form, of all pictures. . . . But the artist is born to pick, and choose, and group with science these elements, that the result may be beautiful." —James McNeill Whistler (1834–1903)

With the advent of abstraction in art, though, the place of nature as the main source of inspiration was reduced. The way the artist looked at the world changed. The manner of looking rather than what was represented became more significant. The inspiration is created within the artist rather than solely radiating from nature and the tables are turned, allowing an artist to dictate the terms on which nature is seen.

"Deal with nature in terms of the cylinder, the sphere, the cone, all seen in perspective, so that each side of an object or plane is directed towards a central point. Lines parallel to the horizon give breadth, so that is to say a section of

nature . . . lines perpendicular to the horizon give depth. However, nature for us men is more depth than surface."
—Paul Cézanne

"Cézanne once expressed the wish to paint nature in complete naiveté of sensation, as if no one had painted it before. Given this radically empirical standpoint, we can understand better his deformations of perspective and all those strange distortions, swelling, elongations, and tiltings of objects which remind us sometimes of the works of artists of a more primitive style who have not yet acquired a systematic knowledge of forms, but draw from memory and feeling."
—Meyer Schapiro

"Nearly all painting . . . has attempted, in part at least, to reproduce objects in nature. . . . But that is . . . exactly what art is not. Art is a successful attempt to render external an internal state of mind or feeling." —Francis Picabia

Interviewer: "People say abstract art has no connection with nature."
Wassily Kandinsky: "No! And no again! Abstract painting leaves behind the 'skin' of nature, but not its laws. Let me use the 'big words' cosmic laws. Art can only be great if it relates to cosmic laws and is subordinated to them."

At the extreme of this viewpoint, Max Ernst (1891–1976) would have you believe that an artist just has to reach into his subconscious and retrieve memories. In this view, nature is passively engaged by an artist's subconscious. The focus has shifted inward and reached its farthest point: the human subconscious:

"Just as the poet listens to and takes note of his automatic thought-processes, the painter projects on paper or on canvas that to which his optical inspiration inspires him. Banished, of course, is the old notion of 'talent'; also banished is hero-worship and the sage of the artist's 'fertility'; so gratifying to the voluptuaries of admiration. Whereby he lays three eggs today, one tomorrow, and none Sunday. Since it is well known that every normal human being (and not only the 'artist') carries in his subconscious an inexhaustible supply of buried pictures, it is a matter of courage or of liberating methods (such as automatic 'writing') to bring to light from expeditions into the unconscious unforged (uncolored by control) objects (pictures)."

Operating in the same realm are dreams and intuition.

"A strong emotion can be translated immediately: dream on it and seek its simplest form." —Paul Gauguin (1848–1903)

"To make a descriptive definition of the deepest content of art is as impossible as it is to define the deepest content of life. Art is created through intuition. In our daily, social, and intellectual life, all of which are only partial expressions of vitality, intuition can lose its force due to many forms of oppression. But in art intuition is free, insofar as it is not oppressed by subjective factors." —Piet Mondrian (1872–1944)

While some artists continue to turn to the natural world, artistic inspiration can be found in anything. They look in cities and towns and suburbs as well—wherever they happen

to find themselves. Memories of an artists birthplace and childhood are likely to be strong. In Marc Chagall's case, what he calls his "environment" explains the recurrence of certain motifs in his work:

> "The fact that I made use of cows, milkmaids, roosters and provincial Russian architecture as my source forms is because they are part of the environment from which I spring and which undoubtedly left the deepest impression on my visual memory of any experiences I have known. Every painter is born somewhere. And even though he may later return to influences of other atmospheres, a certain essence—a certain 'aroma' of his birthplace clings to his work."

> "From time to time I have to make a baseball painting to express a deep national love. By national I mean where you come from, grow up, get formed, national pride etc., etc. What can it be if not a national feeling translated into painting." —R.B. Kitaj

> "The first colors that made a strong impression on me were bright, juicy green, white, carmine red, black and yellow ochre. These memories go back to the third year of my life. I saw these colors as various objects which are no longer as clear in my mind as the colors themselves." —Wassily Kandinsky

A place can have too strong a sense of itself to allow creativity to thrive:

> "I'm a loner and paint out of a certain self-imposed remoteness. When I'm at work, I usually remove my state of mind

from the Negro environment I live in. I paint what's inside, and like to think of it as very personal, very individual environment. Being Negro, of course, is part of what I feel, but in expressing all of what I am artistically, I often find myself in a visionary world, to which 125th Street would prove limited and less than universal in comparison." —Norman Lewis

When seeking inspiration, Pierre Bonnard would look for an idea or what he called the "seduction." If he saw something on the walks he took each day, he'd make a note. Bonnard went to Italy to look at landscapes with the American painter Henry Lachman. The two painters drove to their destination. Lachman got out of the car and started setting up his easel— he was ready to get to work. When Bonnard showed no sign of getting out of the car, Lachman asked him what he was doing. "*Moi*," said Bonnard, "*J'observe.*"

Edgar Degas and fellow painter Walter Sickert (1860– 1942) set off to visit a café. Sickert suggested they take a cab, which at the time meant a horse-drawn carriage. Degas said he didn't want to do that:

"Personally, I don't like cabs. You don't see anyone. That's why I love to ride on the omnibus—you can look at people. We were created to look at one another, weren't we?"

"The poorest avenue, with its straight leafless saplings, in a flat dull horizon, says as much to the imagination as the most spectacular view." —Eugène Delacroix

Toulouse-Lautrec found sanctuary, and artistic ideas, in the Parisian brothels where he would live for weeks at a time.

Some street graffiti is produced by talented artists and it's an obvious example of modern public art that has influenced the artistic mainstream. What George Grosz (1893–1959) found as an inspiration probably qualifies as graffiti too:

> "In order to attain a style which would render the blunt and unvarnished harshness of my objects, I studied the crudest manifestations of the artistic urge. In public urinals I copied the folkloristic drawings; they seemed to me to be the most immediate expression and the most succinct translation of strong feelings."

> "Graffiti is arguably as old as cave paintings. Its existence in public rest rooms and on mass transit is a timeless part of the urban landscape. As early as the nineteenth century, graffiti was being considered in an aesthetic and historical light. The Victorians parsed prison graffiti for examples of innate criminality while praising its unconscious genius; by the early 1900s, a number of artists were self-consciously incorporating it into their work—from Apollinaire to Dubuffet's textured scratchings. The appropriation by the intellectual elite of what could be thought of as the automatic writing of the vox populi is a time-honored tradition." —Phoebe Hoban

Lautrec made more than forty paintings and drawings of the women of the establishment. They were frank pictures of bored women waiting around or playing cards, or even submitting for their mandatory medical examination. The painter found inspiration in the daily life of one of the few places in which he was comfortable.

"It was the brothel and its inhabitants which inspired a sequence of works that constitutes the height of Lautrec's creative achievement and presents an aspect of life which no other artist has ever surpassed." —Bernard Denvir

Inspiration is one of the ingredients that makes any art work. You can carve out the time to work and settle in front of your canvas and just not feel it. Or you might spend years struggling with technique but be bursting with ideas you can't execute. To give themselves the best chance, the artist has to work at preparing to be receptive to inspiration.

In 1911, the twenty-four-year-old Charles-Edouard Jeanneret (better known as Le Corbusier) visited some of the European sites of great ancient buildings: Vienna, Constantinople, and Athens. Le Corbusier felt anxious before he visited the Acropolis because he knew this was a standard by which other buildings were measured. With great self-awareness, Le Corbusier felt a responsibility to the minds he was inspired by. The young artist spent many hours poring over the buildings:

"Those who, while practicing the art of architecture, find themselves at a moment in their careers somewhat empty-headed, their confidence depleted by doubt before that task of giving living form to inert matter, will understand the

melancholy of my soliloquies amid ruins—and my chilling dialogues with silent stones. Very often, I left the Acropolis burdened by a heavy premonition, not daring to imagine that one day I would have to create."

When the inspiration meets the matured creative mind, the result can be exhilarating:

"When the Spanish designer Santiago Calatrava unveiled his plans for the $2 billion transit station at the World Trade Center site in New York last month he apologized for his imperfect English. 'Let me draw for you what I cannot say,' he told the crowd, and, taking a piece of chalk to a large tablet, he fluently sketched a child releasing a bird—a spellbinding image that had inspired his design. Calatrava's seemingly delicate steel-and-glass terminal sprouts enormous wings that supposedly can flap down gently, creating an opening along the crest of the roof and sheltering the surrounding plaza. It's as if an enormous dove of peace were about to alight in the ruins of lower Manhattan." —Cathleen McGuigan

SUBJECTS

"Novelty lies not in the subject but in the manner
of expressing it."

—Camille Pissarro

"In my opinion the subject matters little provided that what I
do is interesting as painting."

—Frédéric Bazille

The question is: What to paint? For hundreds if not thou-
sands of years, most art was created in the name of reli-
gion or for totemic reasons associated with the supernatural.
In the West, in the Christian era, this meant that art was made
to glorify God. Some of the oldest Christian art was made in
the underground cemeteries of Rome—better known as the
catacombs.

"In addition to Jesus the Good Shepherd and Jonah and the
whale, popular Old Testament subjects for catacomb paint-
ings were Noah and the Ark, Moses, the three youths in the

fiery furnace, Daniel in the lion's den, and Susanna. Popular New Testament subjects were taken from the life of Jesus, especially the miracles of healing such as that of the paralytic or the raising of Lazarus. . . .

"The catacomb paintings are intended to stimulate the viewer's thoughts by representing ideas and concepts. Their style, like that of the mosaics of Santa Maria Maggiore in Rome, recall late Roman wall painting. In this abbreviated style neither perspective, nor a specific light source, nor cast shadows are used and the application of paint is sketchy and loose. Anything that does not relate directly to the story is eliminated." —Janetta Rebold Benton

Long after secular subjects became commonplace, Nicholas Poussin (1594–1665) declared that a painter should confine himself to grand and ennobling subjects like battles, the action of heroes, and the divine:

"The painter is required to exercise not only art in giving form to his matter, but judgment in appraising it, and he must choose a subject that will naturally admit of every ornament and perfection. Those who elect mean subjects take refuge in them because of the weakness of their talents."

The invention of photography in the nineteenth century caused some people to prophecy the immediate death of painting. But in terms of subject, painting can record the roaming imagination in ways that a conventional photograph finds difficult to emulate.

"I have no fear of photography as long as it cannot be used in heaven and in hell. Sooner or later there must be an end to this painting of knitting women and reading men. I am going to paint people who breathe, feel, love, and suffer. People will come to comprehend the holiness of it and take their hats off as in church." —Edvard Munch (1863–1944)

Today, of course, nothing is taboo and anything can be taken as the subject of a piece of art. If it hasn't, it probably will be. (See the chapter on taste.) In abstract art, the choice of subject might be less critical than the way the artist goes about rendering it. The actual subject may be of little interest to the artist as she goes about her craft. Or the subject may challenge the notion that a work of art is an object to be appreciated for its beauty or the way it represents its subject. Marcel Duchamp's "readymades" were everyday objects raised to the status of art: a bicycle wheel mounted in a stool, a snow shovel, and *Fountain,* the legendary urinal, signed by R. Mutt, that Duchamp anonymously submitted to the American Society of Independent Artists' Exhibition in New York in 1917 only to have it rejected.

Modern artists who apparently eschew subject may not in fact value form over content. Mark Rothko always talked about what he was painting even when he was attempting to render feeling and emotion on canvas. (Painting emotion is a definition of expressionism.) In 1943, Rothko and fellow painter Adolph Gottlieb wrote a letter to the *New York Times* that was a five-part manifesto. At the time each was pursuing mythical themes in their work. Point five read:

"It is a widely accepted notion among painters that it does not matter what one paints as long as it is well painted. This

is the essence of academism. There is no such thing as good painting about nothing. We assert that the subject is crucial and only that subject matter is valid which is tragic and time-less. That is why we profess spiritual kinship with primitive and archaic art."

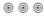

The real subject of many—some would say all—works of art is the artist himself. When an artist makes a self-portrait, this is literally the case.

"The greatest painter of Holland, and one of the greatest painters who ever lived, was Rembrandt van Rijn (1606—69). . . . Rembrandt did not write down his observations as Leonardo and Dürer did; he was no admired genius as Michelangelo was, whose sayings were handed down to posterity; he was no diplomatic letter-writer like Rubens, who exchanged ideas with the leading scholars of his age. Yet we feel that we know Rembrandt perhaps more intimately than any of these great masters, because he left us an amazing record of his life, a series of self-portraits ranging from the time of his youth, when he was a successful and even fashionable master, to his lonely old age when his face reflected the tragedy of bankruptcy, and the unbroken will of a truly great man. These portraits combine into a unique autobiography." —E.H. Gombrich

Richard Avedon speaks of the autobiographical element that even a portrait of another person can embody:

"There is no truth in photography. There is no truth about anyone's person. My portraits are much more about me than they are about the people I photograph. I used to think that it was a collaboration, that it was something that happened as a result of what the subject wanted to project and what the photographer wanted to photograph. I no longer think it is that at all. The photographer has complete control, the issue is a moral one and it is complicated. Everyone comes to the camera with a certain expectation and the deception on my part is that I might appear to be indeed part of their expectation. If you are painted or written about, you can say: but that's not me, that's Bacon, that's Soutine; that's not me, that's Celine."

So the way an artist sees a subject and expresses it reveals a great deal about the personality of the artist. Rembrandt is not only leaving clues and hints about his own personality by painting himself, but the manner in which he chose to represent himself and the style he adopted is telling as well. This autobiographical element can be present when an artist is creating an abstract work. (Picasso said that he wasn't always telling the truth but that, "My work is like a diary. It's even dated like a diary.")

"Pollock's fierce, twinkling bull eyes and great shoulders are there in his work. Some artists' faces are embedded in their work in this way, as a kind of personal resonance, others not: Picasso's face is in his work, and Modigliani's, Klee's, van Gogh's, Delacroix's, Raphael's, but not, say, Soutine's, Mondrian's, Seurat's, Grünewald's. This resonance—a trace of the personal—is an attribute which doesn't add meaning to

nor extract from the work: in fact it invites false values. It is the attribute much prized by hucksters in the entertainment world—that makes readers of movie magazines regard the roles of stars as an adjunct to their private lives." —Elaine de Kooning

The artist leaves a lot of the self in the work. As the chapter on inspiration notes, there has been a shift inward toward the artist in the last century. Rather than the subject itself that is interesting to the artist, it is the way the artist reacts to the subject that becomes more to the point:

"O young artist, you search for a subject—everything is a subject. Your subject is yourself, your impressions, your emotions in the presence of nature." —Eugène Delacroix

"It is, of course, true that the important thing about a picture is how it is painted, and that the subject matters, by comparison, very little." —André Malraux

Even if the subject is taken to matter less than hitherto, it still does matter some:

"It is my misfortune—and probably my delight—to use things as my passions tell me. What a miserable fate for a painter who adores blondes to have to stop putting them into a picture because they don't go with a basket of fruit. . . . I put all the things I like into my pictures. The things—so much the worse for them; they just have to put up with it." —Pablo Picasso

"I'm very affected by the people I paint. Their nature even affects the way my paint goes on. For instance, I see funny things happening when I paint Bella, my daughter." —Lucian Freud

"In one case, I have cut off a flying milkmaid's head, and it is coming along in the air behind her, I didn't do it because I had anything I wanted to say about milkmaids; I did it because I needed to fill up that space in the picture where you now see the head." —Marc Chagall

In time, rather than create a concrete object exterior to themselves, some artists substituted the creative process itself for the finished object. Artist and subject became blurred. Once this idea was established, it became legitimate for the artists to insert themselves into their work and in some cases to *become* their work. This was a notion one writer said gathered momentum at a particular time in history:

"In 1949 the canvas was dripped and poured on by the American Jackson Pollock (*No. 1*), slashed by Argentinian-born Lucio Fontana (*Concetto Spaziale*) and punctured by Japanese Shozo Shimamoto (*Work [Holes]*). In each of these paintings, done within months of each other, the face of art was changed, contended American curator Paul Schimmel, as the painterly action took precedence over the painted subject. A worldwide contingent of artists including Allan Kaprow, George Mathieu, Yves Klein, Atsuko Tanaka, Otto Muehl, Gunther Brus, Joseph Beuys, Jean Tinguely, Nikki de St Phalle,

Robert Rauschenberg, and Piero Manzoni, soon extended the gestural art of Pollock into actual Performances, Happenings, and Events. The social and sexual revolutions of the 1960s found expression in art that was directed away from the canvas into actions that incorporated the viewer into the work of art. For American artists at mid-century it was a short step from action painting (Jackson Pollock's all-over and free application of paint) to action itself as a form of art." —Michael Rush

From other perspectives, however, "performance" is not such a new idea:

"In present-day criticism the term [performative] is used to describe the work of many, very different artists from Cindy Sherman to Eric Fischl or Matthew Barney, whose art is considered 'performative' for its unusually charged content. According to photographer Richard Avedon who insists that 'all portraiture is performative,' even Rembrandt, 'must have been acting when he made his own self-portraits. . . . Not just making faces, but always, throughout his life, working in the full tradition of performance.' " —RoseLee Goldberg

"The idea of the artist as a performer is probably, in some ways, as old as the concept of patronage and commissioned murals, ceiling decorations or altarpieces—some aspects of Michelangelo's labour for Pope Julius in the Sistine Chapel meet some of the conditions and requirements of performance." —Bryan Robertson

Modern performance artists include Yves Klein, who used decidedly nontraditional implements like flamethrowers in

his art. In 1958, he emptied an art gallery in Paris, painted the space white, and installed a guard at the door as if the place were full of van Gogh's paintings. Visitors came to the gallery in the thousands. In *Leap in the Void*, Klein created a photograph in which he appears to be flying toward the ground from a second-floor window. And in *Anthropometries of the Blue Period*, Klein used a naked woman whose body was smeared in blue paint to apply color to a canvas nailed to the floor. As an audience looked on, a small orchestra played what was called a "monotone symphony"—a single note sustained for ten minutes alternated with ten minutes of silence. The event was also filmed and photographed so that it exists in numerous forms.

And so there developed the artistic branch that was called conceptual art, where the idea of the piece was the subject.

"In conceptual art the idea or concept is the most important aspect of the work. When an artist uses a conceptual form of art, it means that all of the planning and decisions are made beforehand and the execution is a perfunctory affair. The idea becomes a machine that makes the art." —Sol LeWitt

Take, for example, Robert Barry's 1969 *Telepathic Piece:*

"During the exhibition I will try to communicate telepathically a work of art, the nature of which is a series of thoughts that are not applicable to language or image."

Installations, performance pieces, earth art, and so on dramatically extend the playing fields of the artist. The only limit is your imagination. In 1977, Walter de Maria made his *Ver-*

tical Earth Kilometer in Kassel, Germany, a brass rod one kilometer long sunk in the ground with nothing visible except its top, a disc two inches in diameter.

Nam June Paik's *Zen for Film* was made up of a home movie screen accompanied by an upright piano and double bass. Onto the screen, 1,000 feet of unprocessed film was projected. Each time it was shown, the dust and scratches the film had accumulated made the once-blank film slightly different.

In 1971, in the name of art, Chris Burden had a friend shoot him in the left arm with a .22 rifle. However it came to pass, Burden was, to all intents and purposes, the victim of a shooting and as such he was interviewed by the police:

"I made up some story about a hunting accident and they're going, 'How's your wife?' They were convinced that my wife had shot me. They basically knew there was something fishy going on. . . . To this day people are still pissed off."

Three years later, in *Trans-Fixed*, Burden was nailed through the palms—crucified—to the roof of a Volkswagen *Beetle*. On other occasions he has spent five days in a locker and lay wrapped in a bag in the middle of a street in Los Angeles. In the 1970s, Carolee Schneemann unfurled a scroll from her vagina in a performance and from the paper read a bad review she'd been given. In a New York gallery, six hours a day, five days a week, Vito Acconci, out of sight, masturbated as visitors milled around him.

Discussed and dissected by critics, these works are accepted as art. If you want to explore the boundaries of art with these pioneers, the farthest reach of the frontier remains to be discovered.

"A vast bank of frequently repeated images emerges—Yves Klein's *Leap into the Void,* Carolee Schneemann's *Interior Scroll*—which may become as iconic to the history of performance as are Marcel Duchamp's *Fountain* or Andy Warhol's *Soup Cans* to the history of performance." —Rose-Lee Goldberg

◎ ◎ ◎

Until the mid-nineteenth century, if you wanted to preserve the image of your artistic subject, you would paint or draw it or make a model or sculpture. Each of these has always been held to be an artistic endeavor. With the invention of photography, a mechanical device, something without a sensibility of its own was interjected between artist and subject. The debate as to whether photography was art was joined. Photographs were admitted in the salon in Paris for the first time in 1859, though separate from the paintings. Their presence in the lofty company of fine art didn't sit well with everyone. Charles Baudelaire said:

"The photographic industry is the refuge for every failed painter, too little talented or too lazy to complete his studies."

"Photography is very young. Writing is very old. Everybody writes but they do not know they are not writers. Everybody photographs, but they realize that they are not photographers." —Berenice Abbott

As Richard Whelan relates in his biography of Alfred Stieglitz, there was a precise moment when photography was

officially designated as art. Mayer and Pierson, a French company, was selling photographs of British prime minister Lord Palmerston and Count Cavour, premier of the Kingdom of Sardinia, both of whom were involved in the unification of Italy. The company applied for copyright of the photographs so they couldn't be reproduced and sold by other retailers. The court initially ruled against Mayer and Pierson, but decided on appeal that a photograph was a work of art and not a factual statement. Legally, facts can't be copyrighted, but their literary or artistic expression can. This decision brought a petition of painters, but to no avail. In November 1862, photography was officially designated art.

Contemporary artists like Delacroix and Degas used photography to help them paint. It was also established as a medium of art in its own right. Although photographs can be manipulated and the prints tampered with, the subject remains central—a photograph is usually *of* something in a literal sense. In 1956, Walker Evans noted which subjects did not, in his opinion, constitute valid photography. No models or celebrities for him:

> "It is not the image of Secretary Dulles descending from a plane. It is not cute cats, nor touchdowns, nor nudes; motherhood; arrangements of manufacturer's products. Under no circumstances is it anything anywhere near a beach. In short it is not a lie—a cliché—somebody else's idea. It is prime vision combined with quality of feeling, no less."

> "I never know in advance precisely what I will photograph. I go out into the world and hope I will come across something that imperatively interests me. I am addicted to the found

object. I have no doubt that I will continue to make photographs till my last breath." —Ansel Adams

"I have had the experience which is a healthy part of every artist's growth: The more you do, the more you realize how much there is to do, what a vast subject the metropolis is and how the work of photographing it could go on forever." —Berenice Abbott

What an artist chooses to represent or work from is one of the factors that makes every individual's art distinctive and original. It can help if you have a good story to tell. Or if you have genuinely original ideas. The themes and concepts ideas an artist works with will often recur, even across long periods in time as in the remarkable career of Marcel Duchamp, a truly original creative mind, whose last work, *Etants donnés* put together in secret over many years and revealed in 1969 referred back to pieces Duchamp had made before World War I.

The career of the painter Philip Guston (1913–1980) was marked by extraordinary shifts in style that covered many of the major movements of the twentieth century. After beginning figuratively, Guston became a leading abstract painter only to abruptly give up abstraction, saying it was a lie and a sham. ("Anything but this," he said.)

"[Guston] began to draw and paint a repentant catalogue of all the mundane objects that had been excluded from his art the past quarter century: old shoes, rusted nails, mended

rags, brick walls, cigarette butts, empty windows, naked light bulbs, wooden floors, faces with day-old stubble." —Kirk Varnedoe and Adam Gopnik

Among the figures that Guston began to paint were hooded Klansmen, some painting pictures as they smoked cigars. Guston had also painted Klansmen in the 1930s in pictures with clear political overtones. In 1978, Guston talked about a drawing for a Klan picture, *The Conspirators*, that he had made in 1930:

> "I discovered it about five years ago in a drawer, in a package of old drawings. It's a sketch for one of the early Klan paintings, though the later Klan paintings are totally different. So one never forgets anything, one never goes forward and forward, you are always moving in a circular way, and nothing is ever finished, nothing is ever finished until you leave."

This notion that a picture is never finished recurs. (See Arshile Gorky, page 184). What is interesting here is a comment made by Harry Cooper, who curated an exhibition of Guston's work. Talking about the 1930 study, he says, "In fact, insofar as it is a self-portrait, it is *totally the same* as the later Klan paintings."

> "I think a man spends his whole lifetime painting one picture or working on one piece of sculpture." —Barnett Newman (1905–1970)

DWM

> "I was always outraged by the bias that I experienced
> as a woman artist. The bias was not up front where you
> could get ahold of it. It was behind my back."
>
> —Lee Krasner

> "The chief obstacle to a woman's success is that she can never
> have a wife. Just reflect what a wife does for an artist."
>
> —Anna Massey Lea Merritt[2]

In January 1971, Linda Nochlin published an essay in *ART-news* entitled "Why Have There Been No Great Woman Artists?" Her contention was that there have been "no women equivalents for Michelangelo or Rembrandt, Delacroix or Cézanne, Picasso or Matisse, or even, in very recent times, for

[2] Merritt (1844–1930) says she "Darns the stockings; Keeps his house; Writes his letters; Visits for his benefit; Wards off intruders; Is personally suggestive of beautiful pictures; Is always an encouraging and partial critic. . . . It is exceedingly difficult to be an artist without this time-saving help. A husband would be quite useless."

de Kooning or Warhol, any more than there are black American equivalents for the same." There is no innate reason why this should be so, she says. It is because of the lack of opportunity:

> "But in actuality, as we all know, things as they are and as they have been, in the arts as in a hundred other areas, are stultifying, oppressive, and discouraging to all those, women among them, who did not have the good fortune to be born white, preferably middle class and, above all, male. The fault lies not in our stars, our hormones, our menstrual cycles, or our empty internal spaces, but in our institutions and our education—education understood to include everything that happens to us from the moment we enter this world of meaningful symbols, signs, and signals. The miracle is, in fact, that given the overwhelming odds against women, or blacks, that so many of both have managed to achieve so much sheer excellence, in those bailiwicks of white masculine prerogative like science, politics, or the arts."

It is not the case, Nochlin argues, that great artists are discovered like golden nuggets so much as they are a product of a specific set of social conditions. Women and minorities in the arts in the West were afforded only peripheral roles, most often as models:

> "When in the early 1860s a well-connected, exuberant, middle-aged Englishwoman named Julia Margaret Cameron took up the camera as a vocation, she usually photographed men differently than she photographed women. The men, who included some of the most eminent poets, sages, and sci-

entists of the Victorian era, were posed for their portraits. The women—somebody's wife, daughter, sister, niece—served mostly as models for 'fancy subjects' (Cameron's label). Women were used to personify ideals of womanliness drawn from literature or mythology: the vulnerability and pathos of Ophelia; the tenderness of Madonna with Child. Almost all the sitters were relatives and friends—or her parlormaid, who, suitably reclothed, incarnated several exalted icons of femininity. Only Jackson, Cameron's niece (and the future mother of the future Virginia Woolf), was, in homage to her exceptional beauty, never posed as anyone but herself." —Susan Sontag

"Gender has mattered in the history of art. Renoir allegedly and notoriously said, 'I paint with my prick.' Museum walls are dominated by female and not male nudes, done by male and not female painters." —Cynthia Freeland

"To be naked is to be oneself.
 "To be nude is to be seen naked by others and yet not recognized for oneself. A naked body has to be seen as an object to become a nude." —John Berger

"And his ambivalence toward women informs virtually every aspect of this painting [Les Demoiselles d'Avignon], from its nominal subject to its conflict between styles. In this painting he compounds and attempts to exorcize a number of deep-seated fears that he associated with women and with sex—fear of being completely possessed by love, of venereal disease, of castration, and of death." —Jack Flam

If not a model, a woman might be male artist's muse, like Dalí's wife, Gala:

> "Perhaps more (or more consciously) than any artists before him, Dalí wanted to become famous. And his muse, Gala, ever attuned to celebrity and image, combined the muse's traditional functions (inspirer, facilitator, lover, mother, accountant, nurse) with the newly required skills of a spin doctor and an impresario who gave Dalí the confidence to successfully market himself as a personality." —Francine Prose

> "Surrealist art and poetry are addressed to men; women are only means to bring about these works. Woman is seen by the male Surrealists only in terms of what she can do for them. She is their muse—who also happens to know how to type, as in Man Ray's photograph of 1924 entitled *Waking Dream Séance*." —Rudolf E. Kuenzli

> "I know I have a talent for painting but I've never had any instructions except when I was at school, and that was useless. I've asked Pablo, but he refuses to give me any advice." —Fernande Olivier (1881–1966)

In fact, women could only receive artistic training in the late nineteenth century. In France, for example, women were only admitted to the major art schools in 1897, two years before the painter Rosa Bonheur (1822–1899) died. Bonheur often painted animal subjects and when she went to see racehorses, or visit an abattoir, she dressed as a man, a practice she had a permit for, issued by the local police. Bonheur was a contemporary of Berthe Morisot. Berthe learned painting

Unless a woman, or anyone else for that matter, was from a privileged background, a career in art was almost unthinkable until the twentieth century, and even then it was a hard row to hoe. The pioneering painter Artemisia Gentileschi (1593—1652) was the daughter of a painter who trained her and introduced her to Michelangelo and Caravaggio.

> "That there are fewer women artists who rank as outstanding reflects the smaller number of practicing female artists in any specific epoch rather than an innately inferior creative capacity in women." —Wendy Slatkin

alongside her sister Edma. They were both taught by Corot. Edma exhibited at four Salons in the mid-1860s and was praised, along with Berthe, by Zola. But in 1868, Edma married a naval officer and gave up painting.

Women artists were also treated differently than their male counterparts:

> "The identification of a woman artist's creativity with the innate and powerful generative forces place women's productions outside the mediated sphere of male cultural activity. Men study and think; women feel and generate instinctively. In the Western polarizing of mind and body, men are rewarded for being intellectual and theoretical, women for being intuitive and procreational. Constructions such as

these reinforce powerful and widely held cultural beliefs that women and their actions are inexplicable and unknowable, and they are widely internalized.

" 'My life was more physical,' Sonia [Delaunay] would later explain. 'He [Robert] would think a lot while I would always be painting. We agreed in many ways, but there was a fundamental difference. His attitude was more scientific than mine when it came to pure painting, because he would search for a justification of theories.' " —Whitney Chadwick

Linda Nochlin: "So you didn't feel any difference?"
Joan Mitchell: "Well, about what?"
Nochlin: "I mean, if you'd been a man painter?"
Mitchell: "I would have had a lot easier time."

"I was talking to Joan Mitchell at a party ten years ago when a man came up to us and said, 'What do you women artists think . . . ?' Joan grabbed my arm and said, 'Elaine, let's get the hell out of here.' " —Elaine de Kooning

The idea that women have had a hard time being accepted as artists is not a universally accepted view. In 1936, Meret Oppenheim (1913–1985) created the fur-covered saucer and spoon that Tom Wolfe mentions in the chapter on taste. She was heavily involved in surrealism, the same movement that was criticized earlier for its misogyny. In 1984, Oppenheim told an interviewer:

"There is no difference between man and woman; there is only artist or poet. Sex plays no role whatsoever. That's why I refuse to participate in exhibitions of women only."

But, also in 1984:

> "[W]omen once again picketed the Museum of Modern Art, New York, protesting against the inaugural exhibition of its remodeled galleries ('An International Survey of Recent Painting and Sculpture') in which, out of 165 artists, only 14 were women. The Guerilla Girls, an anonymous group of women artists, began installing posters on the buildings of Manhattan's Soho district which graphically and statistically documented sexism and racism in New York galleries and museums." —Whitney Chadwick

The campaign continues. In 2003, two Guerrilla Girls, wearing gorilla masks and calling themselves "Frida Kahlo" and "Kathe Kollwitz" (after the Mexican and German artists, respectively) spoke with the Associated Press in New York:

> "All of our research has shown that culture, which so many people see as avant-garde, has always lagged behind in other fields of society in terms of women and people of color. . . .
> "After all, if 50% of the artists graduating from major art schools are women and only 10% of the artists shown at a certain museum are women, then what happened? Why did they fall through the cracks?" —"Kathe Kollwitz"

So has anything changed since 1971? Art has reflected changes in society that have taken place over that time. There surely are more opportunities for nonwhite, nonmale artists. The canon of Western art through the end of World War II or through man-centered abstract expressionism will remain dominated by the DWM (dead white males). Most artists do

not set out on a career in art trying to become great; their ambition is to make art and the Western playing field, if not even, has certainly leveled out some.

> "By the '80s it was pleasantly routine for women to make art and for people to look at it—even to watch for it. There have been female artists for centuries, but courtesy of the women's movement, '80s women were encouraged and able to thrive. We finally passed the time of the single extraordinary woman, like Georgia O'Keeffe. The moment came when a number of us were active and visible." —Jenny Holzer

In March 2003, *ARTnews* published "Who Are the Great Women Artists?" asking if progress had been made since Linda Nochlin's essay in the same pages more than thirty years previously. Marla Prather, a curator of postwar art at the Whitney Museum of American Art, asked, "Do women here in New York have the same kind of access that men do? It's hard to argue that they don't." But male artists lead in terms of acquisitions, exhibitions, and auction prices. Nancy Spector, a curator of contemporary art at the Guggenheim Museum in New York, says:

> "On the whole, women's presence in the art world is much healthier than it was 30 years ago. I don't know whether resuscitating people like Berthe Morisot matters as much as showing artists like Cindy Sherman, Barbara Kruger, Louise Lawler, and Adrian Piper, who have done breakthrough work. There are so many excellent women who have risen to the top."

The article concludes that "[o]n the contemporary front, conditions seem to have evolved to the point where a worthy woman artist has as much access as a man." According to Laura Hoptman, a curator of contemporary art at the Carnegie Museum of Art in Pittsburgh, it is:

> "Provable in museum exhibitions, acquisitions, and also in the publishing record of contemporary art—that is, the monographs that are generated by women and about women. Those are conventional temperature-taking devices, empirical statistics that you can check."

THE WORKS

◎ ◎ ◎

In this chapter, the focus is turned from the artist to individual works of art and what the artist has to say about the act of creation. This doesn't necessarily mean the artist is explaining what the picture is "about," but what he was thinking about or what was intended when the piece was made. (Monet, for example, said that what he was after with his *Haystacks* was "instantaneity," which might have less to do with a literal meaning than with technical intent.) As the chapter on artistic intention demonstrates, if you've created something, you can only answer for your part in the process—what you put in. What others choose to take out is up to them.

"The most famous example of [Édouard] Manet's contrariness is, of course, *Dejeuner* [*sur l'Herbe*]: two women—one completely naked, the other nearly so—and two clothed men, occupying the foreground of a sketchily painted Arcadia landscape. We have been taught to see its allusions (here a homage to [sixteenth-century Italian painter] Giorgione, there a quotation from [Italian engraver] Marcantonio Raimondi), but what infuriated the audience at the Salon des Refusés in 1863, and has caused so many gallons of ink to be spilled on it since, is its insolubility as narrative. An 'uncouth riddle,' one critic called it. What are those people doing? One modernist answer is that they are busy being in a painting."
—Robert Hughes

This point can stand for any work of art. You don't have to *justify* what you are doing. But if you want to, you can offer an explanation. Frida Kahlo painted only two pictures in 1935, the year after she found out that her partner, Diego Rivera, was having an affair with Kahlo's own sister. One of the pictures was called *A Few Small Nips* and was modeled on the work of Mexican printmaker Jose Guadalupe Posada, who made etchings inspired by newspaper stories. Kahlo's picture is informed by a murder case in which a man who killed his girlfriend told the judge, "I only gave her a few small nips." Kahlo said she felt "[m]urdered by life."

James Rosenquist made a series of four paintings, including *The Meteor Hits Brancusi's Pillow* and *The Meteor Hits Picasso's Bed*. The paintings draw on a childhood memory from Rosenquist's time in Minnesota when a woman in his neighborhood was injured in her own bed by a falling meteorite and they meld the memory together with representa-

tions of great works of art. In addition to Brancusi, Monet, and Picasso, Rosenquist includes the figure of the Swimmer who represents the artist:

"Rosenquist did not employ the meteor as an obvious metaphor for the source of creative inspiration for these artists; rather it is a meditation on the day to day 'questions of existence' and the unexpected events that drastically change the course of one's life." —Sarah Bancroft

Martin Puryear created a piece he came to call *Ladder for Booker T. Washington,* which is recognizable as a ladder, albeit a curved and twisted one. Puryear did not start out trying to make a ladder for Booker T. Washington:

"The title came after the work was finished, first of all. I didn't set out to make a work about Booker T. Washington. The title was very much a second stage in the whole evolution of the work. The work was really about using the sapling, using the tree. And making a work that had a kind of artificial perspective, a forced perspective, an exaggerated perspective that made it appear to recede into space faster than in fact it does.

"I mentioned about the perspective being really what the work is about. And the idea of Booker T. Washington, the resonance with his life, and his struggle . . . the whole notion that his idea of progress for the race was a long slow progression of, as he said, 'Putting your buckets down where you are and working with what you've got.'

"The joining of that idea of Booker T. Washington and his notion of progress and the form of that piece—that came

after the fact. But when I thought about a title for it, it just seemed absolutely fitting."

"Funny things get to me. Here it was that odd, slightly reddish cast of those Bermuda onions on the dry, brown barn floor that caught my attention, and I felt I had to capture the feeling. Strange feeling, too." —Andrew Wyeth on *Onions* (1955)

"In the woman I attempted to get the broad, strong-jawed face and blond hair of a Finnish type of which there are many on the Cape. The man is a dark-haired Yankee. The dog is listening to something, probably a whippoorwill or some evening sound." —Edward Hopper on *Cape Cod Evening* (1939)

"*The Portrait of Gertrude Stein* obsessed [Picasso] for months. Stein submitted to eighty or ninety sittings in the winter and spring of 1905–06, but before Picasso went away on vacation to Gosol, in the Pyrenees, he became dissatisfied with the head and painted it out. When he came back to Pairs in the fall, he finished the painting without asking Stein to sit again. The masklike, 'Iberian' face is truer than any likeness. ('We all know that art is not truth,' Picasso said in 1923. 'Art is a lie that makes us realize truth.') As Stein once wrote, the portrait 'is the only reproduction of me which is always I, for me.' " —Calvin Tomkins

After Winslow Homer (1836–1910) finished *The Gulf Stream*, he had difficulty selling it. The painting was exhibited in Pittsburgh, where it was available for $4,000, but no one bought it. *The Gulf Stream* was sent to Venice, where it was shown, and later, Homer sent it to the Worcester Art Museum

for possible sale. The trustees claimed that they didn't understand it and Homer was asked for an explanation. The painter grudgingly provided his agent with some information:

> "You ask me for a full description of my Picture of the Gulf Stream—I regret very much that I have painted a picture that requires any description—The subject of this picture is comprised in *its title*. . . .
>
> "I have crossed the Gulf Stream *ten* times & I should know something about it. The boat & shark are outside matters of little consequence. *They have been blown out to sea by a hurricane.* You can tell these ladies that the unfortunate negro who is now so dazed and parboiled, will be rescued & returned to his home, & ever after live happily."

The Gulf Stream remained unsold until the Metropolitan Museum of Art bought it in 1906.

Leonardo da Vinci's *Mona Lisa,* all thirty by twenty-one inches of it, was painted in the first few years of the sixteenth century and is probably the most famous work of art in the world. Fifty years after the picture was finished, Giorgio Vasari wrote at length about a painting whose renown has only multiplied:

> "For Francesco de Giocondo Leonardo undertook the portrait of Mona Lisa, his wife, and left it incomplete after working on it for four years. This work is now in the possession of Francis, King of France, at Fontainebleau. This head is an extraordinary example of how art can imitate Nature because here we have all the details painted with great subtlety. The eyes possess that most luster which is constantly

seen in life, and about them are those livid reds and hair which cannot be rendered without the utmost delicacy. The lids could not be more natural, for the way in which the hairs issue from the skin, here thick and there scanty, and following the pores of the skin. The nose possesses the fine delicate reddish apertures seen in life. The opening of the mouth with its red ends, and the scarlet cheeks seem not color but living flesh. To look closely at her throat you might imagine that the pulse was beating. Indeed, we may say that this was painted in a manner to cause the boldest artists to despair. Mona Lisa was very beautiful, and while Leonardo was drawing her portrait, he engaged people to play and sing, and jesters to keep her merry, and remove that melancholy which painting usually gives to portraits. This figure of Leonardo's has such a pleasant smile that it seemed rather divine than human, and was considered marvelous, an exact copy of Nature."

The *Mona Lisa* has suffered a few indignities in its 500 years. For one, it was stolen in 1911 and remained lost for more than two years until the thief tried to sell the picture to the Uffuzi gallery in Florence. Then, in 1919, Marcel Duchamp drew a mustache and a goatee on a reproduction of the *Mona Lisa* and wrote *L.H.O.O.Q.* on it. When these letters are read out loud in French, they stand for a sentence that means something along the lines of, "She has a hot ass."

Marcel Duchamp's artistic career was brilliant and also enigmatic. What he says about his art may or may not be illuminating. Witness what he says about his glass masterpiece *The Bride Stripped Bare by Her Bachelors, Even:*

Q: "You called 'The Bride' a 'delay in glass.' "

A: "Yes. It was the poetic aspect of the words that I liked. I wanted to give 'delay' a poetic sense that I couldn't even explain. It was to avoid saying, 'a glass painting,' 'a glass drawing,' 'a thing drawn on glass,' you understand? The word 'delay' pleased me at that point, like a phrase one discovers. It was really poetic, in the most Mallarméan sense of the word, so to speak.

"Titles in general interest me a lot. At that time, I was becoming literary. Words interested me; and the bringing together of words to which I added a comma and 'even,' an adverb which makes no sense, since it relates to nothing in the picture or title. Thus it was an adverb in the most beautiful demonstration of adverbness. It has no meaning.

"This 'antisense' interested me a lot on the poetic level, from the point of view of the sentence. [André] Breton was very pleased with it, and for me this was a sort of consecration. In fact, when I did it, I had no idea of its value. In English, too, 'even' is an absolute adverb; it has no sense. All the more possibility of stripping bare. It's a 'non-sense.' "

"When Marcel Duchamp produced the work called *The Bride Stripped Bare by Her Bachelors, Even,* he contrived an art form without parallel, a unique marriage of visual and linguistic concepts. It was his intention that the *Large Glass* should embody the realization of a written text which had assisted the generation of plastic ideas and which also carried layers of meaning beyond the scope of pictorial expression. The text exists beside the glass as a commentary and within it as a literary component of its structure. Without the notes the painting loses some of its significance and with-

out the monumental presence of the glass the notes have an air of random irrelevance." —Richard Hamilton

René Magritte is the master of playful, or misdirecting, titles, including the famous *La trahison des images* (*The Treachery of Images*), which is a picture of a pipe beneath which Magritte painted the phrase "Ceci n'est pas une pipe" ("This is not a pipe")—providing careers-worth of material for semioticians.

Magritte displays his keen sense of humor in discussing his picture *L'éternité*. Claude Spaak, Magritte's friend, was a novelist, playwright, and head of the art department at the Palais des Beaux-Arts in Brussels who provided ideas for the painter. Spaak suggested Magritte paint something showing a ham hung as a museum exhibit between a couple of pictures:

"Magritte started out with a variation on the theme which is recorded in a letter he wrote to Paul Eluard in December 1935: 'I am busy at the moment on a rather amusing picture: in a museum there are three stands against a wall, with statues of Dante and Hercules on the left and right while the one in the center holds a magnificent pig's head with parsley in its ears and a lemon in its mouth.' By the time the painting was finished Hercules had been turned into Christ and the pig's head into a mound of butter."
—Sarah Whitfield

Magritte's *L'empire des lumières* shows in its upper half a blue sky across which scoot light clouds beneath which is a scene of a street at night with houses illuminated by a street lamp:

Works of art often have titles that seem to fit precisely this phrase of Richard Hamilton's, "Random irrelevance." Hamilton is author of one of the great titles: *Just What Is It That Makes Today's Home So Different, So Appealing?* (1956). Helpfully, Hamilton provides the following "List of interests":

Man
Woman
Humanity
History
Food
Newspapers
Cinema
TV
Telephone
Comics (picture information)
Words (textual information)
Tape recording (aural information)
Cars
Domestic appliances
Space

On the other hand, Lucian Freud says, "The only point of titles on the whole is to distinguish one painting from another."

"I got the *idea* that night and day exist together, that they are one. This is reasonable, or at the very least it's in keeping with our knowledge: in the world, night always exists at the same time as day. (Just as sadness always exists in some people as happiness in others.) But such ideas are not poetic. What *is* poetic is the visible image of the picture."

When Robert Smithson built his *Spiral Jetty* in 1970, the 1,500-foot-long earthwork of black rocks stood in salt water stained pink by algae and bacteria in the Great Salt Lake in Utah. When *Spiral Jetty* was made, the lake was unusually low and the piece was soon engulfed. But it has slowly reemerged in the last few years over the course of long-term drought conditions in the West. As *Spiral Jetty* became visible again, the *New York Times* talked to Bob Philips, the contractor who had helped Smithson lay the rocks on the lake bed more than thirty years before. (Smithson himself died in a plane crash in 1973.)

Spiral Jetty is made up of 6,650 tons of rock and earth that Philips moved. At first, Philips wondered what the artist was up to. "Man, his ideas sounded really strange," he said. But Philips came to realize that Smithson knew exactly what he wanted to do. "He would raise each rock up and roll it around, then he would move this one, change that one until it looked exactly right. He wanted it to look like it was a growing, living thing, coming out of the center of the earth."

"The galactic metaphor was obvious. Smithson admired the science fiction of J.G. Ballard. The red water vaguely evokes a Martian sea. Smithson wrote that the jetty jutting from the shore was 'the edge of the sun, a boiling curve, an explosion rising into a fiery prominence.'" —Michael Kimmelman

Living through the Peninsula War (1808–1814) inspired Goya to create a series of eighty etchings called *Disasters of War*. They include incidents from Spain's war against Napoléon, scenes of a famine that ravaged Madrid from 1811 to 1812, and more allegorical images. The *Disasters* represents, in the words of Robert Hughes, "The greatest anti-war manifesto in the history of art."

> **"He was the first painter in history to set forth the sober truth about human conflict: that it kills, and kills again, and that its killing obeys urges embedded at least as deeply in the human psyche as any impulse toward pity, fraternity, or mercy."**

The images are startling and explicit and the etchings weren't printed until 1863, thirty-five years after the artist's death. Enter contemporary British artists Jake and Dinos Chapman, who purchased a very rare, mint-condition set of prints of Goya's *Disasters* made directly from Goya's plates. The Chapmans had used *Disasters of War* in their work before, having made three-dimensional representations of the images. Now, having bought the prints and looking at them for a while, the brothers set about drawing on them:

> **"We always had the intention of rectifying it, to take that nice word from *The Shining*, when the butler's trying to encourage Jack Nicholson to kill his family—to rectify the situation."** —Jake Chapman

> **"So we've gone very systematically through the entire 80 etchings and changed all the visible victims' heads to clowns' heads and puppies' heads."** —Dinos Chapman

The brothers called the "rectified" Goyas *Insult to Injury* and showed them in an exhibition called "The Rape of Creativity." As the exhibition opened, the brothers were nominated for Britain's prestigious Turner Prize. Speaking the day after the nomination at the site of the exhibition in Oxford, a Spanish protestor threw a jar of red paint in Jake Chapman's face.

Jasper Johns' *Flag* was an instant classic. By 1958, it was already installed in the Museum of Modern Art in New York. In 1954, Johns had destroyed all his art, and *Flag* was one of the first paintings he made once he rededicated himself to his work. The idea for *Flag* came to him in a dream:

> "One night I dreamed I painted a large American flag, and the next morning I got up and I went out and bought the materials to begin it. And I did. I worked on that painting a long time. It's a very rotten painting—physically rotten—because I began it in house enamel paint, which you paint furniture with, and it wouldn't dry quickly enough. Then I had in my head this idea of something I had read or heard about: wax encaustic."

Wax encaustic is a quick-drying suspension that helped Johns facilitate his dream. As much as it is revered today as a patriotic icon, *Flag* is outdated. Because Alaska and Hawaii didn't become states until 1959, *Flag* only has forty-eight stars.

THE ARTIST'S EYE

"Seeing comes before words. The child looks and
recognizes before it can speak."
—John Berger

"The art of seeing nature is a thing almost as much to be
acquired as the art of reading the Egyptian hieroglyphics."
—John Constable (1776–1837)

John Berger's words quoted above are the first line in his
book *Ways of Seeing*. The book is based on a television
series and it is by no means long, but it is densely packed with
provocative ideas about art. The first chapter discusses how
the mass reproduction of images means that a piece of art is
no longer a unique image. Duplicated over and over, it can
now be seen in countless different contexts that have little to
do with the original. This means a painting's main attribute
now is the source of the reproductions. When we stand before
an original painting, we're looking at the painter's actual
materials and we can see the texture of the paint as it was left

after he applied it. There is, Berger says, a closing of the distance in time between the painting of the picture and our looking at it. "Their historical moment is literally there before our eyes." Berger's main subject here is the viewer and the idea of the reproduced image, but his phrase "ways of seeing" includes the artist. When we stand before that painting, or any work of art, we are seeing a vision of the artist's eyes, brought to life:

> "Every image embodies a way of seeing. Even a photograph. For photographs are not, as is often assumed, a mechanical record. Every time we look at a photograph, we are aware, however slightly, of the photographer selecting that sight from an infinity of possible other sights."

How does the artist visualize art, both in terms of the way the art and any source are seen? In the chapter on inspiration, some artists described their ideas about nature and how they transferred what they saw to the canvas. It was noted that deliberate manipulation of the image became more prominent until the artist's idea itself was paramount.

> "The invention of the camera changed the way men saw. The visible came to mean something different to them. This was immediately reflected in painting.
>
> "For the Impressionists the visible no longer presented itself to man in order to be seen. On the contrary, the visible, in continual flux, became fugitive. For the Cubists the visible was no longer what confronted the single eye but the totality of possible views taken from points all round the object (or person) being depicted." —John Berger

"Up to the present, painting has been nothing but photography in color, but the color was always used as a means of describing something. Abstract art is a beginning toward freeing the old pictorial formula. But the real painting will begin when people understand that color has a life of its own, that the infinite combinations of color have a poetry and a language much more expressive than the old methods."
—Sonia Delaunay (1885–1979)

Sonia Delaunay made this statement in 1949. Although he worked sixty years before, van Gogh's use of color, as he himself describes it, deliberately distorts reality and achieves what Delaunay describes:

"You must boldly exaggerate the effects of either harmony or discord which colors produce. It is the same as in drawing—accurate drawing, accurate color, is perhaps not the essential thing to aim at, because the reflection of reality in a mirror, if it could be caught, color and all, would not be a picture at all, no more than a photograph."

"In the South of France, will you see van Gogh's color? I think that what van Gogh saw in the South of France and what [Georgia] O'Keeffe saw in the Southwest of America triggered this exaggeration. But this exaggeration is part of what makes art. When someone told Turner he had never seen a sunset as beautiful as the artist's paintings, Turner replies, 'Don't you wish you had?' " —Beaumont Newhall

Here, the artist's eye, as it discerns and, perhaps, exaggerates, will be examined in more detail. The first question is: Is

there something different about an artist's eye, his "way of see-ing" that predisposes him to an interest in art?

> **"If the great artist's way of seeing is quite different from that of the ordinary man, the reason is that his faculty of sight has been educated, from its earliest days, by paintings and statues; by the world of art."** —André Malraux

> **"My form of expression is painting; there are, of course, other means to this end, such as literature, philosophy, or music; but as a painter, cursed or blessed with a terrible and vital sensuousness, I must look for wisdom with my eyes."** —Max Beckmann (1884–1950)

A nonartist looking at an object will notice particular details. She can be strongly taken with what she sees—delighted or frightened, horrified or amused. An artist look-ing at that object will bring her artist's eyes to bear. She might have a similar reaction as her nonartist friend, but the differ-ence is that she might then go on to assimilate that vision and create art from it. This is what Max Beckmann calls "the vis-ible world in connection with our inner selves," or what we see plus what we feel:

> **"The important thing is first of all to have a real love of the visible world that lies outside ourselves as well as to know the deep secret of what goes on within ourselves. For the visible world in combination with our inner selves provides the realm where we may seek infinitely for the individuality of our own souls. In the best art this search has always existed."**

"Making an object look like what you see is not as important as making the whole square you paint it on feel like what you feel about the object." —Georgia O'Keeffe (1887–1986)

"The people who touch me are poets, because poets, like sculptors, work with images, they do not theorize or philosophize, they create, they visualize images just like a sculptor does." —Louise Bourgeois

"We've been told that's an orange. So we call it an orange. *We've been told* that's an apple. So we call it an apple. But you and I look at those things and we see different objects— with the same name. I paint them in a still life and I set them down in what my intellect tells me is the order and form in which they appear to me. It's a constructive process from beginning to end. No, I'm no anarchist. I believe in total liberty, yes, but subject to an inner order, control—and laws." —Pablo Picasso

In *American Visions*, Robert Hughes relates how American painter Arthur Dove (1880–1946) would distil his vision of a landscape, first painting the object from nature, then having the object fade, a perfect example of the adapted role of the educated artist's eye:

"After working for some time in this way, I no longer observed in the old way, and not only began to think subjectively but also to remember certain sensations purely through their form and color, that is, by certain shapes, planes of light, or character lines determined by the meeting of such planes."

None of this is to say, of course, that artists of previous centuries did not utilize their own acute visual sense. Witness the following three statements about Rembrandt's portraits, including one by the great sculptor Jacob Epstein. These writers are not just saying that Rembrandt painted his subjects differently, but that he looked at them differently as well. It is worth bearing in mind that portraiture is not the same as painting from natural scenes, but the ideas in these quotes are familiar. In the first instance, Kenneth Clark is talking about Rembrandt's *Portrait of Margarethe de Geer, Wife of Jacob Trip:*

> "The human element is essential to a masterpiece. The artist must be deeply involved in the understanding of his fellow men. We can say that certain portraits are masterpieces because in them a human body is recreated and presented to us as an embodiment, almost a symbol, of all that we might ever find in the depths of our hearts. In this field Rembrandt is unique. Through him we commune with our own kind in a way that we would never have done without his penetrating eye. Do we know any living person as well as we know Mrs. Trip?"

> "Though it's difficult to avoid the impression that no painter of his century looked at the human face harder, longer, or more observantly than Rembrandt, his painstaking face-mapping was never done in a spirit of physiognomic pedantry. Though his heads and bodies are rendered with utterly convincing—that is, they seem in some undeniable sense to have the look of vital *truth*—they are seldom described literally, by sharp-edged lines and contours. On the contrary,

only Frans Hals approached the freedom and versatility of Rembrandt's brushwork; in some places applied in short, dashing, dabbed marks, in others with long, fluent arabesque curves. What he was after, of course, was not some sort of additively built-up delineation, a composite of physical features as in a police profile, but rather a decisive illumination." —Simon Schama

"We observe that [Franz Hals's] outlook on humanity is cold and detached, he observes his models without any emotions, and never warms to them. He seemed unfortunate in his sitters; as human beings they evidently aroused in him no feeling of sympathy, and he turned to their clothes with greater pleasure than he got from their faces. He obviously enjoyed his own technique and reveled in his marvelous skill.

"With Rembrandt the opposite seems the case. His great heart seemed to warm towards the men and women who sat for him, and he seemed to penetrate into their inner selves, and reveal their very souls—in children their lively joy, and in grown-ups the burden of living, their sorrow and their disappointments. There is a great wisdom in him, and his people look out of his canvases, human beings whose trades and businesses you cannot tell, but they have deep human thoughts; they are not just tradesmen and shrews as in Hals. A beggar in the hands of Rembrandt is some ancient philosopher, a Diogenes content in his tub; a manservant in a borrowed cloak becomes a King of the East with splendour wreathing him round. So are the portraits of Goya. His men are witty, cynical, brutal, and his women lovely, gallant, and lecherous." —Jacob Epstein

Caravaggio's biographer Peter Robb makes a similar distinction for his subject whom he calls "M." (The painter's name was usually given as Michelangelo Merisi and he signed his own name Marisi. He was also given other names, including that of the town he lived in for part of his childhood, Caravaggio.) The way of seeing, then, is part of the painter's artistic personality:

"The paintings are M's great secret. They still have, for a lot of people, the peculiar inaccessibility of the wide open. They delight and disconcert by seeming, like certain works of Tolstoy and Chekhov, to have nothing to do with art at all. They seem to go straight to shocking and delightful life itself, unmediated by any shaping intelligence. The appearance, of course, misleads. In a time when art was a prisoner first of ideas and then of ideology, M undertook a singlehanded and singleminded exploration of what it was to see the reality of things and people. He did it with a rigor that, like the work of Leonardo a hundred years before him, meant as much to the origins of modern science as it did to modern art—more so in a way, since what Leonardo wrote about in art only became real in M's hands. M rendered the optics of the way we see so truly that four hundred years later his newly cleaned paintings startle like brilliant photos of another age. These images came out of an attention to the real that ignored the careful geometrics of renaissance art as scrupulously as it excluded the dogmas of religion. No other painter ever caught a living bodily presence as M did."

"We cannot conceive a Philip IV in any other way than the one Velázquez painted, Rubens also made a portrait of the

same king and in Rubens' portrait he seems to be quite another person." —Pablo Picasso

◎ ◎ ◎

The educated artist's eye, as discussed here, is clearly integral to the creative process, or the creative act, which is addressed in greater detail later in the book. To Giacometti, the reverse is also true: his art is crucial to his eye:

> "Why does one paint or sculpt? It's the need to dominate things, and one can only dominate by understanding. I make a head to understand how I see, not to make a work of art. One must understand through intuition what moves one, and arrive at domination through logic, not through science. Art is not a science."

In the act of creation, the artist's eye can operate twice—if there is an immediate source for the art, then the eye takes it in, and again when the art is created. Every artist will have a different opinion on creation as it relates to observation and the opinions can be contradictory and, apparently, mutually exclusive. This is not surprising because the eye is a mechanical device that is also decisive in the formation of an artist's sensibility.

> "I hold that painting is essentially a concrete art and does not consist of anything but the representation of real and concrete things." —Gustave Courbet (1819–1877)

John Canaday makes a point of distinguishing between Courbet's theory and his practice. Canaday strikes a cautionary

note that might stand for each statement in this book. Artists are artists before they are theoreticians. Canaday felt that Courbet's theories are "half formed," written with the help of friends, and never quite accorded with Courbet's own practice. After quoting the same statement given above, Canaday says it is:

> "A limitation that would have ruled out all classical history painting, all romantic invention, and most of the work of the old masters most admired by Courbet himself."

Courbet might say it doesn't matter if he is actually correct in an art historical sense, but that is how he feels. His quote will be taken under advisement.

> "My aim is to create new objects which cannot be compared with any object in reality." —Juan Gris (1887–1927)

> "I paint forms as I think them, not as I see them." —Pablo Picasso

> "Painting is a sensual art." —Salvador Dalí

> "One must not imitate what one wants to create." —Georges Braque

In a longer statement, Guillame Apollinaire (1880–1918) articulates Georges Braque's idea, which stands at a far remove from Courbet and from the quote of Thomas Eakins that follows:

> "[Braque] proceeds from a geometric a priori to which the entire field of his vision is submitted. . . . In front of his paint-

ings of women, people have cried in horror, 'Hideous! Monstrous!' . . . Where we think we are about to be confronted with a feminine figure because the catalogue says 'Large Nude,' the artist has seen only the geometric harmonies that, for him, express all nature. . . . No one is less concerned than he with psychology, and I think a stone would be as moving to him as a face. He has created a personal alphabet, in which each letter has universal acceptance."

"If a man makes a hot day he makes it like a hot day he once saw or is seeing; if a sweet face, a face he once saw or which he imagines from old memories or parts of memories and his knowledge, and he combines and combines, never creates—but at the very first combination no man, and least of all himself, could ever disentangle the feelings, that animated him just then, and refer to each one in its right place." —Thomas Eakins

The artist's eye is a particular way of looking at the world, even if there is little agreement among artists as to what that means. The way an artist looks and sees is certainly a more careful and considered process than it is for a nonartist. The eyes are the most important tools an artist possesses and how he uses them helps define how an artist goes about the creative act.

"Right after the Liberation, lots of GIs came to my studio in Paris. I would show them my work, and some of them understood and admired more than others. Almost all of them, though, before they left, would show me pictures of their wives or girl friends. One day one of them who had made

some kind of remark, as I showed him one of my paintings, about how 'It doesn't really look like that, though,' got to talking about *his* wife and he pulled out a tiny passport-size picture of her to show me. I said to him, 'But she's so tiny, your wife. I didn't realize from what you said that she was so small.' He looked at me very seriously. 'Oh, she's not really so small,' he said. 'It's just that this is a very small photograph.' "
—Pablo Picasso

"If only someone else could paint what I see it would be marvelous, because then I could stop painting for good." —Alberto Giacometti

INTENTION

"The significance of the work is in its effort not in its intentions. And the effort is a state of mind, an activity, an interaction with the world."
—Richard Serra

James Lord: "In some of your sculptures and paintings I find a great deal of feeling."
Alberto Giacometti: "You may find it but I didn't put it there. It's completely in spite of me."

If you look at a work of art, are you anxious to understand it, to figure out what it means? The same questions apply if you are making a work of art: do *you* understand it; do you know what it means? The artist is certainly under no obligation to explain what he is doing, even if he can. Meaning is not the responsibility of the artist. When asked, some artists will happily discuss their intentions, while others claim they have none, or say they don't know what they are. Each work of art is what it is, and beyond that any position artists care to take about what it means is valid.

The introduction to this book mentioned Roger Shattuck's

use of the idea of intentional fallacy as he related it to the French painter Henri Rousseau. Intentional fallacy, a literary theory devised by William K. Wimsatt and Monroe C. Beardsley, holds that meaning cannot be found in the author's articulated intentions but can only be gleaned by close, independent reading of the text. In the same way, if the idea is applied to art, then the art itself is an entity that must be judged in isolation from its creator.

> "[Rousseau] strove in his conscious thinking about art to achieve a naturalistic, academic style. He admired Bouguereau and Gérôme and Courtois. Twentieth-century Western art, however, the disgruntled offspring of a great naturalistic tradition culminating in impressionism, was seeking out the methods of primitives from Italy, Africa, and contemporary Paris. Like Picasso and Braque and Matisse and Delaunay, Rousseau worked not with the optical image (a rational transformation of what we see), but with his personal beholding of things. He stood beside them without having made the journey of styles which they had made in their development as artists. He is primitive in that, occupying the same ground as these men, he nevertheless looked yearningly toward a style they violently rejected." —Roger Shattuck

Rousseau's ambition may have been to be an artist who showed in official salons, but he fell short. "Rousseau was primitive in performance but not in intention."

Intentional fallacy is like a critical get-out-of-jail-free card because it seems to validate all critical approaches. Certainly, there can be a dissonance between what the critic says a paint-

ing or any other piece of art is "about" and what the artist intended. They can actually disagree about it.

In 1948, American artist Ben Shahn wrote the essay "The Biography of a Painting" after his painting *Allegory* was attacked in the *New York Sun* by Henry McBride, a man Shahn considered a friend. McBride wrote that Shahn's picture was communist inspired and that Shahn should be deported because of it. In response, Shahn wrote at length about the creation of the picture and what he was thinking about at the time. *Allegory* shows a huge chimera with flames sprouting around it, the beast's body lying across the figures of four children. Shahn says the immediate source for the picture was a fire in Chicago he read about in which a man had lost his four children. Remembering two fires from his childhood, he began work on these themes and put them together with mythological symbols. Shahn wrote that he wasn't looking to create an image of a disaster, rather, "the emotional tone that surrounds disaster; you might call it the inner disaster." Where the artist was seeing emotional tone, the critic saw the red menace.

Confusion may exist on a very basic level between artist and critic. Philip Guston went back to figurative painting from abstract art with an exhibition in 1970. Before the exhibition opened, Guston showed it to Tom Hess, editor of *Artnews*. Guston says:

> "He looked at this painting here, one with a piece of lumber with nails sticking out, and he said, 'What's that, a typewriter?' I said, 'For Christ's sake, Tom, if this were 11 feet of one color, with one band running down the end, you wouldn't ask me what it was.'"

Hess had previously written about Barnett Newman, who had painted eleven-foot pictures such as that described by Guston. Abstract artists, Guston is saying, don't get asked what's in their pictures.

> **"I once videotaped a neighbor of mine skinning a fox. He's a trapper and hunter and painter and jewelry maker, and skinning is part of life to him. But when the video was shown in New York, people took it as an antihunting or antitrapping statement."** —Bruce Nauman

In other cases, the artist may not have said specifically what she had in mind or what she was trying to "say." That might be because, at the time of creation, she had nothing in mind that could be articulated as a meaning about which the critic could write. Paint first; answer questions later (if you care to).

In the book accompanying the exhibition *Gerhard Richter: Forty Years of Painting* around the country, Robert Storr discusses this conundrum. Storr says that Richter was asked in an interview what function the subjects of his realist paintings had and Richter said "sympathy." The interviewer was taken aback, Storr says, and asked Richter about a painting of a chair. Richter said, "It is our chair, which we use. It is really pitiable and very banal, but it has a mood."

> **"I had very little interest in any critique of packaged culture or the consumer world."**

So, is there less here than meets the eye? In a footnote, Storr offers an explanation of any possible misunderstanding:

"In recent criticism, there has been a tendency to confuse the opportunity a work affords to open up legitimate questions about the social and political context surrounding that work with an unstated and undemonstrated intention to do so on the part of the artist. Thus, a writer might say that Andy Warhol's *Campbell's Soup Cans* critiques consumer society, or that his *Gold Marilyn* critiques the cult of celebrity, when there is, in fact, no evidence that Warhol thought in such terms. Moreover, such formulations beg the question of what ideological point of departure the artist might have had. Such assumptions implicitly co-opt the authority of the artist in support of interpretations that must stand or fall on the theoretical constructs of the writer or critic. . . .

"The gap between what [Richter] says about his work and the things critical theory suggests might be said about it does not disallow exploration of the latter but such criticism cannot proceed on the assumption that Richter, an anti-Marxist, with little interest in Freud or post-structuralist thought, has wittingly or unwittingly followed a program allied to such positions."

Rather than arguing like this for the validity of all positions, some artists will call for *less* understanding or meaning:

"When will the arbitrary be granted the place it deserves in the formation of works and ideas? What touches us is generally less intentional than we believe." —André Breton

"Whereas photography was simply a matter of calculation, obtaining what had been figured out beforehand, painting was an adventure in which some unknown force might suddenly change the whole aspect of things. The result could be as much

a surprise to myself as a spectator. The surprises produced by a badly regulated mechanical instrument have no value, but the aberrations of a brain that feels at the same time that it thinks are always interesting." —Man Ray (1890–1976)

"I don't paint pictures in the hope that people will understand them. They understand or not, according to their capacity." —Pablo Picasso

"In his early work, Pollock had made use of mythology, animal sexuality and ancient rituals; after 1948 he eliminated all conventional signs from his paintings. What Pollock created was a system of signs that he refused to imbue with message or meaning. The new style became known as Abstract Expressionism." —Alberto Manguel

A friend of J.M.W. Turner told the painter that his mother had liked Turner's *Snowstorm*. Indignantly, Turner replied:

"I did not paint it to be understood, but I wanted to show what such a scene was like: I got sailors to lash me to the mast to observe it; I was lashed for hours, and I did not expect to escape, but I felt bound to record it if I did. But no one had any business to like the picture."

Others are content to let the work speak for itself:

"I'm now satisfied to tell myself: 'You are a painter, do your job and let those who can, talk.' " —Max Beckmann

"We became less and less inclined to talk about the photographs as we became more and more convinced that the best

photographs talk for themselves, speaking in a language of their own, and that the less there is left to say about a picture, by way of explanation, after looking at it, the better it is as a picture." —André Kertész

Certain artists do make statements about what they intend, "*This* is what I was trying to do." In Norman Rockwell's case, he explains how he created a world with his art and made sure it was not populated with anyone he might find troubling:

"Maybe as I grew up and found that the world wasn't the perfectly pleasant place I had thought it to be I unconsciously decided that, even if it wasn't an ideal world, it should be and so painted only the ideal aspects of it—pictures in which there were no drunken slatterns or self-centered mothers, in which, on the contrary, there were only Foxy Grandpas who played baseball with the kids and boys fished from logs and got up circuses in the back yard. If there was sadness in this created world of mine, it was a pleasant success. If there were problems, they were humorous problems. The people in my pictures aren't mentally ill or deformed. The situations they get into are commonplace, everyday situations, not the agonizing crises and tangles of life."

"I have tried to express the terrible passions of humanity by means of red and green." —Vincent van Gogh on *Night Café* (1888)

"My approach to photography is based on my belief in the vigor and values of the world of nature, in aspects of grandeur and minutiae all around us. I believe in people, in the simpler aspects of human life, in the relation of man to

nature. I believe man must be free, both in spirit and society, that he must build strength into himself, affirming the enormous beauty of the world and acquiring the confidence to see and to express his vision. And I believe in photography as one means of expressing this affirmation and of achieving the ultimate in happiness and faith." —Ansel Adams

Robert Morgan: "There is a question I've always wanted to ask you—that early neon sign from the 1960s which reads: 'The True Artist Helps the World by Revealing Mystic Truths.' Is that a tongue-in-cheek statement, or did you really mean that?"
Bruce Nauman: "I've always felt that I believed it in some sense, but maybe not in the sense that I thought about it originally. It's one of those things you say to find out what you think about it, testing yourself."
Morgan: "So you don't feel your work has to answer questions; you just have to see them revealed?"
Nauman: "Yes, it's more that I figure out what the questions are."

When artists, whose work is abstract, talk about their intentions, their statements may be somewhat opaque, or even abstract themselves. Marcel Duchamp spoke in 1946 about his painting *Nude Descending a Staircase*, which had caused a sensation at the Armory Show in New York in 1913 (where one critic likened it to "an explosion in a shingle factory"):

"My aim was a static representation of movement, a static composition of indications of various positions taken by a form in movement—with no attempt to give cinema effects through painting."

In 1995, the critic Jed Perl wrote about a retrospective of the work of R.B. Kitaj at the Metropolitan Museum of Art. Kitaj wrote a lot of the catalog himself and was "extremely forthcoming about how it feels to live at a time when, as far as art is concerned, anything goes." Kitaj was born in Cleveland but by 1995 he had lived in London for many years. Perl writes:

"Kitaj writes of 'the crazy drama of painting,' and of being 'a painter who snips off a length of picture from the flawed scroll which is ever depicting the train of his interest.' Although Kitaj's insistence on explaining himself to his audience is rather unusual for an artist, I don't think that he's mistaken in believing that an artist who goes his own way will do well to blow his own horn. 'Some people,' he observes, 'live out their lives in places they don't come from, assigning themselves to a strange race and an alien sense of land and city. Who is to say what they do with their lives, and for that matter, why painters do what they do with their painting lives?' By now twentieth-century art is such a maze of depersonalized 'isms' that an artist has to insist on exactly how he does or does not fit in."

In *Slate*, Lee Siegel discusses an Ellsworth Kelly exhibition at the Whitney Museum. In the *New York Times*, Siegel says, the critic Ken Johnson implied Kelly "intends these canvases to refer to television." Siegel disagrees. The pictures, some made of blocks of blue, red, and green colors can remind a viewer of television but that's not to say that "Kelly himself had television in mind when he created these works." Siegel goes on:

> "*Mask* (1958) is the earliest painting in this show. . . . One could say that what *Mask*'s truncated forms—of blue and red, displayed on a green background—are really hiding are further permutations of color. These permutations are infinite, and the other paintings in the series unfold their odyssey. The three primary colors in this series are neither representative of any worldly form the eye can recognize or—à la the abstract expressionists—expressive of an emotion.
>
> "[Mark] Rothko famously said that he wanted his squares with rounded corners suspended in moist fields of color to make the viewer cry. Kelly just wants the viewer to keep looking, to forget what he or she is feeling and where he or she is standing. Of course, artists are famously sly about their intentions. As D.H. Lawrence once said, you have to trust the tale, not the teller. There's no reason that anyone should take Kelly, or any other great artist, at his word. But Kelly's art happens to illustrate his intentions. His telling and his tale are a seamless fit."

"In my pictures I showed objects situated where we never find them. *They represented the realization of the real if unconscious desire existing in most people. . . .*

Decatur Library
Payment Receipt
07/23/12 06:37PM

ATRON: HEMSLEY,
NNASTATIA RA

ategory: fine
or: goddess test
aid Amount: 0.50

alance Due: 0.00

Workstation: DECCR003
ash Drawer: 1

ransaction: 248985 4

Decatur Library
Payment Receipt
07/23/12 06:37PM

ATRON: HEMSLEY,
NNASTATIA RA

ategory: fine
or: goddess test
aid Amount: 0.50

alance Due: 0.00

Vorkstation: DECCR003
ash Drawer: 1

ransaction: 2489854

"The creation of new objects, the transformation of known objects, the change of matter for certain other objects, the association of words with images, the putting to work of ideas suggested by friends, the utilization of certain scenes from half-waking or dream states, were other means employed with a view to establishing contact between consciousness and the external world. The titles of the pictures were chosen in such a way as to inspire a justifiable mistrust of any tendency the spectator might have to over-ready self-assurance." —René Magritte (1898–1967)

"[My shapes] have no direct associations with any particular visible experience, but in them one recognizes the principle of passion of organisms." —Mark Rothko

When making a work of art, can the artist set out to tell a story or present a point of view? The novelist Émile Zola (1840–1902) claimed that the artist was meant only to see honestly and wasn't allowed to moralize:

"The artist paints neither story nor sentiment; dramatic composition does not exist for him, and the task he has set himself is not to represent some idea or some historic act."

This is an issue of artistic intention. Is the artist creating a work akin to a piece of literature? In the modern era, there are no rules to this, but there are still preferences. It is worth bearing in mind that each of the following artists may be defining "literature" differently:

If an artist believes his work has functions beyond the aesthetic, he is again displaying an intentionality. In the section on movements ("All Together Now"), there are bombastic statements from artists who wanted to change the world. These two desires are less ambitious.

"In a picture I want to say something comforting, as music is comforting." —Vincent van Gogh

"Art is like medicine—it can heal." —Damien Hirst

"When an artist explains what he is doing he usually had to do one of two things: either scrap what he has explained, or make his subsequent work fit in with his explanation. Theories may be all very well for the artist himself, but they shouldn't be broadcast to other people." —Alexander Calder

"Fine photography is literature, and it should be." —Walker Evans

"I am against any sort of literature in painting." —Marc Chagall

"There's no book but what's full of photography. James Joyce is. Henry James is. That's a pet subject of mine—how these men are unconscious photographers." —Walker Evans

"True painters disdain 'literature' in painting. It is an error to disdain literature itself. Plainly, painting's structure is suffi-

ciently expressive of feelings, of feelings far more subtle and 'true' to our being than those representing or reinforcing anecdotes: but true poetry is no more anecdotal than painting." —Robert Motherwell (1915–1991)

"Literature explains art without understanding it, art understands literature without explaining it." —Edgar Degas

THE CREATIVE ACT

"Who knows artistically what is right or wrong. You just do it."
—Elizabeth Murray

"In every man who is healthy and natural there is a germinating force as in a grain of wheat."
—Vincent van Gogh

What is creativity? What is the appropriate image that fits with making art? What do you feel when you are making art? Is an artist in the act of creation struck as if by lightning? Fire and heat are commonly associated with creativity: art is forged in the artist's furnace. The artist sweats from the feverishness that comes with inspiration. If she's lucky, the artist might be carried along like this from time to time. You're seized with an idea and you have to start working at once, in a frenzy. But relying on the regular appearance of such flashes would, of course, be dangerous. Rather than wait for the creative urge to come, the artist is better served by cultivating it.

This means work, the hard work of repeated creativity. Mark Rothko describes this perfectly:

> **"The most important tool the artist fashions through constant practice is faith in his ability to produce miracles when they are needed."**

> **"In order to be creative you have to know how to prepare to be creative."** —Twyla Tharp

An artist can apply the "constant practice" Rothko mentions to bouts of educated guesswork or prolonged creative trial and error:

> **"When the artists and sculptors I know work, there's a sort of free play idea. You try things; you experiment. It is kind of naïve and childish, it's like kids in a playpen."** —Frank Gehry

> **"When I have to think about it, I know the picture is wrong."** —Andy Warhol

You try it; you like it; you keep going. You try it; you don't like it; you stop. Alternatively, artists can proceed by making use of what they know and applying that knowledge deliberately and methodically:

> **"Artists do not experiment. Experiment is what scientists do. . . . An artist puts down what he knows and at every moment it is what he knows at that moment. If he is trying things out to see how they go he is a bad artist."** —Gertrude Stein (1874–1946)

Gertrude Stein was one of the great modernist writers. Some representational artists of an earlier age might be said to follow this dictum, even if a good deal of what Stein produced herself looks "experimental." When artists believe they are strictly reproducing what they see, they might be restricting the level of creativity they allow themselves in their work. Witness this statement of Gustave Courbet:

> "Imagination in art is the ability to find the most complete expression for an existing thing, but never the ability to conceive or create an object."

> "What we call 'creation' in great artists is but a way, distinctive of each one, of seeing, combining, and reproducing nature." —Eugène Delacroix

Even here, of course, the artist's creativity comes to bear in expression, and Courbet gave full rein to the techniques available to the painter in his work. What Courbet does not seem to acknowledge in this statement is that he is also expressing himself.

> "What I am after above all is expression.... Expression to my way of thinking does not consist of the passion mirrored upon a human face or betrayed by a violent gesture. The whole arrangement of my pictures is expressive.... Composition is the art of arranging in a decorative manner the various elements at a painter's disposal for the expression of his feelings." —Henri Matisse (1869–1954)

Nor is creation the same as imitation. As the chapter concerning the artist's eye strives to show, a successful portrait is

not merely a record of the subject. Whistler makes the point again:

> "The imitator is a poor kind of creature. If the man who paints only the tree, or flower, or other surface he sees before him were an artist, the king of artists would be the photographer. It is for the artist to do something beyond this: in portrait painting to put on canvas something more than the face the model wears for that one day: to paint the man, in short, as well as his features."

> "[Fernand Léger] thought a painting should be an object in its own right, with the same force and presence that a natural or a machine-made object had. His dictum on abstract art has never been said better by anyone: 'You don't make a nail with a nail, but with iron.' " —Gerald Murphy

Plato would trump everyone in this discussion by challenging the idea that any painter could create anything. In *The Republic*, he writes that painters are all mere imitators. Plato is unequivocal:

> "But would you call the painter a creator and maker?"
> "Certainly not."

He is not a maker but an imitator. Take a bed, Plato says. There is a bed that exists in nature as made by God. This is the ideal bed. There is also one made by a carpenter; and finally one made by the painter. Plato says that God is the maker— "he is the author of this and all things." He allows that the carpenter is also a maker. But the painter?

"But would you call the painter a creator and maker?"

"Certainly not."

"Yet if he is not the maker, what is he in relation to the bed?"

"I think," he said, "that we may fairly designate him as the imitator of that which the others make."

For the purposes of this book, Plato's argument is put aside and the artist retains her place as a creative force. Even if they are the authors of what they create, some wish that their hand remains invisible. Jasper Johns tries to take himself out of the picture, literally and metaphorically:

"My feeling about myself on the subjective level is that I am a highly flawed person. The concerns that I have always dealt with in picture making didn't have to do with expressing my flawed nature or my *self*—I wanted something that wouldn't have to carry my nature as part of its message."

"My aim is to escape from the medium with which I work. To leave no residue of technical mannerisms to stand between my expression and the observer." —Andrew Wyeth

And Mark Rothko said:

"The progression of a painter's work, as it travels from point to point, will be toward clarity: toward the elimination of all obstacles between the painter and the idea, and between the idea and the observer. As examples of such obstacles, I

give (among others) memory, history or geometry, which are swamps of generalization from which one might pull out parodies of ideas (which are ghosts) but never an idea in itself. To achieve this clarity is, inevitably, to be understood."

More than once in this book, artists have said that theirs is a lonely calling. Few claim that when they are laboring alone, they find the act of creating an easy one. If finding a subject or having an idea is not the difficult part and you have your space and your time, and the debtors are at bay, *and* you are feeling sufficiently inspired, getting started on something isn't the problem. Creatively speaking, it's *finishing* a work that is difficult. This is where the really hard work begins. Marcel Duchamp had many more plans for his *Bride Stripped Bare by Her Bachelors, Even* when in 1923 he just stopped working on the glass object, leaving it, in his words, "definitively unfinished." (A large area of the glass in Duchamp's work cracked after the pieces were held for some time in storage. Duchamp painstakingly stabilized the glass but said that he preferred the damaged version. "The more I look at it the more I like the cracks," he said.)

"The more one works on a picture, the more impossible it becomes to finish it." —Alberto Giacometti

"I never finish a painting—I just stop working on it for a while. I like painting because it's something I never come to the end of. Sometimes I paint a picture, then I paint it all out. Sometimes I'm working on fifteen or twenty pictures at the same time. I do that because I want to—because I like to change

my mind so often. The thing to do is always to keep starting to paint, never to finish painting." —Arshile Gorky (1905–1948)

"It was not necessary to smell a painting, the odor of paint was injurious, [Rembrandt] said to people to whom the paintings did not seem completed and who wanted to examine them at close quarters." —Max Doerner

An associated question is whether the artist knows where he is going before he starts. If he says he does, it implies that he'll recognize the finished article when he sees it. An alternative is that the art grows organically, becoming, in Picasso's phrase, like a living creature.

"For me all is in the conception. I must have a clear vision of the whole right from the beginning." —Henri Matisse

"A picture is not thought out and settled beforehand. While it is being done it changes as one's thoughts change. And when it is finished, it still goes on changing, according to the state of mind of whoever is looking at it . A picture lives a life like a living creature, undergoing the changes imposed on us by our life from day to day. This is natural enough, as the picture lives only through the man who is looking at it." —Pablo Picasso

"Rather than setting out to paint something, I begin painting and as I paint, the picture begins to assert itself, or suggest itself under my brush." —Joan Miró

"I work all over the canvas at a time: the first step allover, the second step allover and so on; at the end, there is often a

series of tiny steps. . . . They say Goya always 'finished' his pictures by candlelight, i.e. by dim light. I understand that. Subtle minor adjustments are critical to the feeling of the picture as a whole." —Robert Motherwell

"A painting, however, at any stage of its development, projects a realm of possibilities. Like other forms of expression it provides an occasion for thought, speculation and insight. What is particularly interesting about painting is its capacity to enable a fluid interaction of mental processes in the service of its development. An amazing confluence of events pass before a working painter's eyes, each one triggering associations, suggesting passage toward resolution." —Vincent Desiderio

Alberto Giacometti described how he would make sculptures from images that came to him fully formed:

"For many years I only executed sculptures that have presented themselves to my mind entirely accomplished. I limited myself to reproducing them in space without changing anything, without asking myself what they could mean (if I merely undertake to modify one part, or if I have to search for a dimension, I become entirely lost or the whole project gets destroyed). Nothing has ever appeared before me in the form of a picture. I rarely visualize in the form of a drawing. The attempts at conscientious realization from a picture or even from a sculpture to which I have sometimes yielded have always failed."

"The route of my pencil on the sheet of paper is, in some respects, analogous to the gesture of a man groping in darkness. . . . I am led, I do not lead." —Henri Matisse

Parts of three letters that Claude Monet wrote to the writer and critic Gustave Geffroy, in 1890, 1893, and 1908, illustrate some of the frustrations even a great artist can experience. In 1890, Monet was working on his *Haystacks,* in 1893 he was in Rouen painting the cathedral series, and in 1908 he spent time in his garden at Giverny painting water lilies. These are some of the best-loved of all paintings, and they were the product of extraordinary effort and also of the irritations that might not normally be associated with consummate creativity: the problems of finishing, the slowness of the work, and the lack of progress.

> **"I am working away: I am set on a series of different effects (haystacks), but at this time of year, the sun goes down so quickly that I cannot follow it. . . . I am working at a desperately slow pace but the further I go, the more I see that I have to work a lot in order to manage to convey what I am seeking: 'instantaneity,' above all, the envelopment, the same light spread over everywhere; and more than ever, easy things achieved at one stroke disgust me. Finally, I am more and more maddened by the need to convey what I experience and I vow to go on living not too much as an invalid, because it seems to me that I am making progress."**

In 1893, when he was in the middle of his series of paintings of the Rouen cathedral, Monet wrote of working on fourteen paintings at once:

> **"My stay is drawing to an end which does not mean that I am about to finish my *Cathedrals.* Alas, I keep saying this over and over and over again: as I go on, it is more and more difficult to**

render what I have in mind, and I think that he who claims to have completed a painting is a braggart. By 'completed' I mean fully finished and perfect, and I keep toiling without making any progress, searching, trying but with no result."

In August 1908 he wrote:

"These landscapes of water and reflections have become an obsession. They are beyond the powers of an old man, and I nevertheless want to succeed in rendering what I perceive. I destroy them . . . I recommence them . . . and I hope that from so many efforts, something will come out."

"I cannot work at night. I rise every morning at eight, dash water on my face, and run to my work. In the afternoon, I pre-pare. I sometimes recommence, and yet, even if the canvas is again completely blank, something remains from the first time. I have many paintings at work at once. Each one takes three or four years altogether. Occasionally, I dash one off like Picasso. 'That's all I can do,' I say. It has to stay like that." —Joan Miró

"I don't see why painting should get easier. Someone once said that, in a sense, an artist needs a problem he can't solve. The lucky ones get into a problem that is unsolvable, so they keep going and there's a growth, evolution." —Philip Pearlstein

"In the old days, pictures advanced toward their completion by stages. Every day brought something new. A picture used to be a sum of additions. In my case, a picture is a sum of destructions. I make a picture—then I destroy it" —Pablo Picasso

Creativity in architecture manifests differently from purer arts.

> "The creative processes in architecture have less to do with the muses of inspiration than with the painstaking resolution of site, program, structure, and plan. That procedure can be understood fairly easily; what is less clear are the aesthetic and cultural impulses that account for those very personal decisions that give the solution its specific shape and style." —Ada Louise Huxtable

> "I asked the brick, 'What do you like brick?' And the brick said, 'I like an arch.' " —Louis Kahn

Another recurring idea is that artists engage in a dialogue with their art. The dialogue takes different forms. To Romare Bearden, it is part of the struggle to create. To Ben Shahn, it is a cooperative process. To Duchamp, the dialogue is between the artist and the viewer.

> "Painting to men like President Eisenhower or Churchill was a hobby and a very relaxing one. But it is not so to a very serious artist. Because your painting is constantly saying no to you. And this, you might say, dialogue between you and your art has to each day be renewed which often makes it taxing for the artist. I know a lot of artists just hate in a cer-

tain way to go to paint. So in that sense you can't call paint-ing for a serious artist a hobby. It's a calling. And beyond that if you are a serious painter you don't have time. You read and you go to the theatre and do a few things that are relaxing, but to have anything as a hobby—well, like playing chess—Marcel Duchamp gave up painting to be a chess player—it would demand that type of attention. If I went into wood-working or anything I would give it that same degree of attention and I wouldn't be painting." —Romare Bearden

"From the moment at which a painter begins to strike fig-ures of color upon a surface he must become acutely sensi-tive to the feel, the textures, the light, the relationships which arise before him. At one point he will mold the mate-rial according to his intention. At another he may yield intention—perhaps the whole concept—to emerging forms, to new implications within the painted surface. Idea itself—ideas, many ideas move back and forth across his mind as a constant traffic, dominated perhaps by larger currents and directions, by what he wants to think. This idea rises to the surface, grows, changes as a painting grows and develops. So one must say that painting is both creative and responsive. It is an intimately communicative affair between the painter and his painting, a conversation back and forth, the painting telling the painter even as it receives shape and form.

"Here too, the inward critic is ever at hand, perpetually advising and casting doubt. Here the work is overstated; there it is thin; in another place, muddiness is threatened; somewhere else it has lost connection with the whole; here it looks like an exercise in paint alone; there, an area should be

preserved; thus the critics, sometimes staying the hand of the painter, sometimes demanding a fresh approach, sometimes demanding that a whole work be abandoned—and sometimes not succeeding, for the will may be stubborn enough to override such advice." —Ben Shahn (1899–1969)

"The creative act is not performed by the artist alone; the spectator brings the work in contact with the external world by deciphering and interpreting its inner qualifications and thus adds his contribution to the creative act. This becomes even more obvious when posterity gives its final verdict and sometimes rehabilitates forgotten artists." —Marcel Duchamp

In 1964, James Lord sat for Alberto Giacometti for eighteen days while the painter worked on his portrait. Lord took notes each night and wrote *A Giacometti Portrait,* which is a record of how an accomplished artist struggles to create art. Thirty years before, as quoted above, Giacometti had described making sculptures from complete mental blueprints. Painting James Lord's portrait was a journey without a map. Lord records periods of dissembling and waiting, and of anxiety and false hope once any work was being done. When Lord thought the portrait was good, Giacometti would invariably paint over the face when the next sitting began and start over from scratch. The picture was only finished because Lord, who had put off returning to the United States more than once, really had to leave town. You get the sense reading the book that without the enforced break Giacometti could have kept going indefinitely, pursued by the responsibility he felt as a creator of art:

"Giacometti is committed to his work in a particularly intense and total way. The creative compulsion is never wholly absent from him, never leaves him a moment of complete peace. I remember his saying a number of times that when he wakes up in the morning the very first thought that comes to his mind is of the work waiting to be done, the paintings and sculptures that he may have en route—to use his own expression—at the moment. With this thought, he says, always comes a nightmarish sensation of hopelessness, of having his face pressed against a wall and being unable to breathe. In the same spirit he sometimes talks wistfully of the time he will be able to stop working forever, when just once he will have succeeded in representing what he sees, in conveying tangibly the intangible sensation of a visual perception of reality. This is, of course, impossible and he most certainly knows it. The very measure of his creative drive is that he should longingly dream of someday being free of it."

"All truly profound art requires its creator to abandon himself to certain powers which he invokes but cannot altogether control." —André Malraux

It is difficult to create at will and it can be burdensome to meet the trial of making art in a way that will satisfy the artist's own critic. You must harness all the mental and physical skills at your disposal and accept the challenge, hoping all the while that you'll be filled with the unknowable creative force and carried along by it.

"I believe it was John Cage who once told me, 'When you start working, everybody is in your studio—the past, your friends, enemies, the art world, and above all, your own ideas—all are there. But as you continue painting, they start leaving, one by one, and you are left completely alone. Then, if you're lucky, even you leave.' " —Philip Guston

BEING AN ARTIST

"I never decided at all to be an artist; being an artist
seems to have happened to me."
—Anne Truitt

"I can't think of an artist that hasn't had a complicated life."
—George (of Gilbert and George)

What is it like to be an artist? Is there anything that sep-
arates an artist from a nonartist: a sensibility, a way of
looking at the world, a need to communicate, even a touch of
exhibitionism?

Some artists articulate an attraction to the creative process
of art. When they were drawn to the making of art, they felt
a sense of urgency—it was a compulsion. If you feel that you
have to be an artist, then you'll find a way somehow to make
it happen, even if it's on the weekends, in the middle of the
night, or any time, when you are alone with your imagination
and a blank canvas.

"Now regard this pure white sheet of paper! It is ready for recording the logic of the plan.

"T-square, triangle, scale—seductive invitation lying upon the spotless white surface. Temptation!" —Frank Lloyd Wright

"For me, the reason to do art is that it is compelling. Art is a drive, a very complex desire and need, urgency and pleasure." —Mary Frank

"Right from the start, I thought, no one can keep me from being an artist." —Martin Puryear

"Art itself is produced, in part, from the compulsion to express, a unique attribute of man. It is a desire to find and separate truth from the complex of lies and evasions in which he lives." —Robert Gwathmey

"I was born in Hoboken. I am an American. Photography is my passion. The search for Truth is my obsession." —Alfred Stieglitz

"Roy Liechtenstein, when he first started doing comic-book paintings, said he didn't know what else to do. I just have to do something, so I do something and it might be really stupid, but I just can't think of anything else to do." —Bruce Nauman

"I have a strong need to paint; if I don't paint I cry and get bad headaches." —Judy Levy

Artists may have in common the fact that they can't help themselves from creating. Beyond that, there are as many answers to the question "Why do you paint?" as there are

painters (or sculptors who sculpt, architects who design, and so on):

Q: "Why do you paint?"
A: "To translate my emotions, my feelings and the reactions of my sensibilities into color and design, something that neither the most perfect camera, even in colors, nor the cinema can do." —Henri Matisse

"We paint to discover ourselves, to explain our deepest nature." —Jacques Villon

"It occurred to me once, looking round the new wing of so-called primitive art at the Metropolitan Museum, that if you are an artist and you look at something, some sculpture of a figure, there is always something you would see that an art historian or critic could not. It's this: somebody made the piece with his hands and the person who made it had some similarities to yourself. That artist too had an urge to make something, to depict something, to represent some form of perceived reality, to represent and reproduce experience, even though he lived in a totally different era, a totally different society. This connection between an artist from the past and one from the present is always there." —David Hockney

"Why make art? Because I think there's a child's voice in every artist saying: 'I am here. I am somebody. I made this. Won't you look?' " —Chuck Close

"The painter makes real to others his innermost feelings about all that he cares for. A secret becomes known to every-

one who views the picture through the intensity with which it is felt." —Lucian Freud

In this way, a painter communicates with the person looking at the painting. Lucian Freud is saying that the viewer will feel and understand the passion of the painter. Other artists similarly see themselves as communicators.

"I think that all sorts of art activities, whether written, played, or visualized, are attempts to send messages from one person to another. I don't think of it as news but rather as a kind of condensed communication conveyed with a deep and startling economy." —Barbara Kruger

"What an artist is trying to do for people is bring them closer to something, because of course art is about sharing: you wouldn't become an artist unless you wanted to share an experience, a thought. I am constantly preoccupied with how to remove distance so that we can all come closer together, so that we can all begin to sense we are the same, we are one." —David Hockney

"Architecture is not just about making good buildings . . . it's also about telling stories in some way. And you can tell stories by making interviews, you can . . . tell stories by writing or by painting or by playing music, but you also tell stories by making buildings, because buildings talk." —Renzo Piano

"If a painting does not make human contact, it is nothing." —Robert Motherwell

The writer Alberto Manguel describes this exchange of contact from the other side, from the perspective of the viewer being addressed by the art:

> "I walk through a museum, I see paintings, photographs, sculptures, installations and video screens. I try to understand what I see and read the images accordingly, but the narrative thread that leads to them keeps criss-crossing: the story suggested by the work's title, the story of how the work came into being, the story of its maker, and my own."

Conversations held through art are not models of clarity. They can be one sided. Either the artist or the viewer could be doing all the talking. Or the artist's intent might be misinterpreted. Or they may have no intent. In 1965, Joseph Beuys performed a piece in a gallery in Germany called *How to Explain Pictures to a Dead Hare* in which he held a dead animal in his arms for three hours and mouthed ideas about art to it.

In the introduction, it was useful to define an artist for the purposes of this book as someone who communicates using visual symbols. For any larger purpose, it is not necessarily the case that communication is one of the functions an artist wishes to undertake. You might not be trying to reach out to anyone else.

> Q: "Are you concerned about communication, whether you reach all the people?"
> Clyfford Still: "Not in the least. That is what the comic strip does."
> Q: "Then you paint for yourself."
> Still: "Yes."

"I think any artist would say that first and foremost they make their work for themselves. Look at the disastrous effects that occur when, for example, a group of marketing executives dilutes a film director's vision, or when a gallerist talks an artist into making something for the market, or the editorial board hacks up a writer's work." —Bill Viola

"In the arts self-expression generally comes first. There may be a few holy spirits for whom this is not true, but if so, their position is almost self-contradictory. I cannot imagine a detached or altruistic person achieving very much. If an architect's ego is very small, he is done for; if it is vast then he might make some very important contributions." —Paolo Soleri

If your primary focus is yourself, making art can be cathartic:

"[Edvard] Munch's images seem to come from a young man who has known jealousy, frustration, impotence, and humiliation in love, and, no longer having to live through it, wants to proclaim—even to brag about—how messy and lousy it was." —Sanford Schwartz

Two painters, asked if they might have wanted to do something else with their lives, say they are happy to be doing what they do, if not unequivocally. A sculptor, on the other hand, says he knows of sculptors who have taken refuge in painting.

The last, and, by no means the worst, reason to make art might simply be that it's fun. You want to recapture that childhood feeling of making something. The painter Charles Gleyre taught some of the most prominent artists of his day, including Bazille, Monet, and Renoir.

Gleyre: "No doubt it is to amuse yourself that you are dabbling in paint?"

Pierre-Auguste Renoir: "Why, of course. And if it didn't amuse me, I beg you to believe that I wouldn't do it."

"Love and delight are better teachers of the Art of Painting than compulsion is." —Albrecht Dürer (1471–1528)

Question: "How do you feel about spending your life as an artist? Do you ever wish you were a filmmaker or a pop star?"
Elizabeth Peyton: "No, not a pop star. In kind of low moments I wish I was a photographer. Like maybe life would be easier."

Journalist: "Would you have liked to have been something other than a painter, Monsieur Léger?"
Fernand Léger: "A cattle breeder like my father, but I don't regret painting."

"Sculpture is an exacting and difficult medium, and I have known of sculptors giving it up after time and taking to painting . . . certainly less hard work and less expensive." —Jacob Epstein

On page 19, David Sylvester wrote about Barnett Newman, who didn't start painting until he was forty. Part of an artist's portfolio of tools is the accumulation of life experiences to put into her art.

> "When I was about forty, then I started being able to make work about what was interesting to me. And then my work became much weirder and personally egocentric. I always think I never would have an art career if I had started now." —Kiki Smith

> "I can paint until I'm forty. After that I intend to dry up." —Henri de Toulouse-Lautrec

Alas, Toulouse-Lautrec only lived to be thirty-six.

At the end of this book, having briefly surveyed the life and craft of the artist, how the artist is inspired and influenced, how the creative act is visualized and realized, and how the artist learns and works, there is room to ask what it takes to be a successful artist.

The creative urge can be present and strong in people who struggle to find a medium in which they can express themselves. Or people with a talent for drawing may find the experience empty and unsatisfying. For an artist to be successful, the stars have to come together. Talent, opportunity, and inspi-

ration must align, as they did for the artists quoted in this book.

"I had what it takes to make a good artist: sensitivity and tremendous will power. Hypersensitivity—because in order to be an artist you have to react intensely." —Alice Neel

"There has to be some natural interest and ability for an artist to work with. Beyond that, I think it takes intelligence and wit, a lot of both, to be an artist." —Donald Judd

"A man paints with his brains and not with his hands, and if he cannot have his brains clear he will come to grief." —Michelangelo

"Painting is a thing of intelligence. One sees it in Manet. One can see the intelligence of each of Manet's brushstrokes, and the action of intelligence is made visible in the film on Matisse when one watches Matisse draw, hesitate, then begin to express the thought with a sure stroke." —Alexander Liberman

"An artist must be unusually intelligent in order to grasp simultaneously many structured relations. In fact, intelligence can be considered as the *capacity* to grasp complex relations; in this sense Leonardo's intelligence, for instance, is almost beyond belief." —Robert Motherwell

Many artists are unashamed intellectuals, operating in the same realm and addressing the same subjects as philosophers. Dore Ashton describes Mark Rothko, a true philosopher-painter:

"He tried in 1958, for the last time in public, to specify what it was in the human condition, he wished to express. He spoke of the 'weight of feelings' and used a musical analogy: Beethoven and Mozart have different weights. He had told Elaine de Kooning shortly before, 'I exclude no emotion from being actual and therefore pertinent. I take the liberty to play on any string of my existence.' In so doing, Rothko performed difficult feats of thought."

Rothko liked to talk about "transcendence" and artists, when they reach for the sublime, are trying to recreate emotion or a state of mind.

"The first transcendent experience I remember was sitting underneath a huge, golden maple tree in the fall and looking up and seeing the little blue spaces between the leaves. I felt both beauty and sadness; I really wanted to respond to that mix of emotions. I think making art is trying to respond to being alive, to learning about death and how these things mingle. It's what you paint about. That's why people care about it." —Elizabeth Murray

◎ ◎ ◎

Grayson Perry, a British artist who works primarily in ceramics, helps obliterate any stereotypes about what artists should look like and how they should work. In 2003, Perry won the Turner Prize, the most prestigious accolade in British art. Perry, who has long been a transvestite and who has a female alter-ego he calls Claire, received the award in a purple dress. He said he would give the prize money to his wife, a psy-

chotherapist. Using pots and vases, Perry depicts themes that might seem incongruous to a decorative art like this, subjects like Perry's own unhappy childhood. Perry himself points out that the medium he works in is irrelevant:

> "I've always been an artist who just happens to make pottery, so I'm not a standard bearer for ceramics—I'm an artist."

> "Photography is not an art. Neither is painting nor sculpture, literature nor music. They are only different media for the individual to express his aesthetic feelings; the tools he uses in his creative work. . . . You do not have to be a painter or a sculptor to be an artist. You may be a shoemaker. You may be creative as such. And if so you are a greater artist than the majority of painters whose work is shown in the art galleries of today." —Alfred Stieglitz

Elsewhere in this book, artists have been recorded saying how they want to change the world with their art. Citing less ambitious aims, the following artists are describing what they see the place of art in the world to be. It is clearly important to the aspiring artist that art continues to be valued in society and that the artist remains a valued, if potentially marginalized, member of society.

> "I'm interested in the morality of what it means to be an artist. As an artist I'm most concerned with what art means to me, how it defines my life, etc. And then after that, my next concern is my actions, the responsibility of my own actions in art in

regard to other artists, and then to a wider range of the art audience, such as critics, museum people, collectors, etc. Art to me is a humanitarian act and I believe that there is a responsibility that art should somehow be able to effect mankind, to make the world a better place (this is not a cliché!)." —Jeff Koons

"A painting can help us to think something that goes beyond this senseless existence." —Gerhard Richter

"Is it not true that painting is the mistress of all the arts or their principal ornament?" —Leon Battista Alberti (1404–1472)

"Historically, it has been the artist's role to make manifest the beautiful inherent in all the objects of nature and man." —Arshile Gorky

"Architecture is the art which so disposes and adorns the edifices raised by man, for whatsoever uses, that the sight of them may contribute to his mental health, power, and pleasure." —John Ruskin

"Creative art is for all time and is therefore independent of time. It is of all ages, of every land, and if by this we mean the creative spirit in man which produces a picture or a statue is common to the whole civilized world, independent of age, race and nationality, the statement may stand unchallenged." —Alma Thomas (1891–1978)

Art is never static. Taste and conventions change rapidly, ensuring that what is unacceptable or risky one day might be banal the next. These changes are not linear or predictable.

Technology advances at an even more bewildering pace. Art will be soon made in media that are still on some engineer's drawing board. These techniques will most likely add to the repertoire of art rather than displacing anything. For more than a hundred years, painting has been threatened by photography and declared dead or dying frequently. It has proved resilient, and continues to develop, providing the artist with a means of expression that doesn't feel "old fashioned." André Breton wrote a preface to an exhibition of Max Ernst's work in Paris in 1920:

> "The invention of photography has dealt a mortal blow to the old modes of expression, in painting as well as in poetry, where automatic writing, which appeared at the end of the nineteenth century, is a true photography of thought. Since a blind instrument now assured artists of achieving the aim they set themselves up to that time, they now aspired, not without recklessness, to break with the imitation of appearances."

> Q: "Do you think easel painting is dead?"
> A: "It's dead for the moment, and for a good fifty or a hundred years. Unless it comes back; one doesn't know why, but there's no reason for it." —Marcel Duchamp

> "Someday artists will work with capacitors, resistors, and semiconductors as they work today with brushes, violins, and junk." —Nam June Paik

> "The urge to be a painter is still there even if the process of painting is meaningless, old-fashioned. Today there are bet-

ter ways for artists to communicate to an audience raised on television, advertising and information on a global level."
—Damien Hirst

"I believe that after Pollock created a distance between brush and the canvas by flinging the paint, there was nowhere to go with painting." —Damien Hirst

"We don't believe painting will stop, but as a powerful form, it's finished. The new visuals are coming from cameras."
—Gilbert

"The conversation about painting being dead has gone on for about one hundred years. People have been talking about the death of painting for so many years that most of the people are dead now. Painting is alive; Andy [Warhol]'s paintings are still alive. Painters will paint." —Julian Schnabel

Last words:
In 1954, Jasper Johns destroyed all the work that he had done up to that point:

"Before, when anybody asked me what I did, I said I was going to become an artist. Finally I decided I could be going to become an artist all my life. I decided to stop *becoming* and *be* an artist."

"I have no favorite child, I have no favorite building, and I have no masterpiece. You have to take my work as a whole, and it's either a masterpiece or it isn't. There is no one thing in it. There's no taking it apart. There it is." —Frank Lloyd Wright

"Hell, half the world wants to be like Thoreau at Walden wor-
rying about the noise of the traffic on the way to Boston: the
other half use up their lives being part of that noise. I like the
second half." —Franz Kline

The sculptor Anne Truitt is well placed to comment on the
sacrifices that are often necessary to become an artist. She can
also speak to the fact that the prospect of the creation of art is
alluring and difficult to resist. Hoping to become a therapist,
Truitt studied psychology in college and worked during World
War II at Massachusetts General Hospital with soldiers suffer-
ing from battle fatigue. After this experience, she went to art
school. In the 1950s, Truitt worked on her sculpture in between
her job as a mother and the Washington wife of a journalist.
Truitt had her first show in 1963 when she was forty-one.

"People who set their sails into art tend to work very hard.
They train themselves in school; they practice and they read
and they think and they talk. But for most of them there
seems to be a more or less conscious cutoff point. It can be a
point in time: 'I will work until I am twenty-one [twenty-five,
thirty, or forty].' Or a point in effort: 'I will work three hours
a day [or eight or ten].' Or a point in pleasure: 'I will work
unless . . .' and here the 'enemies of promise' harry the result.
These are personal decisions, more or less of individual will.
They depend on the scale of values according to which artists
organize their lives. Artists have a modicum of control. Their
development is open-ended. As the pressure of their work
demands more and more of them, they can stretch to meet it.
They can be open to themselves, and as brave as they can be
to see who they are, what their work is teaching them. This

is never easy. Every step forward is a new clearing through a thicket of reluctance and habit and natural indolence. All the while they are at the mercy of events. They may have a crippling accident, or may find themselves yanked into a lifelong responsibility such as the necessity to support themselves and their families. Or a war may wipe out the cultural context on which they depend. Even the most fortunate have to adjust themselves to the demands of daily life."

BIBLIOGRAPHY AND SOURCES

◎ ◎ ◎

Introduction

Picasso: bbc.co.uk

Sinclair: Wilford, John Noble. "Figurines Found in German Cave Are among Earliest Artwork." *New York Times*, 18 December 2003.

Conard: bbc.co.uk

Bataille: *The Art of Painting from Prehistory through the Renaissance*. Edited by Pierre Seghers. New York: Hawthorn, 1964.

Curtis: *The Object Sculpture*. Leeds, UK: Henry Moore Institute, 2002.

Delacroix: Delacroix, Eugène. *The Journal of Eugene Delacroix*. New York: Crown, 1948.

Spender: Spender, Stephen. "Painters as Writers." In *Poets on Painters*. Edited by J.D. McClatchy. Berkeley: University of California Press, 1990.

Updike: Updike, John. *Odd Jobs*. New York: Knopf, 1991.

Learning the Art

Leonardo: *The Notebooks of Leonardo da Vinci*. Selected and edited by Irma A. Richter. New York: Oxford University Press, 1952.

Warhol: Koestenbaum, Wayne. *Andy Warhol*. New York: Penguin, 2001.

Vasari: Vasari, Giorgio. *The Lives of the Painters, Sculptors, and Architects*. Translated by A.B. Hinds. New York: Everyman's Library, 1963.

Rivera: *Diego Rivera: My Art, My Life*. New York: Citadel, 1960.

Viola: *Bill Viola*. New York: Whitney Museum of American Art, 1997.

Richardson: Richardson, John. *The Life of Picasso*. Vol. 1, *1881–1906, The Early Years*. New York: Random House, 1991.

Horn: *Rebecca Horn*. New York: The Guggenheim Museum, 1993.

Gehry: *Frank Gehry, Architect*. Edited by J. Fiona Ragheb. New York: The Guggenheim Museum, 2001.

Smithson: robertsmithson.com

Koons: *ArtForum* (March 2003).

Haring: Sussman, Elizabeth. *Keith Haring*. New York: Whitney Museum of Art, 1997.

Saarinen: Peter, John. *The Oral History of Modern*

Architecture. New York: Harry N. Abrams, 1994.

Bernini: Hibbard, Howard. *Bernini.* London: Pelican, 1965.

Rosenquist: Hopps, Walter, and Sarah Bancroft. *Rosenquist: A Retrospective.* New York: The Guggenheim Museum, 2003.

Sylvester: Sylvester, David. *About Modern Art.* 2nd ed. New Haven, CT: Yale University Press, 2002.

Elkins: Elkins, James. *Why Art Cannot Be Taught: A Handbook for Art Students.* Urbana: University of Illinois Press, 2001.

Delacroix: Delacroix, Eugène. *The Journal of Eugène Delacroix.* New York: Crown, 1948.

Neel: Russo, Alexander. *Profiles on Women Artists.* Frederick, MD: University Publications of America, 1985.

Aalto: *Alvar Aalto in His Own Words.* Edited by Göran Schildt. New York: Rizzoli, 1997.

Reynolds: *A Documentary History of Art.* Vol. 2. Selected and edited by Elizabeth Gilmore Holt. Princeton, NJ: Princeton University Press, 1982.

Leonardo: *Artists on Art: From the XIV to the XX Century.* Compiled and edited by Robert Goldwater and Marco Treves. New York: Pantheon, 1945.

Dalí: Etherington-Smith, Meredith. *The Persistence of Memory.* New York: Random House, 1993.

Rauschenberg: Gruen, John. *The Artist Observed: 28 Interviews with Contemporary Artists.* Pennington, NY: A Cappella, 1991.

Hamilton: Hamilton, Richard. *Collected Words, 1953–1982.* New York: Thomas & Hudson, 1982.

Picasso: Lake, Carlton. "Picasso Speaking." *The Atlantic Monthly* (July 1957).

Henri: Henri, Robert. *The Art Spirit.* Boulder, CO: Westview, 1984.

Evans: Mellow, James R. *Walker Evans.* New York: Basic, 1999.

Cohen-Solal: Cohen-Solal, Annie. *Painting American.* New York: Knopf, 2001.

Hopper: Lucie-Smith, Edward. *Lives of the Great 20th-Century Artists.* New York: Thames & Hudson, 1999.

Miró: *Encounters with Great Painters.* Complied by Roger Thérond. New York: Abrams, 2001.

Diebenkorn: *The Art of Richard Diebenkorn.* Berkeley: University of California Press, 1997.

Weston: Weston, Edward. *The Daybooks of Edward Weston.* Vol. 1, *Mexico.* Edited by Nancy Newhall. New York: Aperture, 1973.

Corot: *Painters on Painting.* Selected and edited by Eric

Protter. New York: Grossett & Dunlap, 1963.

Gombrich: Gombrich, E.H. *The Story of Art.* 15th ed. Oxford: Phaidon, 1991.

Goya: Mühlberger, Richard. *What Makes a Goya a Goya?* New York: Metropolitan Museum of Art, 1994.

Malraux: Malraux, André. *The Creative Act.* New York: Pantheon, 1949.

The World of Influences

Lubow: "Inspiration: Where Does It Come From?" *New York Times Sunday Magazine,* November 30, 2003.

Renoir: Pool, Phoebe. *Impressionism.* New York: Thames & Hudson, 1985.

Malraux: Malraux, André. *The Creative Act.* New York: Pantheon, 1949.

Rivera: Marnham, Patrick. *Dreaming with His Eyes Open: A Life of Diego Rivera.* New York: Knopf, 1998.

Bacon: Peppiatt, Michael. *Francis Bacon: Anatomy of an Enigma.* New York: Farrar, Straus & Giroux, 1996.

Chagall: Chagall, Marc. *My Life.* New York: Da Capo, 1994.

Kandinsky: *The History of Impressionism.* New York: Museum of Modern Art, 1973.

Chirico: Lucie-Smith, Edward. *Lives of the Great 20th-Century Artists.* New York: Thames & Hudson, 1999.

Bearden: Interview conducted by Henri Ghent, June 29, 1968. Archives of American Art, Smithsonian Institution. artarchives.si.edu

Calder: Hughes, Robert. *American Visions: The Epic History of Art in America.* New York: Knopf, 1997.

Monet: *Claude Monet at the Time of Giverny.* Edited by Jacqueline Guillard et al. New York: Rizzoli, 1985.

Degas: *The History of Impressionism.* New York: Museum of Modern Art, 1973.

Riley: Klee, Paul. *The Nature of Creation.* London: Hayward Gallery, 2002.

Hill: *Gary Hill.* Edited by Robert C. Morgan. Baltimore, MD: Johns Hopkins University Press, 2000.

Brancusi: Wittkower, Rudolf. *Sculpture.* London: Peregrine, 1979.

Stella: Cernuschi, Claude. *Jackson Pollock: Meaning and Significance.* New York: HarperCollins, 1992.

Salle: *ArtForum* (March 2003).

Noguchi: Noguchi, Isamu. *A Sculptor's World.* New York: Harper & Row, 1968.

Pissarro: *Camille Pissarro: Letters to His Son Lucien.* 3rd ed. Mamaroneck, NY: Paul P. Appel, 1972.

Dalí: Etherington-Smith, Meredith. *The Persistence of Memory.* New York: Random House, 1993.

Hughes: Hughes, Robert. *American Visions: The Epic History of Art in America.* New York: Knopf, 1997.

Van Gogh: Rewald, John. *Post-impressionism from van Gogh to Gaugin.* New York: Museum of Modern Art, 1978.

Rothko: Rothko, Mark. *The Works on Canvas.* New Haven, CT: Yale University Press, 1998.

Davis: Sims, Lowery Stokes. *Stuart Davis, American Painter.* New York: Metropolitan Museum of Art, 1991.

Rodin: Miller, John. *The Studios of Paris: The Capital of Art in the Late Nineteenth Century.* New Haven, CT: Yale University Press,1988.

Cassatt: *Cassatt and Her Circle: Selected Letters.* Edited by Nancy Mowll Mathews. New York: Abbeville, 1984.

Van der Rohe: de la Croix, Horst, and Richard G. Tansey. *Art through the Ages.* New York: Harcourt Brace Jovanovich, 1986.

Foster: bbc.co.uk

Johnson: achievement.org

Schama: Schama, Simon. *Rembrandt's Eyes.* New York: Knopf, 1999.

Riley: *Writers on Artists.* New York: Dorling Kindersley, 2001.

Da Vinci: *The Notebooks of Leonardo da Vinci.* Selected and edited by Irma A. Richter.

New York: Oxford University Press, 1952.

Toker: Toker, Franklin. *Fallingwater Rising: Frank Lloyd Wright, E.J. Kaufman, and America's Most Extraordinary House.* New York: Knopf, 2003.

De Kooning: De Kooning, Elaine. *The Spirit of Abstract Expressionism: Selected Writings.* New York: George Braziller, 1994.

De Kooning: Rosenberg, Harold. *Art and Other Serious Matters.* Chicago: University of Chicago Press, 1985.

Henri: Henri, Robert. *The Art Spirit.* Boulder, CO: Westview, 1984.

In and Out of the Studio

Bellows: *American Impressionism and Realism: The Painting of Modern Life, 1885–1915.* New York: Metropolitan Museum of Art, 1994.

Corot: *Corot.* New York: The Metropolitan Museum of Art, 1996.

Jeanniot: *Manet 1832–1883.* New York: The Metropolitan Museum of Art, 1983.

Campbell: Campbell, Peter. "At the Royal Academy." *London Review of Books,* 5 February, 2004.

Varnedoe: Varnedoe, Kirk. *Jackson Pollock.* New York: Museum of Modern Art, 1999.

Goncourt: Milner, John. *The Studios of Paris: The Capital of Art in the Late Nineteenth Century.* New Haven, CT: Yale University Press, 1988.

Milner, John. *The Studios of Paris: The Capital of Art in the Late Nineteenth Century.* New Haven, CT: Yale University Press, 1988.

Johnson: Johnson, Jill. *Jasper Johns: Privileged Information.* New York: Thames & Hudson, 1996.

Seidner: Seidner, David. *Artists at Work: Inside the Studios of Today's Most Celebrated Artists.* New York: Rizzoli, 1999.

Pirchan: Dean, Catherine. *Klimt.* Oxford: Phaidon, 1996.

Olivier: Olivier, Fernande. *Loving Picasso: The Private Journals of Fernande Olivier.* New York: Abrams, 2001.

Liberman: Liberman, Alexander. *The Artist in His Studio.* New York: Viking, 1960.

Severini: Severini, Gino. *The Life of a Painter.* Princeton, NJ: Princeton University Press, 1995.

Cézanne: Nochlin, Linda. *Impressionism and Post-impressionism, 1874–1904.* Englewood Cliffs, NJ: Prentice-Hall, 1966.

Milner: Milner, John. *The Studios of Paris: The Capital of Art in the Late Nineteenth Century.* New Haven, CT: Yale University Press, 1988.

Morisot: Morisot, Berthe. *The Correspondence.* Compiled and edited by Denis Rouart. Mount Kisco, NY: Moyer Bell, 1987.

Smithson: Interview with Robert Smithson for the Archives of American Art/Smithsonian Institution (1972). robertsmithson.com

Monet: *Readings in Art History.* Vol. 2. 3rd ed. Edited by Harold Spencer. New York: Scribner's, 1983.

Boudin: *The History of Impressionism.* New York: Museum of Modern Art, 1973.

Cézanne: Cézanne, Paul. *Letters.* Edited by John Rewald. New York: Hacker Art Books, 1984.

The Artist at Work

Van Gogh: *The Letters of Vincent van Gogh.* Selected and edited by Ronald de Leeuw. New York: Penguin, 1996.

Truitt: *ArtForum* (May 2002).

Spender: Spender, Matthew. *From a High Place: A Life of Arshile Gorky.* New York: Knopf, 1999.

Van Gogh: Pickvance, Ronald. *Van Gogh in Arles.* New York: Metropolitan Museum of Art, 1984.

Delacroix: Delacroix, Eugène. *The Journal of Eugène Delacroix.* New York: Crown, 1948.

Kingsley: Kingsley, April. *The Turning Point*. New York: Simon & Schuster, 1992.

Noguchi: Potter, Jeffrey. *To Violent Grave: An Oral Biography of Jackson Pollock*. New York: Putnam, 1985.

Ashton: Ashton, Dore. *About Rothko*. New York: Da Capo Press, 1996.

Gwathmey: Kamman, Michael. *The Life and Art of a Passionate Observer*. Chapel Hill: University of North Carolina Press, 1999.

Mitchell: Livingston, Jane. *The Paintings of Joan Mitchell*. New York: Whitney Museum of American Art, 2002.

Hopper: "Traveling Man." *Time*, 19 January 1948.

Close: Stein, Harvey. *Artists Observed*. Photographs by Harvey Stein. New York: Abrams, 1986.

Fischl: bombsite.com

Dalí: Dalí, Salvador. *Diary of a Genius*. Translated by Richard Howard. Garden City, NY: Doubleday, 1965.

Hirst: Hirst, Damien. *I Want to Spend the Rest of My Life Everywhere, with Everyone, One to One, Always, Forever, Now*. New York: Monacelli, 1997.

Miller: Prose, Francine. *The Lives of the Muses: Nine Women and the Artists They Inspired*. New York: HarperCollins, 2002.

Hare: Mackie, Alwynne. *Art/Talk: Theory and Practice in Abstract Expressionism*. New York: Columbia University Press, 1989.

Homer: Hendricks, Gordon. *The Life and Work of Winslow Homer*. New York: Abrams, 1979.

Da Vinci: *The Notebooks of Leonardo da Vinci*. Selected and edited by Irma A. Richter. New York: Oxford University Press, 1952.

Vasari: Vasari, Giorgio. *The Lives of the Painters, Sculptors, and Architects*. Translated by A.B. Hinds. New York: Everyman's Library, 1963.

Pei: bbc.co.uk

Making a Living

Léger: Tomkins, Calvin. *Living Well Is the Best Revenge*. New York: Modern Library, 1998.

Delacroix: Delacroix, Eugène. *The Journal of Eugène Delacroix*. New York: Crown, 1948.

Henri: Henri, Robert. *The Art Spirit*. Boulder, CO: Westview, 1984.

Eisenstadt: Eisenstadt, Alfred. *Eisenstadt on Eisenstadt*. New York: Abbeville Press, 1985.

Johnson: Peter, John. *The Oral History of Modern Architecture*. New York: Harry N. Abrams, 1994.

Rothko figures: Breslin, James E.B. *Mark Rothko: A Biography*. Chicago: University of Chicago Press, 1993.

Saltzman: Saltzman, Cynthia. *Portrait of Dr. Gachet: The Story of a van Gogh Masterpiece*. New York: Viking, 1998.

Kempers: Kempers, Bram. *Painting, Power and Patronage. The Rise of the Professional Artist in the Italian Renaissance*. New York: Penguin, 1994.

Pei: bbc.co.uk

Callister: Heyer, Paul. *Architects on Architecture*. New York: Walker and Company, 1966.

Van Gogh: *The Letters of Vincent Van Gogh*. Selected and edited by Ronald de Leeuw. New York: Penguin, 1996.

Gaugin: Nochlin, Paul. *Impressionism and Post-impressionism, 1874–1904*. Englewood Cliffs, NJ: Prentice-Hall, 1966.

Berger: Berger, John. *About Looking*. New York: Pantheon, 1980.

Hoban: Hoban, Phoebe. *Basquiat: A Quick Killing in Art*. New York: Viking, 1998.

Hughes: Hughes, Robert. *The Shock of the New*. 2nd ed. New York: McGraw-Hill, 1991.

Hughes: Hughes, Robert. *Nothing If Not Critical*. New York: Knopf, 1990.

Edelson: Stein, Harvey. *Artists Observed*. Photographs by Harvey Stein. New York: Abrams, 1986.

Warhol: Warhol, Andy. *The Philosophy of Andy Warhol (From A to B and Back Again)*. New York: Harcourt Brace Jovanovich, 1975.

Russell: Russell, John. *The Meanings of Modern Art*. New York: HarperCollins, 1981.

Shell: Shell, Marc. *Art and Money*. Chicago: University of Chicago Press, 1995.

Duchamp: Tomkins, Calvin. "The Creative Act." In *Duchamp: A Biography*. By Calvin Tomkins. New York: Henry Holt, 1996.

Still: *Clyfford Still*. Edited by John P. O'Neill. New York: Metropolitan Museum of Art, 1979.

Technique

Morisot: Higonnet, Anne. *Images of Women*. Cambridge, MA: Harvard University Press, 1992.

Calder: *Guggenheim Museum Collection A to Z*. Edited by Nancy Spector. New York: Guggenheim Museum, 2001.

Matisse: *Matisse Picasso*. New York: Museum of Modern Art, 2002.

Still: Frazier, Nancy. *The Penguin Concise Dictionary of Art History*. New York: Penguin, 2001.

Garrido: Brown, Jonathan, and Carmen Garrido. "Velázquez's Materials and Technique." In *Velázquez: The Technique of Genius*. New Haven, CT: Yale University Press, 1998.

Kitaj: *R.B. Kitaj.* Edited by Richard Morphet. New York: Rizzoli, 1994.

Henri: Henri, Robert. *The Art Spirit.* Boulder, CO: Westview, 1984.

Renoir: *The History of Impressionism.* New York: Museum of Modern Art, 1973.

Hirst: Hirst, Damian, and Gordon Burn. *On the Way to Work.* London: Faber and Faber, 2001.

Sedgwick: Sedgwick, John P. *Discovering Modern Art.* New York: Random House, 1966.

Van Gogh: *The Letters of Vincent van Gogh.* Selected and edited by Ronald de Leeuw. New York: Penguin, 1996.

Pissarro: Rewald, John. *Post-impressionism from Van Gogh to Gaugin.* New York: Museum of Modern Art, 1978.

Hoban: Hoban, Phoebe. *Basquiat: A Quick Killing in Art.* New York: Viking, 1998.

Chirico: *The Memoirs of Giorgio de Chirico.* New York: Da Capo, 1994.

Ruskin: Ruskin, John. *The Seven Lamps of Architecture.* New York: Dover, 1989.

Rubens: *Artists on Art: From the XIV to the XX Century.* Compiled and edited by Robert Goldwater and Marco Treves. New York: Pantheon, 1945.

Seidner: Seidner, David. *Artists at Work: Inside the Studios of Today's Most Celebrated Artists.* New York: Rizzoli, 1999.

Reff: Reff, Theodore. *Degas: The Artist's Mind.* Cambridge, MA: Harvard University Press, 1987.

Menand: Menand, Louis. "Capture the Flag." *Slate,* 30 October 1996.

Pollock: Pollock, Jackson. "My Painting." *Possibilities,* no. 1 (Winter 1947–1948).

Namuth: Varnedoe, Kirk. "Pollock at Work: The Films and Photographs of Hans Namuth." In *Jackson Pollock.* By Kirk Varnedoe. New York: Museum of Modern Art, 1999.

Schapiro: Schapiro, Meyer. *Modern Art: 19th and 20th Centuries.* New York: George Braziller, 1978.

Leonardo: *Painters on Painting.* Selected and edited by Eric Protter. New York: Grossett & Dunlap, 1963.

Sloan: Sloan, John. *Gist of Art.* New York: American Artists Group, 1939.

Pei: Von Boehm, Gero. *Conversations with I.M. Pei.* Munich: Prestel, 2000.

Alberti: Alberti, Leon Battista. *On Painting.* New York: Penguin, 1991.

Hirsch: Hirsch, Edward. *The Demon and the Angel: Searching for the Source of Artistic Inspiration.* New York: Harcourt, 2002.

Kandinsky: Castro, Jan Gardner. *The Art and Life of Georgia O'Keeffe*. New York: Crown, 1985.

Garrido: Brown, Jonathan and Carmen Garrido. *Velázquez: The Technique of Genius*. New Haven, CT: Yale University Press, 1998.

All Together Now

Hughes: Hughes, Robert. *The Shock of the New*. 2nd ed. New York: McGraw-Hill, 1991.

Estes: Stein, Harvey. *Artists Observed*. Photographs by Harvey Stein. New York: Abrams, 1986.

Richardson: Richardson, John. *A Life of Picasso*. Vol. 2, *1907–1917: The Painter of Modern Life*. New York: Random House, 1996.

Rosenberg: Rosenberg, Harold. *Art and Other Serious Matters*. Chicago: University of Chicago Press, 1985.

Cassatt: Hale, Nancy. *Mary Cassatt*. Garden City, NY: Doubleday, 1975.

Smithson: Interview with Robert Smithson for the Archives of American Art/Smithsonian Institution (1972). robertsmithson.com

Katz: Katz, Jonathan. "The Art of Code: Jasper Johns and Robert Rauschenberg." In *Significant Others: Creativity and Intimate Partnership*. Edited by Whitney Chadwick

and Isabelle de Courtivron. New York: Thames & Hudson, 1993.

Hopps and Bancroft: Hopps, Walter, and Sarah Bancroft. *James Rosenquist: A Retrospective*. New York: The Guggenheim Museum, 2003.

Marinetti: Lynton, Norbert. "Futurism." In *Concepts of Modern Art from Fauvism to Postmodernism*. 3rd ed. Edited by Nikos Stangos. New York: Thames & Hudson, 1984.

Hughes: Hughes, Robert. *Nothing If Not Critical: Selected Essays on Art and Artists*. New York: Knopf, 1990.

Arp: Ades, Dawn. "Dada and Surrealism." *Concepts of Modern Art*. 3rd ed. Edited by Nikos Stangos. New York: Thames & Hudson, 1984.

Motherwell: Motherwell, Robert. *The Collected Writings of Robert Motherwell*. New York: Oxford University Press, 1992.

Newman: Harrison, Charles. "Abstract Expressionism." In *Concepts of Modern Art*. 3rd ed. Edited by Nikos Stangos. New York: Thames & Hudson, 1984.

Newman ("Harold Rosenberg . . ."): Mackie, Alwynne. *Art/Talk: Theory and Practice in Abstract Expressionism*. New York: Columbia University Press, 1989.

Picasso: Tomkins, Calvin. *Post- to Neo-: The Art World of the*

1980s. New York: Henry Holt, 1988.

Shahn: Rosenberg, Harold. *Art and Other Serious Matters.* Chicago: University of Chicago Press, 1985.

Lin: achievement.org

Stella: Cernuschi, Claude. *Jackson Pollock: Meaning and Significance.* New York: HarperCollins, 1992.

Rothko: Rothko, Mark. *Mark Rothko: A Biography.* James E.B. Breslin. Chicago: University of Chicago Press, 1993.

Rosenberg: Rosenberg, Harold. *Art and Other Serious Matters.* Chicago: University of Chicago Press, 1985.

Riley: *Writers on Artists.* New York: Dorling Kindersley, 2001.

Picabia: Camfield, William A. *Francis Picabia.* New York: The Guggenheim Museum, 1970.

Steichen: Steichen, Edward. *A Life in Photography.* Garden City, NY: Doubleday, 1963.

Warhol: Danto, Arthur C. *After the End of Art.* Princeton, NJ: Princeton University Press, 1997.

Danto: Danto, Arthur C. *After the End of Art.* Princeton, NJ: Princeton University Press, 1997.

Denvir. New York: Thames & Hudson, 1987.

Heller: Heller, Nancy. *Why Painting Is Like Pizza.* Princeton, NJ: Princeton University Press, 2002.

Delacroix: Delacroix, Eugène. *The Journal of Eugène Delacroix.* New York: Crown, 1948.

Elkins: Elkins, James. "Open to Criticism." *Circa* (Winter 2000).

Richardson, John. *A Life of Picasso.* Vol. 2, 1907–1917: *The Painter of Modern Life.* New York: Random House, 1996.

Stein: Hobhouse, Janet. *Everybody Who Was Anybody.* New York: Putnam, 1975.

Stein: Hobhouse, Janet. *Everybody Who Was Anybody.* New York: Putnam, 1975.

Steichen: Niven, Penelope. *Steichen: A Biography.* New York: Clarkson Potter, 1997.

Giuliani: Barry, Dan, and Carol Vogel. "Giuliani Vows to Cut Subsidy over Art He Calls Offensive." *News York Times,* 23 September 1999.

Ofili: Vogel, Carol. "Chris Ofili: British Artist Holds Fast to His Inspiration." *New York Times,* 28 September 1999.

Van der Zee: *The Guardian,* 1 November 2003.

Taste

Wolff: *The Impressionists at First Hand.* Edited by Bernard

Freeland: Freeland, Cynthia. *But Is It Art?: An Introduction to Art Theory.* New York:

Oxford University Press, 2001.

Serrano: communityarts.net

Cattelan: artnewspaper.com

Kunitz: Kunitz, Daniel. "True Sensation." *Salon.com*, 2 October 1999.

Hewlett: Smith, David. "He's Our Favourite Artist: So Why Do the Galleries Hate Him So Much?" *The Observer* (London), 11 January 2004.

Hughes: Hughes, Robert. *Nothing If Not Critical: Selected Essays on Art and Artists*. New York: Knopf, 1990.

Macmillan: Smith, David. "He's Our Favourite Artist: So Why Do the Galleries Hate Him So Much?" *The Observer* (London), 11 January 2004.

Elkins: Elkins, James. "Open to Criticism." *Circa* (Winter 2000).

Wolfe: Wolfe, Tom. "The Painted Word." *Harper's Magazine* (April 1975).

The World of Inspiration

Bonnard: Bell, Julian. *Bonnard*. Oxford: Phaidon, 1994.

Delacroix: Delacroix, Eugène. *The Journal of Eugène Delacroix*. New York: Crown, 1948.

Van Gogh: Nochlin, Linda. *The Politics of Vision*. New York: Harper & Row, 1989.

Francisco de Hollanda: *The Art of Painting from Prehistory through the Renaissance*. Edited by Pierre Seghers.

New York: Hawthorn, 1964.

Van Gogh: Denvir, Bernard. *Post-impressionism*. New York: Thames & Hudson, 1992.

Renoir: Nochlin, Linda. *Impressionism and Post-impressionism, 1874–1904*. Englewood Cliffs, NJ: Prentice-Hall, 1966.

Van Gogh: Silverman, Debora. *Van Gogh and Gaugin: The Search for Sacred Art*. New York: Farrar, Straus & Giroux, 2000.

Cézanne: Hughes, Robert. *The Shock of the New*. 2nd ed. New York: McGraw-Hill, 1991.

Eakins: Hughes, Robert. *Nothing If Not Critical: Selected Essays on Art and Artists*. New York: Knopf, 1990.

Runge: Canaday, John. *Mainstreams of Modern Art*. New York: Holt, Rinehart & Winston, 1981.

Whistler: Reff, Theodore. *Degas: The Artist's Mind*. Cambridge, MA: Harvard University Press, 1987.

Cézanne: Golding, John. *Cubism: A History and an Analysis, 1907–1914*. Cambridge, MA: Belknap, 1988.

Schapiro: Schapiro, Meyer. *Paul Cézanne*. New York: Harry N. Abrams, 1952.

Picabia: Camfield, William A. *Francis Picabia*. New York: The Guggenheim Museum, 1970.

Kandinsky: Kandinsky, Wassily. *Complete Writings on Art.* Vol. 2, *1922–1943.* Edited by Kenneth C. Lindsay and Peter Vergo. Boston: G.K. Hall, 1972.

Ernst: Ernst, Max. *Surrealists on Art.* Edited by Lucy R. Lippard. Englewood Cliffs, NJ: Prentice-Hall, 1970.

Gaugin: Bowness, Alan. *Gaugin.* London: Phaidon London, 1971.

Mondrian: Mondrian, Piet. *The New Art—The New Life: The Collected Writings of Piet Mondrian.* New York: Da Capo, 1993.

Chagall: Alexander, Sidney. *Marc Chagall: A Biography.* New York: Putnam, 1978.

Kitaj: *R.B. Kitaj.* Edited by Richard Morphet. New York: Rizzoli, 1994.

Kandinsky: Gage, John. *Color and Meaning.* Berkeley: University of California Press, 1999.

Lewis: Patton, Sharon F. *African-American Art.* New York: Thames & Hudson, 1998.

Bonnard: Bell, Julian. *Bonnard.* Oxford: Phaidon, 1994.

Degas: Hughes, Robert. *Nothing If Not Critical: Selected Essays on Art and Artists.* New York: Knopf, 1990.

Delacroix: Delacroix, Eugène. *The Journal of Eugène Delacroix.* New York: Crown, 1948.

Grosz: Lucie-Smith, Edward. *Lives of the Great 20th-Century Artists.* New York: Thames & Hudson, 1999.

Hoban: Hoban, Phoebe. *Basquiat: A Quick Killing in Art.* New York: Viking, 1998.

Denvir: Denvir, Bernard. *Toulouse-Lautrec.* New York: Thames & Hudson, 1991.

Le Corbusier: *Journey to the East.* Edited and translated by Ivan Žakni Cambridge: MIT Press, 1987.

McGuigan: McGuigan, Cathleen. "Calatrava Takes Flight." *Newsweek,* 23 February 2004.

Subjects

Pissarro: Pissarro, Camille. *Letters to His Son Lucien.* 3rd ed. Mamaroneck, NY: Paul P. Appel, 1972.

Bazille: Pool, Phoebe. *Impressionism.* New York: Thames & Hudson, 1985.

Benton: Benton, Janetta Rebold. *Art of the Middle Ages.* New York: Thames & Hudson, 2002.

Poussin: *Artists on Art: From the XIV to the XX Century.* Compiled and edited by Robert Goldwater and Marco Treves. New York: Pantheon, 1945.

Munch: Scharf, Aaron. *Art and Photography.* New York: Penguin, 1986.

Rothko and Gottlieb. *The New York Times,* June, 1943.

Gombrich: Gombrich, E.H. *The Story of Art*. 15th ed. Oxford: Phaidon, 1991.

Avedon: Wisniak, Nicole. "An Interview with Richard Avedon." *Egoïste* (September 1984).

De Kooning: De Kooning, Elaine. *The Spirit of Abstract Expressionism: Selected Writings*. New York: George Brazillier, 1994.

Delacroix: Delacroix, Eugène. *The Journal of Eugène Delacroix*. New York: Crown, 1948.

Malraux: *Writers on Artists*. Edited by Daniel Halpern. New York: North Point, 1990.

Picasso: *Matisse Picasso*. New York: Museum of Modern Art, 2002.

Freud: Kimmelman, Michael. *Portraits*. New York: Random House, 1998.

Chagall: Fifield, William. *In Search of Genius*. New York: William Morrow, 1982.

Rush: Rush, Michael. *New Media in Late 20th-century Art*. New York: Thames & Hudson, 1999.

Goldberg: Goldberg, RoseLee. *Performance: Live Art since 1960*. New York: Abrams, 1998.

Robertson: *The Grove Book of Art Writing*. Edited by Martin Gayford and Karen Wright. New York: Grove, 2000.

LeWitt: *ArtForum*, June, 1967.

Barry: Smith, Roberta. "Conceptual Art." In *Concepts of Modern Art*. 3rd ed. Edited by Nikos Stangos. New York: Thames & Hudson, 1984.

Burden: *ArtForum* (December 2001).

Goldberg: Goldberg, RoseLee. *Performance: Live Art since 1960*. New York: Abrams, 1998.

Baudelaire: Whelan, Richard. *Alfred Stieglitz: A Biography*. Boston: Little, Brown, 1995.

Abbott: Abbott, Berenice. *Photographer: A Modern Vision*. New York: New York Public Library, 1989.

Evans: Mellow, James R. *Walker Evans*. New York: Basic, 1999.

Adams: Adams, Ansel. *An Autobiography*. Boston: Little, Brown, 1985.

Abbott: Abbott, Berenice. *Changing New York, 1935–1939*. New York: The New Press, 1999.

Varnedoe and Gopnik: Varnedoe, Kirk, and Adam Gopnik. *High and Low: Modern Art and Popular Culture*. New York: Museum of Modern Art, 1991.

Guston: Weber, Joanna, et al. *Philip Guston: A New Alphabet*. New Haven, CT: Yale University Press, 2000.

Cooper: Weber, Joanna, et al. *Philip Guston: A New Alphabet*. New Haven, CT: Yale University Press, 2000.

Newman: tate.org.uk

DWM

Krasner: Stein, Harvey. *Artists Observed*. Photographs by Harvey Stein. New York: Abrams, 1986.

Merritt: Merritt, Anna Massey Lea. "A Letter to Artists: Especially Women Artists." City: Publisher, 1900.

Nochlin: Nochlin, Linda. "Why Have There Been No Great Woman Artists?" *ARTnews* (January 1971).

Sontag: Leibovitz, Annie, and Susan Sontag. *Women*. New York: Random House, 1999.

Freeland: Freeland, Cynthia. *But Is It Art?: An Introduction to Art Theory*. New York: Oxford University Press.

Berger: Berger, John. *Ways of Seeing*. New York: Viking, 1973.

Flam: Flam, Jack. *Matisse and Picasso*. Boulder, CO: Westview, 2003.

Prose: Prose, Francine. *The Lives of the Muses: Nine Women and the Artists They Inspired*. New York: HarperCollins, 2002.

Kuenzli: Kuenzli, Rudolf E. "Surrealism and Women." In *Surrealism and Women*. Edited by Mary Ann Caws, Rudolf Kuenzli, and Gwen Raaberg. Cambridge: MIT Press, 1991.

Olivier: Olivier, Fernande. *Loving Picasso: The Private Journals of Fernande Olivier*. New York: Abrams, 2001.

Slatkin: Slatkin, Wendy. *Women Artists in History*. Englewood Cliffs, NJ: Prentice-Hall, 1985.

Chadwick: Chadwick, Whitney. "Living Simultaneously: Sonia and Robert Delaunay." In *Significant Others: Creativity and Intimate Partnership*. Edited by Whitney Chadwick and Isabelle de Courtivron. New York: Thames & Hudson, 1993.

Mitchell: Interview conducted by Linda Nochlin, April 16, 1986. Archives of American Art, Smithsonian Institution. artarchives.si.edu

De Kooning: Livingston, Jane. *The Paintings of Joan Mitchell*. New York: Whitney Museum of American Art, 2002.

Oppenheim: *Surrealism and Women*. Edited by Mary Ann Caws, Rudolf Kuenzli, and Gwen Raaberg. Cambridge: MIT Press, 1991.

Chadwick: *Women, Art and Society*. New York: Thames & Hudson, 1990.

"Kollwitz": Millard, Pauline M. "The War of Art." Associated Press, 4 December 2003.

Holzer: *ArtForum* (April 2003).

Prather: Landi, Ann. "Who Are the Great Women Artists?" *ARTnews* (March 2003).

Spector: Landi, Ann. "Who Are the Great Women Artists?" *ARTnews* (March 2003).

Hoptman: Landi, Ann. "Who Are the Great Women

Artists?" *ARTnews* (March 2003).

The Works

Monet: *Readings in Art History*. Vol. 2. 3rd ed. Edited by Harold Spencer. New York: Scribner's, 1983.

Hughes: Hughes, Robert. *Nothing If Not Critical: Selected Essays on Art and Artists*. New York: Knopf, 1990.

Kahlo: Herrera, Hayden. "Beauty to His Beast: Frida Kahlo and Diego Rivera." In *Significant Others: Creativity and Intimate Partnership*. Edited by Whitney Chadwick and Isabelle de Courtivron. New York: Thames & Hudson, 1993.

Bancroft: Hopps, Walter, and Sarah Bancroft. *James Rosenquist: A Retrospective*. New York: The Guggenheim Museum, 2003.

Puryear: pbs.org

Wyeth: Wyeth, Andrew. *Autobiography*. New York: Bulfinch, 1995.

Hopper: Catalog of the National Gallery of Art in Washington, DC. New York: Thames & Hudson, 1992.

Tomkins: Tomkins, Calvin. *Post- to Neo-: The Art World of the 1980s*. New York: Henry Holt, 1988.

Homer: Hendricks, Gordon. *The Life and Work of Winslow Homer*. New York: Abrams, 1979.

Vasari: Vasari, Giorgio. *The Lives of the Painters, Sculptors, and Architects*. Vol. 2. Translated by A.B. Hinds. New York: Everyman's Library, 1963.

Duchamp: Cabanne, Pierre. *Dialogues with Marcel Duchamp*. New York: Viking, 1971.

Hamilton: Hamilton, Richard. *Collected Works*. New York: Thomas & Hudson, 1983.

Whitfield: Whitfield, Sarah. *Magritte*. London: The South Bank Centre, 1992.

Magritte: Whitfield, Sarah. *Magritte*. London: The South Bank Centre, 1992.

Hamilton: Hamilton, Richard. *Collected Works*. New York: Thomas & Hudson, 1983.

Freud: Feaver, William. *Lucian Freud*. London: Tate, 2002.

Philips: Sanford, Melissa. "The Salt of the Earth Sculpture." *New York Times*, 13 January 2004.

Kimmelman: Kimmelman, Michael. "Out of the Deep." *New York Times Magazine*, 13 October 2002.

Hughes: Hughes, Robert. *Goya*. New York: Knopf, 2003.

Chapman: Jones, Jonathan. "Look What We Did." *The Guardian*, 31 March 2003.

Chapman: Jones, Jonathan. "Look What We Did." *The Guardian*, 31 March 2003.

Johns: guardian.co.uk

The Artist's Eye

Berger: Berger, John. *Ways of Seeing*. New York: Viking, 1973.

Constable: *Painters on Painting*. Selected and edited by Eric Protter. New York: Grossett & Dunlap, 1963.

Berger: Berger, John. *Ways of Seeing*. New York: Viking, 1973.

Berger: Berger, John. *Ways of Seeing*. New York: Viking, 1973.

Delaunay: Baron, Stanley. *Sonia Delaunay*. New York: Abrams, 1995.

Van Gogh: Scharf, Aaron. *Art and Photography*. New York: Penguin, 1986.

Newhall: Castro, Jan Gardner. *The Art and Life of Georgia O'Keeffe*. New York: Crown, 1985.

Malraux: Malraux, André. *The Creative Act*. New York; Pantheon, 1949.

Beckmann: Beckmann, Max. *Self-Portrait in Words*. Chicago: University of Chicago Press, 1997.

Beckmann ("The important thing . . ."): Beckmann, Max. *Self-Portrait in Words*. Chicago: University of Chicago Press, 1997.

O'Keeffe: Robinson, Roxana. *Georgia O'Keeffe*. New York: Harper & Row, 1989.

Bourgeois: home.hpo.net

Picasso: Lake, Carlton. "Picasso Speaking." *The Atlantic Monthly* (July 1957).

Dove: Hughes, Robert. *American Visions: The Epic History of Art in America*. New York: Knopf, 1997.

Clark: Clark, Kenneth. *What Is a Masterpiece?* New York: Thames & Hudson, 1981.

Schama: Schama, Simon. *Rembrandt's Eyes*. New York: Knopf, 1999.

Epstein: Epstein, Jacob. *Epstein: An Autobiography*. London: Vista, 1963.

Robb: Robb, Peter. *M: The Man Who Became Caravaggio*. New York: Henry Holt, 2000.

Picasso: Ashton, Dore. *Picasso on Art: A Selection of Views*. New York: Da Capo, 1992.

Giacometti: Liberman, Alexander. *The Artist in His Studio*. New York: Viking, 1960.

Courbet: Pool, Phoebe. *Impressionism*. New York: Thames & Hudson, 1985.

Canaday: Canaday, John. *Mainstreams of Modern Art*. New York: Holt, Rinehart & Winston, 1981.

Gris: Golding, John. *Cubism: A History and an Analysis, 1907–1914*. Cambridge, MA: Belknap, 1988.

Picasso: Hughes, Robert. *The Shock of the New*. 2nd ed. New York: McGraw-Hill, 1991.

Dalí: Etherington-Smith, Meredith. *The Persistence of Memory*. New York: Random House, 1993.

Braque: *Georges Braque*. New York: The Guggenheim Museum, 1988.

Apollinaire: Flanner, Janet. *Men and Monuments*. New York: Da Capo, 1990.

Eakins: Johns, Elizabeth. *Thomas Eakins: The Heroism of Modern Life*. Princeton, NJ: Princeton University Press, 1983.

Picasso: Lake, Carlton. "Picasso Speaking." *The Atlantic Monthly* (July 1957).

Giacometti: Lord, James. *A Giacometti Portrait*. Rev. ed. New York: FSG, 1980.

Intention

Serra: Frazier, Nancy. *The Penguin Concise Dictionary of Art History*. New York: Penguin, 2001.

Lord and Giacometti: Lord, James. *A Giacometti Portrait*. Rev. ed. New York: FSG, 1980.

Shattuck: Shattuck, Roger. *The Banquet Years*. Rev. ed. New York: Vintage, 1968.

Shahn: Shahn, Ben. *The Shape of Content*. Cambridge, MA: Harvard University Press, 1957.

Guston: Weber, Joanna, et al. *Philip Guston: A New Alphabet*. New Haven, CT: Yale University Press, 2000.

Nauman: Kimmelman, Michael. *Portraits*. New York: Random House, 1998.

Richter: Storr, Robert. *Gerhard Richter: Forty Years of Painting*. New York: Museum of Modern Art, 2002.

Storr: Storr, Robert. *Gerhard Richter: Forty Years of Painting*. New York: Museum of Modern Art, 2002.

Breton: Breton, André. *What Is Surrealism?* Edited and introduced by Franklin Rosemont. New York: Pathfinder, 2000.

Ray: Ray, Man. *Self-Portrait*. New York: McGraw-Hill, 1963.

Picasso: Lake, Carlton. "Picasso Speaking." *The Atlantic Monthly* (July 1957).

Manguel: Manguel, Alberto. *Reading Pictures: A History of Love and Hate*. New York: Random House, 2000.

Turner: Berger, John. *About Looking*. New York: Pantheon, 1980.

Beckmann: Beckmann, Max. *Self-Portrait in Words*. Chicago: University of Chicago Press, 1997.

Kertész: Kertész, André. *Of Paris and New York*. Edited by Sandra S. Phillips et al. New York: Thames & Hudson, 1985.

Rockwell: Rockwell, Norman. *My Adventures as an Illustrator*. New York: Abrams. 1988.

Van Gogh: Huffington, Arianna. *Picasso Creator and Destroyer.* New York: Simon & Schuster, 1988.

Adams: Adams, Ansel. *An Autobiography.* Boston: Little, Brown, 1985.

Nauman: *Bruce Nauman.* Edited by Robert C. Morgan. Baltimore, MD: Johns Hopkins University Press, 2002.

Perl: Perl, Jed. *Eyewitness.* New York: Basic, 2000.

Duchamp: Tomkins, Calvin. *Duchamp: A Biography.* New York: Henry Holt, 1996.

Siegel: Siegel, Lee. "The Revolution That Wasn't Televised." slate.msn.com

Magritte: *Surrealists on Art.* Edited by Lucy R. Lippard. Englewood Cliffs, NJ: Prentice-Hall, 1970.

Rothko: Mackie, Alwynne. *Art/Talk: Theory and Practice in Abstract Expressionism.* New York: Columbia University Press, 1989.

Zola: Rubin, James H. *Impressionism.* New York: Phaidon, 1999.

Van Gogh: Denvir, Bernard. *Post-impressionism.* New York: Thames & Hudson, 1992.

Hirst: Hirst, Damian. *I Want to Spend the Rest of My Life Everywhere, with Everyone, One to One, Always, Forever, Now.* New York: Monacelli, 1997.

Calder: *From the Painter's Object.* Edited by Myfanwy Evans. London: Gerald Howe, 1937.

Evans: Mellow, James R. *Walker Evans.* New York: Basic, 1999.

Chagall: Alexander, Sidney. *Marc Chagall: A Biography.* New York: Putnam, 1978.

Evans: Mellow, James R. *Walker Evans.* New York: Basic, 1999.

Motherwell: Mackie, Alwynne. *Art/Talk: Theory and Practice in Abstract Expressionism.* New York: Columbia University Press, 1989.

Degas: Reff, Theodore. *The Artist's Mind.* Cambridge, MA: Harvard University Press, 1987.

The Creative Act

Murray: artchive.com

Van Gogh: Denvir, Bernard. *Post-impressionism.* New York: Thames & Hudson, 1992.

Rothko: *Painters on Painting.* Selected and edited by Eric Protter. New York: Grossett & Dunlap, 1963.

Tharp: Tharp, Twyla. *The Creative Habit.* New York: Simon & Schuster, 2003.

Gehry: *Frank Gehry: Architect.* Edited by J. Fiona Ragheb. New York: The Guggenheim Museum, 2001.

Warhol: Warhol, Andy. *From A to B and Back Again.* New York: Harcourt Brace Jovanovich, 1975.

Stein: Hobhouse, Janet. *Everybody Who Was Anybody.* New York: Putnam, 1975.

Courbet: *The Grove Book of Art Writing.* Edited by Martin Gayford and Karen Wright. New York: Grove, 2000.

Delacroix: Huyghe, Rene. *Ideas and Images in World Art.* New York: Abrams, 1959.

Matisse: Matisse, Henri. "Notes of a Painter." City: Publisher, 1908.

Whistler: Weintraub, Stanley. *Whistler.* New York: Dutton, 1984.

Murphy: Tomkins, Calvin. *Living Well Is the Best Revenge.* New York: Modern Library, 1998.

Plato: *The Republic.* Translated by Benjamin Jowett. City: Publisher, 1871.

Johns: Johnson, Jill. *Jasper Johns: Privileged Information.* New York: Thames & Hudson, 1996.

Wyeth: *Painters on Painting.* Selected and edited by Eric Protter. New York: Grossett & Dunlap, 1963.

Rothko: Waldman, Diane. *Mark Rothko, 1903–1970: A Retrospective.* New York: The Guggenheim Museum, 1978.

Duchamp: Tomkins, Calvin. *Duchamp: A Biography.* New York: Henry Holt, 1996.

Giacometti: Lord, James. *A Giacometti Portrait.* Rev. ed. New York: Farrar, Straus & Giroux, 1980.

Gorky: Lucie-Smith, Edward. *Movements in Art since 1945.* Rev. ed. New York: Thames & Hudson, 2001.

Doerner: Doerner, Max. *The Materials of the Artist.* New York: Harcourt, Brace & World, 1934.

Matisse: *Matisse Picasso.* New York: Museum of Modern Art, 2002.

Picasso: Ashton, Dore. *Picasso on Art.* New York: Da Capo, 1992.

Miró: *The Art Institute of Chicago: The Essential Guide.* Chicago: The Art Institute of Chicago, 1993.

Motherwell: Motherwell, Robert. *The Collected Writings of Robert Motherwell.* New York: Oxford University Press, 1992.

Desiderio: Desiderio, Vincent. *Paintings.* New York: Marlborough Gallery, 2004.

Giacometti: *Surrealists on Art.* Edited by Lucy R. Lippard. Englewood Cliffs, NJ: Prentice-Hall, 1970.

Matisse: *Matisse Picasso.* New York: Museum of Modern Art, 2002.

Monet ("I am working away . . ."): Nochlin, Linda. *Impressionism and Post-impressionism, 1874–1904.* Englewood Cliffs, NJ: Prentice-Hall, 1966.

Monet ("My stay . . ."): *Claude Monet at the Time of Giverny.* Edited by Jacqueline Guillard et al.

New York: Rizzoli, 1985.

Monet ("These landscapes . . ."): *Readings in Art History*. Vol. 2. 3rd ed. Edited by Harold Spencer. New York: Scribner's, 1983.

Miró: Fifield, William. *In Search of Genius*. New York: William Morrow, 1982.

Pearlstein: Stein, Harvey. *Artists Observed*. Photographs by Harvey Stein. New York: Abrams, 1986.

Picasso: Flanner, Janet. *Men and Monuments*. New York: Da Capo, 1990.

Huxtable: Huxtable, Ada Louise. *Architecture Anyone?* Berkeley: University of California Press, 1986.

Kahn: *My Architect: A Son's Journey*. Directed by Nathaniel Kahn. Louis Kahn Project, Inc., 2003.

Bearden: Interview conducted by Henri Ghent, June 29, 1968. Archives of American Art, Smithsonian Institution. archivesofamericanart.si.edu

Shahn: Shahn, Ben. *The Shape of Content*. Cambridge, MA: Harvard University Press, 1957.

Duchamp: Tomkins, Calvin. "The Creative Act." In *Duchamp: A Biography*. New York: Henry Holt, 1996.

Lord: Lord, James. *A Giacometti Portrait*. Rev. ed. New York: FSG, 1980.

Malraux: Malraux, André. *Writers on Artists*. Edited by

Daniel Halpern. Berkeley, CA: North Point, 1988.

Guston: Mackie, Alwynne. *Art/Talk: Theory and Practice in Abstract Expressionism*. New York: Columbia University Press, 1989.

Being an Artist

Truitt: Russo, Alexander. *Profiles on Women Artists*. Frederick, MD: University Publications of America, 1985.

George: Anthony, Andrew. "Artful Dodgers." *The Observer*, 5 May 2002.

Wright: *Frank Lloyd Wright: An Autobiography*. New York: Duell, Sloan and Pearce, 1943.

Frank: Stein, Harvey. *Artists Observed*. Photographs by Harvey Stein. New York: Abrams, 1986.

Puryear: cnn.com

Gwathmey: Kamman, Michael. *Robert Gwathmey: The Life and Art of a Passionate Observer*. Chapel Hill: University of North Carolina Press, 1999.

Stieglitz: *Stieglitz on Photography*. Compiled and annotated by Richard Whelan. New York: Aperture, 2000.

Nauman: *Bruce Nauman*. Edited by Robert C. Morgan. Baltimore, MD: Johns Hopkins University Press, 2002.

Levy: Stein, Harvey. *Artists Observed*. Photographs by

Harvey Stein. New York: Abrams, 1986.

Matisse: Aaron Scharf. *Art and Photography*. New York: Penguin, 1986.

Villon: *Painters on Painting*. Selected and edited by Eric Protter. New York: Grossett & Dunlap, 1963.

Hockney: Hockney, David. *That's the Way I See It*. San Francisco, CA: Chronicle, 1993.

Close: Kimmelman, Michael. *Portraits*. New York: Random House, 1998.

Freud: Gruen, John. *The Artist Observed: 28 Interviews with Contemporary Artists*. Pennington, NY: A Cappella, 1991.

Kruger: Kruger, Barbara. *Barbara Kruger*. Los Angeles: Museum of Contemporary Art, 1999.

Hockney: Hockney, David. *That's the Way I See It*. San Francisco, CA: Chronicle, 1993.

Piano: bbc.co.uk

Motherwell: *Painters on Painting*. Selected and edited by Eric Protter. New York: Grossett & Dunlap, 1963.

Manguel: Manguel, Alberto. *Reading Pictures: A History of Love and Hate*. New York: Random House, 2000.

Still: *Clyfford Still*. Edited by John P. O'Neill. New York: Metropolitan Museum of Art, 1979.

Viola: *Bill Viola*. New York: Whitney Museum of American Art, 1997.

Soleri: Heyer, Paul. *Architects on Architecture*. New York: Walker and Company, 1966.

Schwartz: Schwartz, Sanford. *Artists and Writers*. New York: Yarrow, 1990.

Renoir: *The History of Impressionism*. New York: Museum of Modern Art, 1973.

Dürer: *A Documentary History of Art*. Vol. 1. Selected and edited by Elizabeth Gilmore Holt. Princeton, NJ: Princeton University Press, 1981.

Smith: pbs.org

Peyton: indexmagazine.com

Léger: *Encounters with Great Painters*. Compiled by Roger Thérond. New York: Abrams, 2001.

Epstein: Epstein, Jacob. *Epstein: An Autobiography*. London: Vista, 1963.

Toulouse-Lautrec: *Henri de Toulouse-Lautrec*. Edited by Riva Castleman and Wolfgang Wittrock. New York: Museum of Modern Art, 1985.

Neel: Munro, Eleanor. *Originals: American Women Artists*. New York: Simon & Schuster 1979.

Judd: Stein, Harvey. *Artists Observed*. Photographs by Harvey Stein. New York: Abrams, 1986.

Michelangelo: *Artists on Art: From the XIV to the XX Century*. Compiled and edited

by Robert Goldwater and Marco Treves. New York: Pantheon, 1945.

Liberman: Liberman, Alexander. *The Artist in His Studio*. New York: Viking, 1960.

Motherwell: Cabanne, Pierre. *Dialogues with Marcel Duchamp*. New York: Viking, 1971.

Ashton: Ashton, Dore. *About Rothko*. New York: Da Capo Press, 1996.

Murray: *Elizabeth Murray: Paintings and Drawings*. New York: Harry N. Abrams, 1987.

Perry: graysonperry.co.uk

Stieglitz: Whelan, Richard. *Alfred Stieglitz: A Biography*. Boston: Little, Brown, 1995.

Koons: jca-online.com

Richter: Storr, Richard. *Gerhard Richter: Forty Years of Painting*. New York: Museum of Modern Art, 2002.

Alberti: Alberti, Leon Battista. *On Painting*. New York: Penguin, 1991.

Gorky: Schwacher, Ethel J. *Arshile Gorky*. New York: Whitney Museum of American Art, 1957.

Ruskin: Ruskin, John. *The Seven Lamps of Architecture*. New York: Dover, 1989.

Thomas: Patton, Sharon F. *African-American Art*. New York: Oxford University Press, 1998.

Breton: Breton, André. *What Is Surrealism?: Selected Writings*. Edited and introduced by Franklin Rosemont. New York: Pathfinder, 2000.

Duchamp: Cabanne, Pierre. *Dialogues with Marcel Duchamp*. New York: Viking, 1971.

Paik: Tomkins, Calvin. *Post- to Neo-: The Art World of the 1980s*. New York: Henry Holt, 1988.

Hirst: *The Grove Book of Art Writing*. Edited by Martin Gayford and Karen Wright. New York: Grove, 2000.

Hirst ("I believe . . ."): Hirst, Damien. *I Want to Spend the Rest of My Life Everywhere, with Everyone, One to One, Always, Forever, Now*. New York: Monacelli, 1997.

Gilbert: *The Grove Book of Art Writing*. Edited by Martin Gayford and Karen Wright. New York: Grove, 2000.

Schnabel: *ArtForum* (April 2003).

Johns: Lucie-Smith, Edward. *Lives of the Great 20th-Century Artists*. New York: Thames & Hudson, 1999.

Wright: Peter, John. *The Oral History of Modern Architecture*. New York: Harry N. Abrams, 1994.

Kline: Storr, Robert. "No Joy in Mudville." In *Modern Art and Popular Culture*. Edited by Kirk Varnedoe and Adam Gopnik. New York: Abrams, 1990.

Truitt: Truitt, Anne. *Daybook: The Journey of an Artist*. New York: Pantheon, 1982.

INDEX

◎ ◎ ◎

ACKNOWLEDGMENTS

◎ ◎ ◎

At Random House, I would like to thank my editor Jena Pincott, her colleague Laura Neilson, and publisher Sheryl Stebbins for their help and support. Thanks also to Beth Levy, Steven Long, Tigist Getachew, and Tina Malaney. My friend Bud Kliment helped me again by sharing his thoughts and offering encouragement and I am grateful to him. For the generous loan of her books, I thank Diane Arne. And thanks also to my friend Adolfo Profumo.

This book is for Lindsay, Sam, and Kara.